D0563178

MAGNETIC

The Art and Science of Engagement

133/150 Man Ray

MAGNETIC

The Art and Science of Engagement

Anne Bergeron and Beth Tuttle

 The AAM Press

2013

MAGNETIC

The Art and Science of Engagement
By Anne Bergeron and Beth Tuttle

© 2013 Anne Bergeron and Beth Tuttle. All rights reserved.

No part of this book may be reproduced for any purpose, with the exception of brief passages in the context of a critical review, without prior written permission of the publisher.

Published by The AAM Press
American Alliance of Museums
1575 Eye St. NW, Suite 400
Washington, DC 20005

John Strand, publisher
Susan v. Levine, creative director

Polly Franchini, designer

Frontispiece: *Electro-Magie,* Man Ray.
©2013 Man Ray Trust/Artists Rights Society (ARS),
New York/ABAGP, Paris

ISBN 978-1-933253-83-1
ISBN 978-1-933253-88-6 e-book

Library of Congress Cataloging-in-Publication Data
Bergeron, Anne.
Magnetic : the art and science of engagement / Anne Bergeron and Beth
Tuttle.
 pages cm
Includes index.
ISBN 978-1-933253-83-1
1. Museums--Management. 2. Service learning. 3. Engagement
(Philosophy) 4. Management. I. Tuttle, Beth. II. Title.
AM121.B47 2013
069.068--dc23
 2013006506

Contents

Introduction

In Search of Magnetic Museums

The first decade of the 21st century was a rough ride. Since 2000, the United States has endured terrorist attacks, a series of unprecedented natural disasters, a meltdown on Wall Street, and a stubborn economic recession. Businesses and households struggled as all sought ways to do more with less. For those working in the cultural sectors, the ripple effects impacted operations: hard-won endowments plummeted in value and returns on investment dwindled to almost nothing. The competition for philanthropic dollars increased as basic human and social service needs spiraled. The tourism market and leisure spending contracted as the number of cultural organizations competing for shrinking audiences increased. Old business models stopped working and many institutions found their relevancy declining as personalized entertainment options proliferated.

According to the American Alliance of Museums (AAM), museums employ 400,000 Americans and contribute $21 billion to the U.S. economy each year (2008 estimate).[1] That's big business. Yet, we rarely look to the cultural or museum sectors for examples of highly successful businesses. Instead, we regularly hear the news of undercapitalized museum expansions, boards considering selling collections or historic buildings in order to keep the doors open, and shotgun mergers that may or may not result in lasting or fruitful marriages.

So, it may perhaps seem counter-intuitive that we turned to the museum as a business model.

In the literature of management excellence in general, and in the nonprofit leadership literature in particular, cultural references are scarce and museum examples are

Opposite: Cloud Arbor *by artist Ned Kahn.*
Photo: Monica Granato, courtesy of Children's Museum Pittsburgh

almost non-existent. We asked ourselves, where are the great, high-performance institutions in the museum sector?

More than three years ago, we decided to find the answer to this question by embarking on a project to identify and study museums that had not just survived the last decade, but were thriving and growing in spite of the challenges. What we learned not only provides insight for museums, but also can offer useful lessons for anyone in the corporate or nonprofit arenas who seeks to motivate, inspire, and enlist others in their causes.

In late 2009, we issued a call to colleagues in the museum field that, in essence, asked: Are there any institutions out there that seem to be doing better than others? We received more than 50 suggestions. As we began to talk with the leadership at these institutions, we learned that virtually all had undergone what they felt was a major transformation since the late 1990s—either recovering from a period of financial instability, moving through a leadership transition, or facing a challenge or constraint that required strategic reinvention to set a new course. Several of these museums were, in fact, experiencing growth in one or several areas, such as programs, attendance, income, and organizational capacity, and some even an increase in the size of their physical campus. But most intriguing was the number of museum representatives who talked about how increased audience and community engagement efforts, or significant investments in building personal relationships, had been factors in their organizations' successes.

At the 2010 Alliance annual meeting, we presented the stories of nine of these museums and introduced an emerging concept called "Magnetic Museums." We offered a preliminary definition of the Magnetic Museum as *a high performance institution with a superior ability to attract and retain the resources necessary to deliver sustained programmatic excellence and growth over time.* In addition to financial capital, these resources include talented and committed leadership, staff, and volunteers; loyal and engaged audiences, donors, and stakeholders; positive reputation; and deep reserves of public goodwill.

The response from the Alliance audience was overwhelming and indicated that our colleagues were seeking a roadmap in these turbulent times. People wanted to know more—not just what these institutions were doing, but how and why. Some saw this as the route to enhanced financial stability, others as a means to greater mission impact—almost everyone wanted to get some of the "secret sauce," as one of the museum trustees we interviewed humorously referred to the ingredients of the transformation process.

With the cooperation of the Alliance and encouragement from the Institute for Museum and Library Services (IMLS) and other leaders in the field, we decided to

undertake a more comprehensive study. We wanted to understand the relationship between audience and stakeholder engagement as a principal organizational strategy, and the results on mission delivery and business performance.

This book is the result of two years of additional study, combining a quantitative analysis using data from the AAM Museum Financial Information Survey and from the National Center for Charitable Statistics (NCCS) to identify high performing museums, with a series of qualitative interviews and case study visits to identify the drivers of these organizations' success. That review resulted in six principally featured museums: Children's Museum Pittsburgh; Chrysler Museum of Art, Norfolk, Va.; Conner Prairie Interactive History Park, Fishers, Ind.; The Franklin Institute, Philadelphia; Natural Science Center of Greensboro, N.C.; and Philbrook Museum of Art, Tulsa, Okla. A complete description of our methodology is included in Appendix A.

As a result of our study, we identified six common organizational practices of Magnetic Museums, which we, and the museums we profile in this book, believe have helped them to achieve significant gains in mission delivery, business performance, community standing, and audience and community support. What also has emerged from this study is a picture of a richer, more holistic approach to "engagement" for museums and other social-benefit enterprises to consider. In addition, we developed a more descriptive definition of the Magnetic Museum based on what learned:

Magnetic Museums are high performance organizations that deliver tangible cultural and civic value, and achieve superior business results through a commitment to service, engagement, and empowerment of others. They are distinguished by powerful alignment around a compelling vision and the lasting bonds they create through meaningful experiences that enrich and strengthen their internal and external communities.

Take the word "museums" in this definition, substitute the word "organizations," or "businesses," or even "corporations," and we believe that the general principle holds. Becoming "magnetic," we learned, starts with creating alignment at the center of your operations by engaging and empowering those closest to your organization in the pursuit of a compelling vision of the future. It means investing in people, forging deep relationships, and activating powerful networks and communities. It means creating real value for your customers and constituents by being responsive, relevant, and meeting real needs. Becoming "magnetic" means building trust, loyalty, and support by consistently meeting or exceeding expectations.

Our findings correlate with much of the guidance found in the literature on

corporate and nonprofit management excellence—in particular, Jim Collins's *Good to Great* (2001), and Leslie Crutchfield's and Heather McLeod Grant's *Forces for Good* (2008). Magnetic Museums are, first and foremost, well-managed and well-programmed organizations, which is to be expected. What was surprising, however, was the degree to which these museums had intentionally pursued a profound philosophical and cultural shift in order to achieve their transformations. Although there is a wide range of management practices, business models, and organizational structures represented among the institutions we examined, the common thread linking these Magnetic Museums is the importance they place on people, service, and creating an organizational culture dedicated to building relationships and fostering meaningful engagement. These museums have moved along the spectrum from an internal to a more external focus; from conveying information to facilitating experiences; from offering authoritative monologue to participating in ongoing dialogue; from attracting visitors to serving "guests;" and from academic isolation to real-world relevance. The six practices of Magnetic Museums codify these shifts. The stories we share illustrate how museums of varied types, sizes, and situations are putting these practices to work and achieving outcomes that exceeded expectations and outpaced those of the museum sector as a whole.

This book does not intend to suggest that the six museums profiled are *The* Magnetic Museums. Nor was it our intention to create a comprehensive list of the *most* Magnetic Museums. Our goal instead was to offer the field a descriptive study highlighting successful institutional practices and to demonstrate these practices through a series of case study snapshots that bring to life the insights and experiences of peer museums.

Magnetic examines the ways that some museums have actively prioritized audience and stakeholder engagement, and discusses the outcomes they have achieved as a result. The recommendations and insights we offer are based on conversations with nearly 100 museum leaders and practitioners; a wide-ranging review of the literature on leadership, high performance organizations, and trends in employee, customer, and stakeholder engagement in the corporate and nonprofit sectors; and in-depth qualitative assessment of six institutions. They also draw on the experiences of the additional eight museums featured in our original 2010 AAM presentation, whose stories inspired us to pursue this study. These include: Dallas Museum of Art; Institute for Contemporary Art, Boston; Hammer Museum, Los Angeles; Museum of Art & Design, New York City; Museum of Science and Industry, Chicago; Thomas Jefferson's Monticello, Charlottesville, Va.; and the United States Holocaust Memorial Museum, Washington, DC. We are confident that there are more Magnetic Museums that already exist and many more in the making.

A FUNDAMENTAL SHIFT

What business are museums really in?

The collecting business? The exhibitions business? The education business?

Of course, museums are in all of these businesses. We believe, however, that above all else, museums are in the *relationship business.*

Why relationships rather than collecting, preserving, exhibiting, interpreting, or educating? Because we believe that relationships are the starting point for everything else. The collector falls in love with the civil war letter; the scientist is passionate about understanding deep space; the patron is inspired by a conversation with a curator; the student is engaged by a peer's YouTube post; the receptionist is proud to work at a place that so many people love; the audience feels welcomed and connected enough to make time for a second and third visit. Whether the relationship is with an object, idea, subject, organization, or another person, that spark of connection is essential to creating the motivation to collect, learn, explore, or take action.

Our belief in the primacy of relationships grows out of each of our experiences working for the past 25 years on what is often referred to (sometimes dismissively) in cultural organizations as the "people" side of the operation. Anne's expertise is in fundraising, resource development, and operational planning. Beth's is in organizational planning and development, integrated communications, marketing, and branding. Our primary responsibilities have been attracting the necessary resources and capital to enable our museums' missions. We have generated human capital in the form of talented, tireless, and generous staff, boards, volunteers, members, friends, partners, and collaborators. We have been responsible for creating awareness, attracting audiences, and building positive reputations for our institutions through communications, marketing, branding, strategic partnerships, and community outreach. Leveraging that foundation of relationships, awareness and reputation, we also have generated financial capital in the form of donations, grants, sponsorships, admissions, events, sales, and other income from the networks of people who are connected to our institutions. We know in our hearts that what success we have enjoyed has always been contingent on how effectively and deeply an institution engaged the hearts, energies, and imaginations of all the people in its orbit. So it's no surprise that we preach the gospel of engagement.

Having completed this research project, we believe more strongly than ever that museums must continue to rebalance the scales and move beyond a polarizing "either-or" framing of "content" versus "people" to achieve greater success in today's challenging

environment. This is a time for "both." It is time for "and." It is also a time to change the way we educate, nurture, and support museum leaders. Our desire to enable such a shift was a principal inspiration for the Magnetic Museums project.

This notion is not new; it is simply overdue. More than 40 years ago, museum director Duncan Cameron delivered an address at the University of Colorado entitled "The Museum, A Temple or A Forum?" He argued that although museums are and should continue to be "temples" that present the best cultural production, museums must also foster "forums" that support cultural dialogue and process.[2] The idea of museums as forums that allow people to engage with the essential, challenging issues of the day is an early articulation of the "more than a museum" refrain interviewees used to describe the Magnetic Museums in our study.

A quarter of a century later in 1999, Stephen Weil's seminal article, "From Being *about* Something to Being *for* Somebody: The Ongoing Transformation of the American Museum,"[3] articulated a related change in museum thinking. It chronicled the evolution of educational philosophy and the growing professionalism in the field, which sparked a shift in some institutions to a more audience-centered, experiential, and facilitative approach.

Magnetic examines what happened in the first decade of the 21st century for a group of museums that early on decided, purposefully and intentionally, to be "for somebody." We owe a great debt to forward thinkers like Cameron and Weil, who set the stage for our understanding of this next era in the museum field.

IS BIGGER BETTER?

When we first began to consider growth metrics as an initial screen for identifying institutions for our study, Philip Katz, assistant director for research at the Alliance, and Carlos Manjarrez, director of the office of planning, research, and evaluation at IMLS, challenged us to think about whether "bigger is better" in the museum sector, and how quantitative growth is related to mission advancement. Because our original inquiries had focused on the relationship between audience and stakeholder engagement and the generation of resources required to fuel the programmatic efforts that facilitate mission delivery, we determined that growth was an appropriate indicator for helping to identify Magnetic Museums.

Measuring the growth of these institutions, however, wasn't what principally interested us; how and why they grew was. The quantitative benchmarking process we

undertook was a means to finding needles in the haystack. We were looking for positive deviants.

Noted futurist Jonathan Peck of the Institute for Alternative Futures suggested positive deviance to us as an approach. Chip and Dan Heath's book, *Switch: How to Change When Changing Things is Hard*, ably describes this concept, renaming "positive deviants" as "bright spots."[4] Based on extensive research, the Heath brothers suggest 10 ways to make effective change, the first of which is: "Follow the Bright Spots." The Bright Spots are the people or organizational peers that seem to be doing better and having more success than everyone else, even without benefit of extraordinary circumstances, resources, or skills. Sometimes they even shine when conditions are more adverse than others. By observing their behaviors, one can often glean useful ideas for improvement.[5]

We decided that if there were museums that were beating the odds, we wanted to talk with them.

A NOTE ON QUALITY

Just as we thought hard about the question of whether bigger is better, we also considered whether the relative stature, quality, and size of a museum's collection and facilities were significant. Some of our advisors cautioned us not to overlook these issues and other standards typically considered in rating a museum's overall performance. These helpful conversations led us to a conclusion. Most museums do not stand a chance of having the "best" or "biggest" collections—instead, they strive to have the best collection possible within the context of their means and in relation to competing demands for limited resources. What was really important, for the purposes of this study, was in what ways and how well an institution deploys its assets, not how many assets it has or the quality of those assets. This creates a more level playing field for museums in the U.S. and positions the goal of becoming magnetic within reach of all.

WHY THIS BOOK NOW?

Museums have reached an important pivot point. In the financial and securities sector, a "pivot point" is an analytic marker that helps to predict where the market is headed. In sports, it is the place from which a player can decide to go forward, backward, left, right, or even up. Either way, this point marks a moment of directional change.

The consumer marketplace arrived at just such a moment more than a decade ago. In

his 2005 book *Lovemarks*, Kevin Roberts, CEO of advertising and branding giant Saatchi & Saatchi, writes that during the 20th century, consumer marketing moved from a focus on selling products to establishing trademarks to building brands. In the 21st century, he suggests, "lovemarks" will take center stage. "Lovemarks are the brands, events, and experiences that people love. Not just like or admire, but love passionately. For great brands to survive, they must create loyalty beyond reason…"[6]

Roberts asserts that forging emotional connections with consumers must be at the foundation of everything a company does because emotions drive behaviors.[7] He quotes neurologist Donald Calne, who says, "The essential difference between emotion and reason is that emotion leads to action while reason leads to conclusions."[8] This concept is important because every business, whether for-profit or nonprofit, needs to motivate people—employees, customers, donors—to take action in order for that business to thrive.

Magnetic Museums are bringing the idea of "lovemarks" to life in the cultural sector. They wholeheartedly embrace the imperative to forge emotional relationships, internally and externally, which grow deeper and stronger over time and lead to positive actions on behalf of their institutions. This book explores how and why Magnetic Museums are doing this and the outcomes they have achieved.

While we seldom hear the word "love" used in a business context, Tim Sanders, chief solutions officer at Yahoo! and author of *Love is the Killer App*, shares his definition: "Love is the act of intelligently and sensibly sharing your knowledge, networks, and compassion with your business partners… Share your knowledge aggressively; expand your network of people who share your values and connect as many of them with each other as possible; and, perhaps most important, be as openly human as you can be and find the courage to express genuine emotion in the harried, pressure-filled world of work. And one last point: Behave this way not because you expect something in return—a quid pro quo—but because it's the right way to behave. The less you expect in return for acts of professional generosity, the more you will receive."[9]

While Sanders's comments are directed to the corporate sector, for those of us in the social benefit sector it is an even more appealing call. Yet how many of us were trained to think of leadership in these terms?

The nature of museum leadership is also at a moment of inflection. Directors who gathered in San Francisco for the 2012 Association of Art Museum Directors meeting focused on topics of strategic foresight, crafting alternative futures scenarios, and developing creative thinking skills for leading innovation. And the 2011 AAM annual meeting was packed with sessions on leadership strategies for the 21st century. Directing a

museum, it seems, has become much more akin to hosting a salon or facilitating a conversation than commanding the troops. For decades, the surest path to the museum director's office was through content expertise, connections, and charisma. Now, substantive knowledge and personal style must be paired with business savvy and high touch, emotional intelligence. Talent management skills and an emergent, collaborative, and networked leadership style are required.

David Novak, CEO of Yum Brands and author of *Taking People With You*, writes, "If you want to start a business…if you are developing or launching a new product, if you want your company to move in a new direction, if you want to expand your sales territory, if you want to raise money for a good cause…you're going to need people to help you get there. You'll never accomplish anything big if you try to do it alone."[10] That is the lesson of *Magnetic*. Investing in people and relationships not only pays big business dividends, it also makes the journey much more fulfilling.

Too often many in the corporate and nonprofit sectors fall into the trap of believing that personal charisma is the primary means of enlisting followers and generating support. Many of the people who heard our first AAM presentation threw up their hands in defeat, saying, "My director is not charismatic. How can we make change without changing our leader?" At the time, we did not yet understand how leadership functions inside Magnetic organizations.

In our conversations with Magnetic Museum leaders and staff, the difference between being personally charismatic and practicing charismatic leadership became increasingly clear. While the Magnetic Museum leaders exhibit personal charisma to varying degrees, each nonetheless deploys many of the traits of charismatic leadership. They articulate compelling visions; align staff, board, and stakeholders with that vision; relate their institutional program to the needs and interests of their audiences and communities; and effectively enlist others in their cause.

Magnetic institutions draw their strength by aligning and enabling leadership at all levels. Rather than relying on the efforts of a few to carry the many, they enable the many to carry the mission. They develop reserves of talent throughout their organizations and activate, engage, and empower it. This results in a high degree of mutual regard and loyalty among professional and volunteer leadership and staff. In the end, leadership matters, but empowering leadership matters most.

WHAT THIS BOOK OFFERS YOU

We realize that using the museum as a successful business model is an unconventional approach: for-profit business models are more typically applied to museums. But the lessons of Magnetic Museums can be applied to any business or organization, for-profit or nonprofit, large or small, that seeks to deepen engagement with its customers and stakeholders and build a more enduring brand loyalty.

Anyone who believes that museums have not only the potential, but also the responsibility to transform lives should read this book. So many of us chose museum careers because we sought work that was meaningful, inspiring, and valuable to ourselves and to the audiences and communities our institutions touch. This book can help to unleash that potential and lead not only to creating more sustainable and more valuable institutions, but also to ensuring that museums become more creative, empowered, fulfilling, and joyful workplaces.

For museum directors and other organizational leaders, this book will show how applying the six practices of Magnetic Museums can help you to dramatically strengthen your leadership and improve your organization's results. You may already be working on some of these approaches, or you may just be getting started. Wherever you are on your journey, this book illustrates what others have done that has worked and provides insight into the unique hows and whys of your peers' experiences.

For staff, this book is for you, too. You will learn how energizing and exciting it can be to work in an organization where your efforts are strengthened and guided by a vision you clearly understand and embrace. Deciding to get behind someone else's vision is a powerful choice that each of us can make in life. We hope this book starts you thinking about how you might more fully commit your heart, as well as your hands and mind, to your organization. We will examine the importance of an internal culture of service, responsibility, and accountability. We trust that the stories of the "glass-half-full"-empowered people who are working in Magnetic Museums will inspire you to contribute to a "can-do" culture for your institution.[11]

For board members, donors, or volunteers, your gifts of time, expertise, and financial resources enable the organizations that you support to fulfill their missions. Whether you are already involved with a museum or just thinking about it, this book can help you to know what to look for in a healthy, thriving institution. Once you are part of an organization, you have tremendous power to attract others to its cause. We hope you will fuel that power with an ever-stronger emotional commitment.

If you are involved with another nonprofit or business in your city, you might share these practices and look for ways to connect organizations with each other. Your increased participation will only strengthen an organization's ability to attract resources and have greater mission impact. You will read about other volunteers and the growing sense of fulfillment and meaning they found as their level of engagement deepened with their museum.

For foundations, corporate funders, and philanthropists, your support of an institution sends a powerful signal to others about an organization's value and importance. Throughout the case studies, funders consistently report that Magnetic Museums are trusted stewards of financial resources. They run efficient and effective operations, they are imaginative and non-bureaucratic partners, and they contribute value to their communities that goes well beyond the inherent value of their core missions. In short, magnetic organizations are a good investment. We hope that the philanthropic sector will find ways to help more museums build their capacity and put these principles to work.

For civic leaders and policymakers, this study points to the potential for museums to significantly and materially contribute to the economic, educational, and social health and vitality of the municipalities they serve. We urge you to bring your local museums to the table in discussions of critical issues facing your community to help maximize the potential for powerful partnerships and solutions that might emerge. Several of the Magnetic Museum stories provide specific examples where museums and municipalities have forged surprising and substantive partnerships. Equally important is the impact that even modest levels of government and civic support can have on a museum's ongoing operational sustainability. When civic leaders embrace and advocate for the value of their cultural institutions, private funders take note.

For consultants and advisers, as you work with your clients in the museum field or elsewhere in the cultural or nonprofit sectors, or in the for-profit business world, this book has implications for you and for them. If your clients are working in isolation, encourage them to get outside and get in touch with the world around them. Help them to turn outward by introducing ideas and people from other sectors. Model non-competitive openness in your own practice. Encourage approaches that are cross-disciplinary and multi-level, and help your clients to engage in a new kind of conversation to create an empowered people- and relationship-oriented culture. This book also will help you to explain to your clients that becoming "magnetic" isn't about developing just one new strength or practice. Instead it is about deploying several related practices that mutually enhance and reinforce one another.

For academics and researchers, the museum field needs you to continue and amplify this work. We, the authors, are not social scientists and this project faced certain constraints. Our methodology was limited by the lack of funding available to independent researchers not affiliated with or contracted by a nonprofit, a foundation, or an academic institution. For this reason, we worked with available quantitative data from the field to identify potentially high performing institutions. If a museum did not participate in the AAM Museum Financial Information Surveys in 2002 and 2008, or was not identified in the NCCS database, then that museum was not considered for the study. This calls for a greater participation by museums in the creation of standard national databases, such as the IMLS online Museum Census, and the Cultural Data Project's online financial information collection and reporting tool. We were not able to conduct quantitative research to prove our hypotheses by establishing cause and effect relationships in terms of organizational, audience, or community outcomes and impact. Therefore we believe that there is significant need for additional research to understand these concepts, as well as to document the public value created by Magnetic Museums as a result of adopting the strategies we outline in this book.

START WITH SELF-ASSESSMENT

In Appendix C, you will find a self-assessment questionnaire to help you to determine where your organization is on the path to becoming Magnetic. We hope this work inspires you to take up the fulfilling work of transforming your institution by embracing the art of engagement.

Introduction Notes

1. American Alliance of Museums, http://www.aam-us.org/about-museums/facts (accessed 12 Dec. 2012).

2. Duncan F. Cameron, "The Museum, a Temple or a Forum," *Curator: The Museum Journal* 14, (1971) 11–24.

3. Stephen E. Weil, "From Being *about* Something to Being *for* Somebody," *Daedalus* vol.128, no. 3 (Summer, 1999), 229.

4. Chip Heath and Dan Heath. *Switch: How to Change When Changing Things is Hard* (New York: Broadway Books, 2010), 27–48.

5. For a related study of high performing organizations in the performing arts sector, see "Bright Spots and Hard Bargains," by Helicon Collaborative, commissioned by the Doris Duke Charitable Foundation in 2010.

6. Kevin Roberts, *Lovemarks: The Future Beyond Brands* (New York: PowerHouse Books, 2007) inside cover.

7. *Ibid.*, 42.

8. *Ibid.*, 42.

9. Tim Sanders, "Love is the Killer App," *Fast Company*, 31 Jan. 2001, http://www.fastcompany.com/44541/love-killer-app (accessed 11 Nov. 2012).

10. David Novak, *Taking People With You: The Only Way to Make Big Things Happen* (New York: Penguin Group, 2012), 1.

11. Shirley Sagawa and Deborah Jospin, *The Charismatic Organization: 8 Ways to Grow a Nonprofit* (San Francisco: Jossey-Bass, 2009), 55-73.

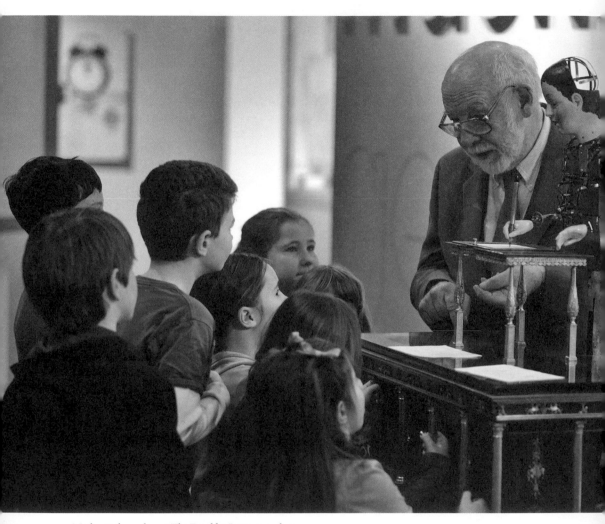

*Mechanical wonders at The Franklin Institute such as
Maillardet's automaton fascinate visitors young and old.*
Photo: The Franklin Institute

Magnetism and the Art of Engagement

Magnetism: i. the properties of attraction possessed by magnets; ii. a class of physical phenomena that include the attraction for iron observed in lodestone and a magnet, are inseparably associated with moving electricity, are exhibited by both magnets and electric currents, and are characterized by fields of force; iii. a strong attractive power or charm.
—Merriam-Webster

For more than 30 years, Jim Haynes, a Louisiana-born entrepreneur, travel writer, and retired University of Paris professor, has hosted Sunday dinner at his apartment.[1] Each week he opens his Paris home to the first 50 people who write or email him and ask to attend, regardless of whether he knows them or not. In fact, more often than not, he does not know his guests, nor do they know each other. Yet they come from all over the world for food, conversation, and the opportunity to meet the "friends they haven't met yet," according to Haynes.

The reason Haynes hosts and coordinates his weekly feasts is his abiding belief in the power of connection and how the consistent practice of this simple and enjoyable tradition has enriched the lives of others. In a not insignificant way, he has helped to change the world by engaging people with one another across vast divides of demographics, geography, culture, and belief.

Despite no office, infrastructure, or advertising, more than 140,000 people have found their way to this Sunday meal, drawing others into the circle. While Haynes's home is not a museum, his weekly salon is clearly magnetic and illustrates many of the characteristics we found in Magnetic Museums.

What makes Magnetic Museums different from the rest of the field is that they exhibit a powerful ability to attract and retain the four types of capital needed for museums to conceive, develop, and deliver superior exhibitions, programs, and experiences to their audiences: *core, social,* and *brand capital,* and, of course, *financial capital.*[2] (Figure 1.1) Like Haynes, Magnetic Museums inspire loyal communities of people who are tightly

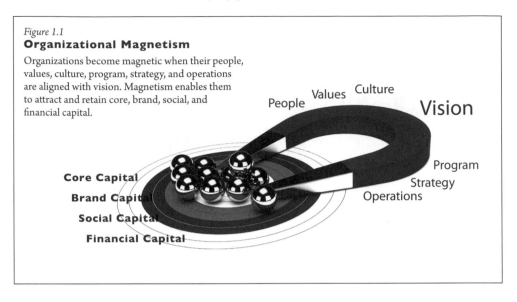

Figure 1.1
Organizational Magnetism

Organizations become magnetic when their people, values, culture, program, strategy, and operations are aligned with vision. Magnetism enables them to attract and retain core, brand, social, and financial capital.

bonded by a belief in the value, mission imperatives, and vision of these institutions. Like a magnet, they exert a "pull" that can almost seem magical. But as any high school physics student knows, magnetism isn't magic; it's science.

THE SCIENCE OF MAGNETISM

All progress in quantum physics aside, the simplest explanation for magnetism lies at the deepest atomic level, where electrons circling the nuclei of atoms create an electrical current. That current starts the atoms moving and shaking. When the atoms fall into place with their north and south poles pointing in the same directions, they begin to cooperate and a magnet is formed. The magnet grows stronger as the current flows through the atoms and more and more of the particles become aligned. If for some reason those atoms fall out of alignment, the material loses its power to attract and becomes demagnetized.

Once a magnetic current is established, an electromagnetic force field occurs that works to align the atoms residing in other charged objects that come within its reach. As those objects become magnetic, their force fields join and a new, larger magnetic field is created.[3]

To put it more simply, imagine waving a horseshoe magnet over a pile of paperclips. Those closest to the magnet immediately spring up and attach themselves to the ends of the magnet. The attachments closest to the magnet are very strong. As the magnet is lifted, the first clip attracts the next and so on, until a magnetic chain of paperclips forms.

Each successive connection occurs because of the paperclip's alignment and engagement with the electromagnetic field.

THE ART OF ENGAGEMENT

While the laws of physics and the universe control the behavior of electrons, people are motivated by emotions and reason. This is where the art of engagement comes into play.

Engagement is a powerful word. It means connecting one person or thing to another; making a promise, perhaps to meet; entering into an emotional involvement that might lead to marriage; or joining forces, like gears in a machine, to create motion or energy.

Over the past two decades, museums have made advances in the levels and kinds of engagement they pursue, and with whom. A Google search for "museums + engagement" delivers an impressive 9,510,000 results in 0.33 seconds.[4] And a review of the literature on museum audiences reveals the depth of thinking on how to enhance visitor learning, experience, and enjoyment through engagement techniques.

In 2002, AAM issued its report, *Mastering Civic Engagement,* that challenged museums to think about their roles and responsibilities in relation to the communities they serve.[5] And in 2010, Nina Simon discussed in *The Participatory Museum* what she saw as a need to provide meaningful ways for visitors to contribute to and co-create the museum experience.[6] What we found in our study was a group of institutions that have knit these lessons together and internalized a culture of engagement, participation, and service, which are now reaping impressive benefits as a result.

Magnetic Museums are both engaging and engaged places. They are highly people-centered organizations. They thrive on a fundamental desire to connect people with the subjects, ideas, and objects that inspire passion, curiosity, and learning. They focus on creating meaningful experiences that have emotional resonance, which, in turn, serve to create fulfilling relationships. Moreover, Magnetic Museums care equally about engaging internal and external audiences, as well as the communities they serve. To echo Stephen Weil, they are both "about something" and "for someone."[7]

Magnetic Museums also widen the circle of involvement at every opportunity, practicing what we call "360 Engagement." (See Figure 1.2.) They are inclusive, open-minded, and openhearted organizations. They work from the inside out, starting by engaging staff, board, and volunteers, followed by donors and members, community leaders and organizations, and of course, on-site audiences, as well as those in the virtual world.

Magnetic Museums have found their strength by embracing the "service" aspect of their public service roles. By committing their institutional assets unconditionally to

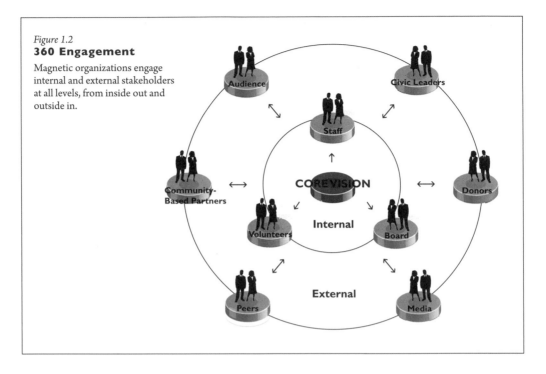

Figure 1.2
360 Engagement

Magnetic organizations engage internal and external stakeholders at all levels, from inside out and outside in.

meeting the needs, empowering the efforts, and enriching the experiences of the people and communities they serve—whether employees, trustees, donors, volunteers, civic and community partners, or especially, audiences—they ultimately generate the relationships, reputation, and resources that enrich their institutions.

THE MAGNETIC MUSEUMS IN OUR STUDY

Tucked into the middle of the country, the Philbrook Museum of Art was once a remote preserve for the wealthiest citizens of Tulsa, Okla. Today, it teems with families, children, and an ethnically and economically diverse audience ranging from first-time museum visitors to sophisticated connoisseurs of art. It also is an institutional partner to more than 20 organizations in the city, from the local library to the food bank to the public schools. The Philbrook became a vital urban asset in a relatively simple way: by adopting an inspiring, shared vision for the museum based on building community through access, service, collaboration, and engagement, and aligning everything it does with achieving that vision. The Philbrook has reframed its approach to collections, exhibitions, gallery

interpretation, educational programming, even media outreach, which has markedly impacted the diversity and size of its audiences. When colleagues say incremental change is all one can expect, especially in terms of audience diversity efforts, Randall Suffolk, director of the Philbrook, replies, "Not if you really commit to it and make inclusivity part of your institutional DNA."[8]

Then there's Conner Prairie Interactive History Park, a living history museum that shines a bright light on Indiana's 19th-century past. It is also an organization that survived a life-threatening two-year governance dispute only to emerge stronger than ever. How? By emphasizing visitor engagement. The museum reoriented its focus to regard audience members as "guests" and put them at the center of every decision affecting participation and planned activity. Its award-winning approach, called "Opening Doors to Great Guest Experiences," has produced in six years a 58 percent increase in attendance, a 22 percent increase in membership, and a 40-plus percent increase in the ratings for visitor satisfaction and quality of experience.

A financial crisis in the mid-1990s turned out to be a turning point for the Chrysler Museum of Art, and the leadership transition that followed allowed the Norfolk, Va. museum to reinvent itself. A new mission to foster transformative experiences through art, a dedication to serving the area's diverse community, especially its African-American population, and a commitment to fiscal responsibility have combined to galvanize the staff and board. Fostering a highly empowered, service-oriented culture has not only transformed the Chrysler into a welcoming and participatory museum, it has created an extraordinarily loyal and motivated staff and board culture.

More than a decade ago, the Children's Museum Pittsburgh (CMP) was only a small organization with big ambitions. In the intervening years, it has nearly quadrupled in size, multiplied its offerings, nearly tripled its membership and attendance, and more than doubled its annual operating income, making it the fastest growing institution that we studied. What fueled this growth? Articulating a powerful agenda for children and inviting others to contribute to realizing that agenda. From humble beginnings in the basement of a former post office building, CMP is now a recognized leader in the museum field and is the heart and centerpiece of a campus for children and families in Pittsburgh. By widening its circle of interaction, support, and influence, it has become a catalyst for the redevelopment of Pittsburgh's North Side through collaborations that have strengthened the capacity and connectedness of dozens of community-based organizations.

The National Science Center of Greensboro (NSC) in North Carolina joined civic, business, and nonprofit leaders in rebuilding the economic vitality of a city that had never

fully recovered from an onslaught of 1980s corporate downsizing. Embracing the busi-
ness recruitment efforts of the Action Greensboro consortium, NSC focused its activities
to enhance educational opportunities and quality of life initiatives, becoming a leading
destination for cultural tourism in the region. It also solidified its position as a frontrun-
ner in science education for elementary, middle, and high school students. Residents re-
sponded resoundingly to the museum's intentional community focus, not only showing
up in droves, but also approving a $20 million bond to build a state-of-the-art SciQuari-
um for the study of diverse aquatic ecosystems.

The oldest and largest of the museums we studied is The Franklin Institute. Change
often comes slowly to large-scale organizations, but creating a business-savvy, people-
and performance-focused culture has enabled the Institute to broaden its audience, ex-
pand its service to the community, and enlarge its base of support. Welcoming more than
800,000 visitors to its historic building each year is only a start. The Institute also founded
a science-focused magnet high school, engaged teens in out-of-school science education
and career preparation programs, and became the leading source for science education in
Philadelphia and beyond.

These vignettes are just a preview of the six stories of transformation that we share
in depth in the following chapters. (See Figure 1.3 for an overview of the Magnetic
Museums.) As you will see, each institution's approach is unique, yet a refrain of common
practices runs through all their stories. In Chapter 2 through Chapter 7, we pair one of the
Magnetic Museums with one of the six practices. In addition to an in-depth case study, each
chapter offers context, insights, and anecdotes gleaned from our research, conversations
with other museums and experts in the field, as well as our own professional experience.
At the end of each chapter, we offer practical tips for implementing the practices. Chapter
8 provides guidance in putting it all together and getting started on the path to being
magnetic.

MAGNETIC MUSEUM PROFILES

Museum Location Year Founded	2010 Operating Budget/Attendance % Δ 2000 vs 2010	Leadership Tenure	Pivot Points	Summary
Children's Museum Pittsburgh, PA 1983	$4.0M/250,000 +187% +277%	Jane Werner 14 years (22 years total on staff)	*Mister Rogers' Neighborhood* exhibition Facilities expansion	Children's Museum Pittsburgh created a "campus" for children and families, including a significantly expanded Silver LEED-certified museum that co-houses and incubates youth-serving nonprofits. Signature initiatives include MAKESHOP®; The Charm Bracelet Project; restoration of Buhl Community Park and New Hazlett Theater.
Chrysler Museum of Art Norfolk, VA 1933	$6.5M/159,674 +14%/+10%	William Hennessey 15 years	Financial difficulty Leadership transition Chrysler Glass Studio	Chrysler Museum of Art brings art and people together through experiences that delight, inform, and inspire with an exemplary commitment to customer service. CMA's "servant-leader" ethic fosters a highly empowered, service-oriented culture. Signature initiatives include the gallery host program and a state-of-the-art participatory Glass Studio.
Conner Prairie Interactive History Park Fishers, IN 1934	$10.6M/163,591 +34%/+11%	Ellen Rosenthal 13 years	Governance dispute "Opening Doors to Great Guest Experiences" Post-independence strategic plan	Conner Prairie transformed and diversified its guest experience "to inspire curiosity and foster learning" through a pioneering visitor engagement approach and innovative programming. Following a governance dispute leading to independence, the museum implemented a strategic plan focusing on rigorous financial management and inventive audience engagement. Signature initiatives include "Follow the North Star," 1859 Balloon Voyage, 1863 Civil War Journey, along with an NSF-funded program to merge STEM learning with history.
The Franklin Institute Philadelphia, PA 1824	$24.9M/834,683 +26%/+15%	Dennis Wint 18 years	Financial difficulty related to expansion Leadership transition Board and staff development	The Franklin Institute has created a high-performance culture that marries mission delivery, market responsiveness, and business acumen to create high quality informal science learning opportunities. Signature initiatives include founding a science-focused magnet high school and engaging teens in out-of-school science education and career preparation programs.
Natural Science Center of Greensboro Greensboro, NC 1957	$3.5M/300,500 +40%/+79%	Glenn Dobrogosz 8 years	Governance change Leadership/cultural transition Internal alignment with vision and master plan Expansion	Natural Science Center helped to revitalize its city's economy by becoming a leading destination for cultural tourism in the region. It also solidified its position as a frontrunner in science education for elementary, middle, and high school students. Signature initiatives include the OmniSphere Theater (HD/3D); a zoo for endangered species; and a state-of-the-art SciQuarium for the study of diverse aquatic ecosystems.
Philbrook Museum of Art Tulsa, OK 1939	$6.3M/121,846 +47%/+13%	Randall Suffolk 5 years	Leadership transition	Philbrook Museum of Art is an art museum dedicated to building community through access, service, collaboration, and engagement. Serving a highly diverse audience, Philbrook is an institutional partner with more than 20 local organizations, ranging from the library to the food bank. Signature programs include free "Second Saturdays," "My Museum," "Third Thursdays," and "Wine Experience Weekend".

Figure 1.3

Educational programs at the Natural Science Center
Greensboro, like Dino Detectives camp, teach children
about science in fun and engaging ways.
Photo: Natural Science Center Greensboro

SIX PRACTICES OF MAGNETIC MUSEUMS

The first and most important insight to emerge from this study is that there is no trump card to be played, no silver-bullet solution in the quest to becoming a Magnetic Museum.

The strength of the Magnetic Museum emerges only when multiple practices are deployed. Although not all of the museums we studied were equally strong in all areas, each of them exhibited capability in a majority of the categories that we identified. All are working towards a model in which these focus areas, taken together and pursued in a coordinated fashion, become a defining organizational philosophy in which each practice reinforces and enhances the power of the others.

The second insight is that there are few shortcuts on the path to becoming magnetic. It takes time to change organizational culture, and time to build relationships and trust. Each of the museums we studied evolved over a period of five to 15 years, with stable leadership in place. All say the process continues today.

We identified six practices common to Magnetic Museums:

1. Build Core Alignment

Magnetism starts at the core when strong alignment is created within the professional staff and board around a shared vision, mission, or compelling set of long-term goals. This internal alignment is the necessary condition for becoming magnetic and sets the course for the organization's transformation. Leaders of Magnetic Museums are relentless in their efforts to enlist others in helping to make the institutional vision a reality. While it may take some time for vision to permeate a complex institution, positive energy begins to flow as soon as a core group of staff and trustees comes together behind a powerful idea or goal and begins to consistently communicate its passion, making the vision visible to others.

2. Embrace 360 Engagement

Magnetic Museums practice 360 engagement, involving internal and external stakeholders in meaningful experiences that make a difference for both the individual and the institution. By doing so, these museums strengthen and expand the reach of their "magnetic fields" by drawing more people in, creating more powerfully charged connections, and aligning them more closely with the work of their institutions. Magnetic

Museums understand that emotional engagement is a catalyst for action and advocacy. Creating personally meaningful experiences while providing opportunities to participate, contribute, and make a difference builds a sense of common purpose, efficacy, and loyalty that inspires everyone to do more.

3. Empower Others

Magnetic Museums are motivated by a people-first, service-first philosophy that seeks to meet the needs, develop the leadership, and activate the potential of others. They cultivate and empower many leaders within their ranks, and have loyal and often long-tenured executive teams. Authority and information flow freely between the trustees and directors, who work in genuine partnership towards a common goal. Each has a distinct role and responsibilities that support clear boundaries between governance and management. Widespread empowerment is enabled by a high degree of internal alignment and the clear sense of direction that results.

4. Widen the Circle and Invite the Outside In

Magnetic Museums widen their circles of engagement and, as a result, widen their circles of influence. They operate from a fundamental principle of respect for what others can contribute, whether they are community or cultural partners, funders or civic leaders, subject matter advisors or audiences. They personify openness and inclusiveness, and value transparency because it is the foundation of trust in relationships. They freely share their resources, expertise, and talent, and readily partner with others willing to do the same. By turning outward, inviting outside perspectives, and working with multiple partners at the earliest stages of idea development, Magnetic Museums create shared ownership in ways that seeking after-the-fact buy-in can never accomplish.

Magnetic Museums also connect people to each other around ideas, issues, and experiences. Whether serving as gathering places, creating opportunities that bring disparate audiences together, or facilitating virtual or in-person communities of interest, they forge relationships with and among people. They leverage the power of networks not only to advance their institutional missions, but also to create a stronger social fabric within their communities.

5. Become Essential

Magnetic Museums overcome one of the central challenges facing cultural institutions today: becoming essential. By increasing their relevance, responsiveness, and value in mission-related ways, they become more meaningful, useful, and pertinent to daily life in their communities. They recognize the importance of meeting real needs that reflect authentic community priorities. Magnetic Museums intentionally seek out and invest in the points of intersection between the institutional vision and the community vision.

6. Build Trust Through High Performance

Magnetic Museums are high-performance organizations that build trust over time by consistently delivering superior results. These organizations have high ambitions and attract people who are similarly motivated to be the best at what they do, which can be particularly valuable in terms of staff and board capacity. They appreciate and reward talent, recruit for cultural fit as much as for skills, and invest in developing their people. They are disciplined about planning and financial management. They set, meet, and frequently exceed goals. They value data in their decision-making, benchmark performance, measure progress, and adjust course as necessary. Magnetic Museums are adaptable and imaginative, especially when facing constraints or challenges. They embrace experimentation and failure as part of daily learning and improvement. Because of their consistent performance, they are viewed as good investments.

In the chapters that follow, you will see these six practices put into action and the outcomes these institutions achieved as a result. Underlying all the stories is an unbroken narrative of the magnetic potential of high performance museums as places that inspire, connect, ignite, and serve.

SIX PRACTICES OF
MAGNETIC MUSEUMS

1. Build Core Alignment

2. Embrace 360 Engagement

3. Empower Others

4. Widen the Circle and Invite the Outside In

5. Become Essential

6. Build Trust Through High Performance

Chapter 1 Notes

1. Jim Haynes, "Inviting the World to Dinner," 12 Jan. 2009, Prod. Jay Allison and Dan Gediman with John Gregory and Vicki Merrick, *All Things Considered* (National Public Radio).

2. Core capital includes human and intellectual capital as well as collections facilities. Social capital equates to relationships and networks within internal and external communities. Brand capital is evident in good will, trust, reputation, and public value created. Financial capital is the resources that flow in response to the creation of the first three assets.

3. University of Illinois, http://van.physics.illinois.edu/qa/listing.php?id=434 (accessed 12 Jan. 2013).

4. Google, http://www.google.com (accessed 19 Jan. 2013).

5. American Association of Museums, *Mastering Civic Engagement: A Challenge to Museums* (Washington: American Association of Museums Press, 2002).

6. Nina Simon, *The Participatory Museum*, www.participatorymuseum.org/read/ (Creative Commons, 2010).

7. Weil, *op. cit.*

8. Author correspondence with Randall Suffolk, director of Philbrook Museum of Art, Nov. 15, 2012.

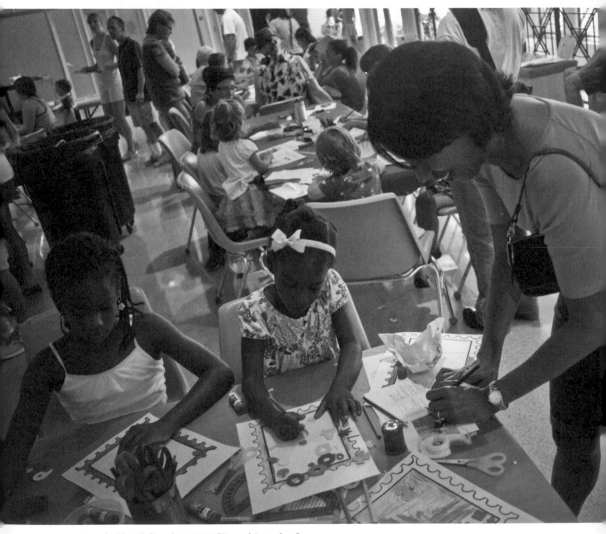

Launched by Philbrook in 2007, "Second Saturdays" is a free program of family-friendly, art-infused activities that regularly attract over 2,000 visitors to the museum on the second Saturday of each month.

© 2012 Philbrook Museum of Art

Build Core Alignment

Philbrook Museum of Art

Start With "Why" / Make Vision Visible / Create Memorable Mantras

Bruce Renfroe, a New York City elevator operator at Manhattan's 181st Street station in the Bronx, is an unlikely visionary and change agent. Each day he carries neighborhood commuters to and from the subway tracks located 10 stories below ground. Back in 1995 when he started the job, Renfroe noticed that everyone was somber, quiet, and unsmiling. One day, he decided to change all that.

Renfroe began to decorate his elevator with pictures—colorful images clipped from magazines, photos of his family and neighborhood children, and pictures of pets and faraway places. He hung a plant from the ceiling and brought in a vase with fresh flowers. He started playing jazz to entertain the riders. He welcomed every passenger who stepped into his vertical cab and sent the riders off with good wishes for a day that "they would be proud of."[1]

Soon his passengers were talking to one another, smiling, bringing in photos of their own to add to the wall, or a favorite CD they thought Renfroe and the others might enjoy. Those passengers became a community, even if only for the 40-second ride each day. "I initially brought in the pictures and music for myself, [but] this stuff isn't mine any more, it belongs to the people," Renfroe said.[2] When asked by a reporter what moved him to enliven the elevator for his passengers, he replied, "I wondered whether an ordinary elevator man could hope to make a difference."[3]

Renfroe's vision of a better morning commute had, in fact, made a very big difference. Several other Metropolitan Transportation Authority (MTA) elevator operators followed his lead and introduced music, posters, and conversation into their elevators.

When the MTA intervened (first in 1999 and again in 2001) to require the removal of his installation for safety reasons, thousands in the neighborhood came to Renfroe's defense and signed a petition in favor of reinstating the elevator adornments. "It has forever changed the way people go to work," said Rosa Naparstek, a local resident who led the community efforts on behalf of Renfroe.[4]

In 2009, nearly a decade after Renfroe set out to change his small piece of the world, a community arts group and the MTA reached agreement on a pilot project to introduce art into the subway elevators.[5]

Renfroe's story illustrates how a powerful personal vision, authentically communicated and generously shared, can take root and inspire a movement. If an elevator man in a steel box can align a group of disconnected New York City commuters in under a minute, imagine what a cultural organization or a business with a compelling vision and resources might be able to accomplish.

We know from high school physics that internal alignment is the source of magnetism, but at the heart of every Magnetic Museum, vision is the lodestone compelling that alignment. One of the first things to strike us about the museums we studied is the fact that while not all of them have a beautifully crafted vision statement posted on the wall, each of the organizations exhibits a crystal clear understanding of where it is going and why going there matters. The form in which the vision is articulated—a five-year strategic plan, a set of high-level goals, or just a statement of guiding philosophy—is not so important. What does make a difference in Magnetic Museums, however, is the depth of alignment that exists and the level of enthusiasm inspired by having a well-defined picture of the future and a desired impact in mind.

A considerable amount of information exists in the literature of management excellence underscoring the critical importance of establishing a shared vision as a first step in organizational transformation. Author Jim Collins offers the "hedgehog" concept, in which an organization identifies what it is deeply passionate about, determines what it can excel at in terms of value to the world, and develops the necessary motivations and mechanisms to attract resources of time, talent, and treasure.[6] Complementing the hedgehog is what Collins and co-researcher Jerry Porras call the Big Hairy Audacious Goal (BHAG, pronounced Bee-HAG), a goal that they say is "clear and compelling and serves as a unifying focal point of effort—often creating immense team spirit."[7] Their research found that companies with motivational and ambitious goals achieve greater, sustained success than those without such guides.[8] BHAGs are simple, concrete statements that everyone in the organization can easily grasp. For example, Ford Motor Company's BHAG was to "democratize the automobile." Sony's was to "create a pocketable transistor radio."[9]

Similarly, the Natural Science Center of Greensboro (NSC) has set a goal of positioning "science–based tourism [at] the forefront of [the city's] economic and cultural future."[10] This has required NSC to exercise discipline in evaluating legacy programs that no longer contribute towards this long-term vision.

Daniel Jordan, former president of the Thomas Jefferson Foundation and Thomas Jefferson's Monticello, relates that when he was asked during his CEO interview about his vision for the historic home, he replied without hesitation, "to be the world center for Jeffersonian studies."[11] This unambiguous and compelling statement of vision galvanized the Foundation's trustees, staff, and donors. Now, some 20 years later, Monticello is just what Jordan envisioned and more.

START WITH WHY

Simon Sinek, ethnographer, teacher, and author, has studied the communication patterns of great leaders. He found that the most successful leaders are those who are able to inspire by giving people "a sense of purpose or belonging that has little to do with any external incentive or benefit to be gained." Inspiration, according to Sinek, is the key to action. "Those who truly lead are able to create a following of people who act not because they were swayed, but because they were inspired…They act…not because they have to, but because they want to."[12]

Sinek explains that great leaders, like Dr. Martin Luther King, Jr. or Steve Jobs, and great organizations, like Southwest Airlines or Harley Davidson, communicate in a particular way, which is "the exact opposite" from nearly everyone else.[13] He finds that while most people start by telling *what* they hope to do, and then *how* they plan to do it, inspiring leaders begin by sharing the personally motivating *why* behind the doing. Their success, he argues, comes from the fact that the human brain is wired in such a way that people are inspired to action by emotion rather than by reason. (We'll share more on this in Chapter 3, which explores how Magnetic Museums so effectively engage people.) By answering the "why" question first with an authentically compelling belief conveyed with passionate personal commitment, these leaders more effectively speak to the hearts of those who become followers. As Sinek repeats with an almost hypnotic call-and-response rhythm in a 2009 TEDx® Talk, "people don't buy *what* you do, they buy *why* you do it."[14]

Each of the Magnetic Museum leaders with whom we spoke conveyed a fundamental belief in the transformative power of his or her museum. Jane Werner of Children's Museum Pittsburgh, for example, knows that her museum makes a difference in the lives of children and their capacity for learning and creative thinking. Ellen Rosenthal of Conner

Prairie Interactive History Park knows that her museum stimulates curiosity and learning about 19th-century Indiana among the numerous families and student groups who visit every year. Bill Hennessey knows that the Chrysler Museum of Art's commitment to serving visitor needs has created an environment where extraordinary encounters between people and art can occur.

We observed a high degree of thoughtfulness, self-awareness, and purposeful dedication of self in service to others among our case study museum directors. Each of them thinks deeply about how his or her personal sense of mission connects with institutional mission. For these leaders, as with most in the nonprofit sector, vocation is also avocation, and they act with a contagious level of enthusiasm, energy, and conviction that excites the people around them.

While organizational vision often originates within a single individual or a small group, others need to embrace that vision in order for it to become a magnetic institutional driver. John P. Kotter, in *Leading Change,* writes of establishing a "guiding coalition" with four essential characteristics: "Position Power," meaning people with power to accelerate or block progress within the organization; "Expertise," ensuring that various disciplines and points of view are represented to make intelligent decisions; "Credibility," inasmuch as the coalition must be believable and trusted by others; and "Leadership," including enough people with proven ability to take initiative and enlist others.[15] Providing opportunities for key stakeholders to participate in developing and defining aspects of organizational vision is one way that Magnetic Museums ensure a shared vision.

From our numerous conversations with museum leaders, we frequently heard that an engaging strategic planning process or an effective board-staff retreat served to catalyze alignment around a transformational vision. At UCLA's Hammer Museum, conversations between trustees and staff revealed "generosity" as a core value and operating principle of the institution. This, in turn, sparked an idea to draw upon the school's intellectual breadth and the city's rich artistic circles to present programming free of charge to students and community members alike, transforming a once distant academic institution into a vibrant hub for cultural, social, and political discourse.[16]

When Holly Hochner was appointed to lead the American Craft Museum in New York City in 1997, she found an organization with, in her words, "limited relevance to today's audiences."[17] The museum was housed in a small, awkward space across from the Museum of Modern Art, with inadequate room to show its collection and little enticement for anyone to visit. It had a small endowment, a limited base of external support, and was struggling to remain in business.

Hochner used the opportunity of her appointment and her objectivity as a new-comer to take the organization through a deliberative, consultant-led planning process to strategically reinvent the museum. She courageously posed such questions as, "Should we continue to exist?" "Who should we be?" and "What is success, and what does it look like?" Adopting such a candid and realistic approach proved to be challenging, yet ultimately, transformational.

Sixteen years later, when Hochner announced that she would step down as director of the re-invented and renamed Museum of Arts & Design, or MAD, in early 2013, the institution had completed a $110 million reclamation and renovation of a signature building on Columbus Circle, turning a neglected space into a state-of-the-art facility and more than tripling its exhibition space that is always active with visitors. MAD has increased its endowment six-fold, and established a comprehensive, interdisciplinary education program for K-12 youth, plus a signature "open studio" program that provides audiences with the opportunity to see and interact with artists and the creative process.

MAKE VISION VISIBLE

Peter Senge's seminal work, *The Fifth Discipline,* which heralded a major shift in leadership and organizational practice, discusses shared vision in depth. "Many leaders have personal visions that never get translated into shared visions that galvanize an organization… When there is a genuine vision (as opposed to the all-too-familiar 'vision statement'), people excel and learn, not because they are told to, but because they want to…The practice of shared vision involves the skills of unearthing shared 'pictures of the future' that foster genuine commitment and enrollment rather than compliance. In mastering this discipline, leaders learn the counter-productiveness of trying to dictate a vision, no matter how heartfelt."[18]

While most leaders know the importance of getting everyone on the same page, creating shared vision is often one of the most difficult tasks that directors face. In our work with museums through the years, we frequently heard the lament, "I've shared my vision dozens of times, but everyone keeps asking, 'Where are we going?'"

Jeffrey Pfeffer and Robert I. Sutton of the Harvard Business School identified this "knowing-doing gap" and found that, too often, organizations erroneously equate talking about something with actually doing something about it.[19] Writing a vision statement does not substitute for having and pursuing a vision.

Magnetic Museums have been successful in bridging this gap. First, they recognize

the importance of attracting board and staff members who share a set of core values and motivations that drive their collective work. Second, they engage their boards and staff in shaping and developing a vision, which allows everyone to imagine her/himself as part of that future. Third, they take action quickly to make vision visible in both big and small ways, enabling others to grasp its meaning and potential impact.

Jeff Harrison, chief curator of the Chrysler Museum of Art, recalled a moment of epiphany when he and his colleagues first saw what the museum's new customer service philosophy looked like in action. "I think everybody was saying [this vision] sounds great and we are all on board and let's try it. But no one was really doing much except … around the edges. But when the gallery hosts [staff members who are present in the galleries to interact with visitors and heighten their museum experience] all started appearing … there was a major contingent … that you could watch moving down the field. …You [could see the vision] work en masse and that started the momentum going for everybody."[20]

Creating a shared vision begins a self-reinforcing cycle. When vision emerges and people begin to talk about it, experiment with it, shape it, and make it their own, the meaning of the vision becomes apparent—it becomes real and compelling. And as the vision begins to materialize and its benefits become self evident, then enthusiasm for the vision grows (Figure 2.1).

CREATE MEMORABLE MANTRAS

A further lesson we learned from Magnetic Museum leaders is the importance of using straightforward language and concepts to convey vision. Pfeffer and Sutton confirm this approach as critical to helping transform vision into action. "Organizations that are better at learning and translating knowledge into action understand the virtue of simple language, simple structures, simple concepts, and the power of common sense, which is remarkably uncommon in its application … Simple talk is valuable because it is more likely to lead to action."[21]

The leaders of Magnetic Museums are clear and concrete in how they communicate vision. The phrase, "Play with Real Stuff," galvanized the Children's Museum Pittsburgh to become a place for experiential learning. Its staff even created a "flip book" with illustrations of the new vision in action, which was referenced frequently for inspiration. [22]

Purposefully altering the language used to describe their audiences, referring to them as "guests" rather than "visitors," and consistently reinforcing a commitment to "putting

Figure 2.1
Shared Vision

Vision originates from an individual or small group. As internal stakeholders are invited to contribute to, adapt, and express the vision, it becomes a compelling and shared aspiration for the future.

•Identify vision
•Articulate vision
•Inspire and enlist others in vision

•Shape vision
•Develop vision
•Advocate for vision

•Experiment with vision
•Adapt vision
•Implement vision

CORE VISION LEADERSHIP TEAM

TRUSTEES, SENIOR STAFF, KEY EXTERNAL STAKEHOLDERS

FULL STAFF, VOLUNTEERS

the guests at the center" of any activity transformed Conner Prairie from a venue for requisite fourth-grade field trips to a welcoming and sought-after place for families.[23]

And as you will read in the story that follows, Philbrook Museum of Art Director Randall Suffolk charged his staff to "Focus on what we do, not on what we are," to shift his institution from a static, place-based museum experience to one that is vibrant and dynamic and fundamentally connected to the community it serves.[24]

We cannot overstate the importance of frequent and consistent communication of guiding principles, or what we call "memorable mantras." While a few of the staff members from the case-study museums joked about "drinking the Kool-Aid" or tattooing vision statements on their forearms like a Harley-Davidson logo, they also affirmed the importance of repetition, consistency, and integrity in communicating vision and applying core beliefs or guiding philosophies. Dennis Wint of The Franklin Institute shared these words of advice. "People have a tendency of not wanting to repeat [themselves]. For alignment, you say it again, again, and again, consistently each and every time."[25]

Our first case study brings each of these lessons to life, demonstrating how the Philbrook Museum of Art was transformed by a clearly defined and shared vision in the hands a closely aligned team.

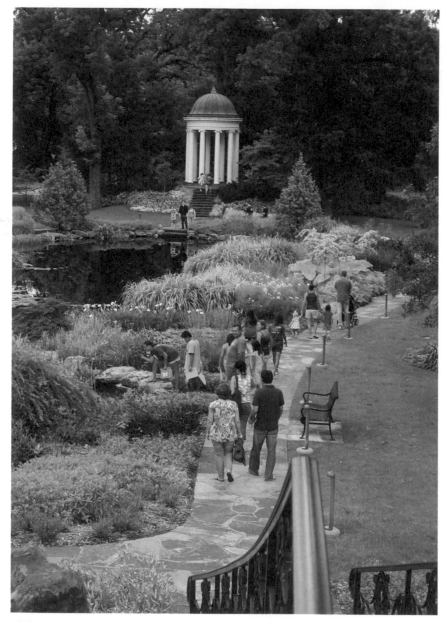

*Philbrook utilizes its legendary gardens
and "wonderful sense of place" to forge
connections with visitors.*

© 2012 Philbrook Museum of Art

case study

PHILBROOK MUSEUM OF ART

ALIGNING THROUGH VISION AND VALUES

On a weekday afternoon in late July, Tulsa, Okla. can seem like the hottest place on earth. Perhaps that's why the legendary gardens of the Philbrook Museum of Art are devoid of people, and its elegant plantings go unappreciated in the kiln-like temperatures.

But inside, the historic house is hopping, bustling with all generations of families who reflect the full breadth of Tulsa's population. And later that evening, the museum will host more than 200 people picnicking on its vast lawn and enjoying its outdoor film series. Tonight's selection is *Shakespeare in Love,* offered as a prelude to the following week's *Comedy of Errors,* presented at the Philbrook in partnership with the American Theater Company as part of its Shakespeare on the Lawn series.[1]

So how does a regional cultural institution that began life at the turn of the last century in a reality so far removed from everyday experience become a vital urban asset, connected to the very fabric of the community? By adopting a vision of community access, service, collaboration, and engagement shared by many.

This story of transformation begins with Oklahoma oil tycoon Waite Phillips and his wife Genevieve who commissioned Kansas City architect Edward Buehler Delk in 1926 to build and outfit a 62-room showplace in the Italian Renaissance Revival style. A year later, they moved into the architectural masterpiece with their two young children and stayed for just over a decade. Then, towards the end of the Great Depression, they packed up and moved again, leaving to the city of Tulsa their majestic Villa Philbrook with its renowned formal and informal gardens on 23 acres, along with a

small collection of furnishings, decorative and Southwestern art. It was the Phillips' hope that their beloved home would become a cultural organization to benefit the city. And it did just that, joining forces with the Southwestern Art Association and opening to the public as a museum in 1939.

The Philbrook grew through acquisitions and programs, achieving collection strengths in Renaissance and Baroque painting, American, European, African, and Asian art, as well as 20th-century Native American art. It also became known for its focus on education. In 1940, the museum initiated tours for fifth and sixth graders from Tulsa's public schools that continued for more than 60 years, considered a rite of passage by most residents. It also began a robust program of studio art classes that later morphed into the Museum School, a classroom-based, hands-on art-making program led by adjunct faculty. A new wing built in 1969 to accommodate demand was later replaced with the extant 75,000 square foot Raymond F. and Bessie R. Kravis Wing in 1990, slightly before interest in the program began to wane.[2]

By 2000, having weathered the financial upheavals of the 1980s and stabilized its operations in the 1990s, Philbrook was regarded as a beautiful but "sleepy" institution that catered primarily to local wealthy residents. According to Chief Operating Officer David Singleton, although the museum carefully managed its budget to remain deficit free, "… [it was] barely surviving, unable to get loans and without [a line of] credit." The retirement of the long-tenured former director Marcia Manhart, who ably led the nonprofit for over 20 years, gave the Philbrook board an opportunity to do something both strategic and transformative by focusing on director candidates who would change the status quo and make the museum more open to the community.

Trustee Larry Lee related that they decided to "look for someone… who could recast the energy level of the museum." Brian Ferriso, who led the Philbrook from 2003 to 2006 before being recruited to the Pacific Northwest, proved to be the kind of director the board had been seeking. During his brief term, Ferriso made a critical hire, filling a vacancy in the curatorial department, oversaw the opening of the refurbished gardens, and revived a signature fundraising event. He instigated the shift towards making the museum "relevant to the whole community," said Christina Burke, curator of Native American and Non-Western Art. "Philbrook was opening the doors to the community,

literally and figuratively." And this paved the way for the board to attract Randall Suffolk to Tulsa in 2007.

Formerly director of the Hyde Collection Art Museum in upstate New York, Suffolk used his outsider status to objectively appraise the museum and determine a course of action. Even before he took the job, he conducted what he called an "unscientific survey" and asked everyone he encountered—cab drivers, gas station attendants, hotel employees, and food service workers—the same question: "Is Philbrook known for what it *is* or what it *does*?" The answers he received were uniformly consistent: "The villa is gorgeous, the gardens are beautiful, I remember visiting as a kid." No one with whom Suffolk spoke mentioned anything about seeing an exhibition, savoring a favored artwork, or participating in a program. Suffolk also noticed that promotional photos of the museum's stately architecture and sculpted gardens were empty of people, just as the grounds were on a hot summer day.

When he accepted the directorship, these perceptions framed what he took as his marching orders—to use the Philbrook's "wonderful sense of place" to forge new connections between the museum and the community. And it presaged what has become one of many organizational mantras communicated by Suffolk and repeated by board and staff: "Focus on what we do, not on what we are." Suffolk encouraged the staff to think about using the museum's assets—its beautiful home, gorgeous gardens, and treasured collection— in meaningful service to and active engagement with the community. He also introduced them to a matrix that he developed called the *Five I's of Organizational Impact:* (Figure 2.2)

INNOVATION: All around, ongoing improvement	INTEGRITY: Earning the public trust
INVENTION: Developing what's next	**INSPIRATION**: Be compelling, always
INTEGRATION: Creating relevance and accessibility	

Figure 2.2 © 2007 Randall Suffolk. Reprinted with permission.

Applying this matrix and working from a shared belief that "aesthetic engagement and visual literacy should be a fundamental component in the education of every person," the staff also was urged to think in unconventional ways, take risks, and embrace innovation, all within the confines of the $6 million operating budget. As Suffolk noted, "We challenged ourselves to be more compelling, relevant, and engaged in the life and direction of our city," as well as transparent about these efforts.

Suffolk spoke with such enthusiasm and conviction that he inspired the staff to action, and community access and engagement soon became a passion embraced by the full team. With the *Five I's* as a guide, the museum began by repurposing educational activity away from school visits and towards on-site initiatives, with the intent of making everyone feel welcome at Philbrook. The objective, according to Museum Educator Susan Green, was to "open up the museum and offer more" to the general public. Director of Exhibitions and Collections Chris Kallenberger described the shift as an "emphasis away from a purely scholarly and artistic focus to an audience development focus" encouraging broader participation.

Philbrook soon launched "Second Saturdays," a day each month when the museum offers free admission and a range of family-friendly activities, such as tours, art-making projects, and picnics on the lawn; "My Museum," a free program for children ages 4 through 12 that promotes familiarity and engagement with art and art making, especially between children and their caregivers; and "Third Thursdays," activities for a young psychographic (youth and seniors alike) designed around "art making, music, conversation, curating, and socializing… all tied back to [substantive] programming [in modern and contemporary art]...It's all about 'the *doing*,'" said Education Coordinator Roselle Tyner, "the experience of engagement." And "because Rand [Director Randall Suffolk] sets a high standard for engagement, it elevates everyone's performance," said Director of Communications Tricia Milford-Hoyt.

Community leaders took note of the changes. Philbrook's new accessible programs "provided the opportunity to change [the] impression of a staid, classical art museum as a place for families," said Bill Major, executive director of the Zarrow Families Foundation, a local funder that has underwritten "Second Saturdays." The number of kids and diversity of ethnicities is more like a children's museum...Philbrook could be considered isolated, physically and

attitudinally," located in the affluent part of town, perched atop its protected acreage, but instead it has "opened itself to the whole community...[and] attracts broad audiences." Sharon Terry, former executive director of the Tulsa Historical Society, concurred. "The emphasis on community has helped to 'addict' kids to the museum at an early age, so they feel invited and welcomed."

In FY2008, 80 percent of the $530,000 education budget had been directed to programs serving fewer than 3,000 children. Within three years, 40 percent of the education budget was directed to family programming, a change that has encouraged more repeat visitation and resulted in increased membership. Assessing impact strictly by the numbers, prioritizing community engagement has produced remarkable results at Philbrook. Between FY2007 and FY2011, participation in "Second Saturdays" jumped more than 300 percent (from 491 to 2,070). "My Museum" drew more than 11,000 visitors, while "Third Thursdays" now regularly attract 150 to 200 participants per event.

"We challenged ourselves to be more compelling, relevant, and engaged in the life and direction of our city."

Philbrook also focused its community-centered vision on its collections and exhibitions program. To make the art-viewing experience more inviting to the public, "we reinstalled [75 percent of] the galleries, changed the wall colors, changed pathways, and opened some walls to connect the galleries to the landscape," said Burke. In the Native American galleries, the museum chose to show the art thematically, rather than chronologically or by tribe, as it is most often exhibited elsewhere.

Then the staff conducted extensive research by quietly tracking and observing visitors, recording their pathways and conversations through the galleries. After analyzing the data, they changed the interpretive language to make it accessible to a range of visitors. Object labels are now intentionally brief, using only 80 to 90 words in non-'curator speak' and written to draw the viewer's attention back to the artwork. The museum also makes transparent the curatorial perspective and explains, for example, the rationale behind certain works hanging together.

In its continuing quest to engage the community, the staff recognized the importance of facilitating personal connections between visitors and the museum, in addition to making the artwork and physical campus accessible. They offered free audio tours of the special exhibitions, recorded by the

curators. The tours also are available as podcasts, giving flavor and personality to the works and connecting the public directly to the staff.

Curator of European Art Tanya Paul recalled another story about engagement and thinking outside of the box, literally. "We decided to use the mundane aspect of sculpture to… [provide the public] a peek behind the scenes. A Rodin sculpture returning to the museum had arrived and the staff realized how beautiful and intricate the crate was that protected it. So we decided to do a slow reveal in the rotunda. First, we positioned the [unopened] crate and left it for a few days. This caused a great deal of curiosity. Then we started to take it apart and [arranged] the pieces to reveal the elaborate reverse sculpture inside cradling the piece. It was a brilliant, engaging idea," that excited both staff and visitors, cost little to undertake, and demonstrated how a bit of imagination can create connections. And it came about because staff members were inspired by the museum's vision and empowered to make it their own.

Philbrook also fosters connections through what Suffolk calls a "culture of collaboration," which he actively promotes, externally and internally, as both an audience engagement and staff development tool. By 2010, Philbrook was partnering with over 20 local or regional organizations, including the opera, symphony, library, and independent movie houses, and even had extended its reach internationally. That same year, the museum announced a partnership with the Vitra Design Museum in Weil em Rhein, Germany to bring its unparalleled collection of design objects to Oklahoma. According to Tulsa City-County Library CEO Gary Shaffer, "Philbrook is not above anyone… not an ivory tower. They regularly partner with organizations" and welcome their constituencies to the museum.

This propensity for community collaboration, coupled with the growing inventiveness and empowerment of staff, is exemplified in the museum's partnership with the local food bank. In the wake of the financial crisis of 2008, budget cuts in 2009 made the planting of annuals in one of the museum's formal beds a challenge. In response, the garden staff conceived of turning the space into a French *potager* garden (a decorative vegetable garden) and then reached out to the Community Food Bank of Eastern Oklahoma. Museum staff designed, planted, and cared for the garden, while volunteers from the Food Bank harvested the yield—nearly 1,800 pounds of tomatoes, squash, okra, melons, beans, and other fresh vegetables.[3] The following year, the garden

produced 2,800 pounds—altogether more than two tons of food that was distributed to needy residents, and all because Philbrook couldn't afford to buy some flowers.

Collaboration also is evident in the everyday at Philbrook. "There is a 'pioneer spirit' here—we get it done if we work together," said Tricia Milford-Hoyt. "Collaborative thinking fosters integration and builds trust," stated Director of Finance Donna Durrin, and Chief Curator Catherine Whitney concurred. "There is a healthy internal culture—empowerment, but challenged."

How does the Philbrook staff accomplish all that it sets out to do to realize its vision for the future? Through strategic and inter-departmental planning. "Great planning frees you to be flexible," said Event Coordinator Diane Shen. Guided by Director Rand Suffolk, the staff undertook a strategic planning process in 2008 to articulate and codify its core values, program philosophy, and planning guidelines. In addition, the staff has institutionalized the calendar and holds weekly interdepartmental "execution meetings" to coordinate and manage activities. "The culture of trust and mutual respect [which emanates from Suffolk's leadership] is self-perpetuating … [and] embedded in Philbrook's DNA," said Museum Educator Susan Green. "Everyone has a voice," she said. "There is no siloing," echoed Milford-Hoyt. "It's very energizing."

The museum's core operating values—"engagement, transparency, proactive communications, accountability, and integrity," as Durrin recounted—are now front and center in any decision-making. When the Great Recession descended in 2008, it created financial challenges for the museum that "called for strategic creativity focused on engagement and growth," she said, repeating another one of Suffolk's oft-used institutional mantras: "Growth, Inclusivity, Collaboration."

"Our charge was to do more with less or more with the same," and they weathered the financial crisis, according to Shen, through "transparent, honest communication" and because the staff was "empowered to *do*, even with limited means." When the recession hit, Philbrook had the opposite reaction to everyone else, remarked Online Communities Manager Jeff Martin. Instead of retrenching, "we ramped up in a big, bold way that impacted the city. People noticed."

The financial crisis also did something else. "It raised the level of

professionalism among the staff," said Durrin, and created a "turning point in financial literacy. We started to track the full cost of exhibitions, then did the same with education." Everyone became aware of what resources were needed to mount a show or present a program, which informed better decision-making. Without losing sight of institutional mission or vision, "the *Five I's* have allowed us to innovate and we have become business people," said Whitney.

The museum was able to make an even stronger case for an innovation begun in 2002 to group exhibitions into a series and then "sell" the series as a holistic package. "We choose shows that are different from each other and complement the permanent collection. Then we tie [them] all together through presentation and didactics that support different learning styles," explained Burke. A sampling of both original and traveling exhibitions from a recent series included something for everyone: Robert Rauschenberg limited editions; European masterworks from 1600 to1800; the elegant pottery of Southwestern artist Maria Martinez; religious rituals in Native American art; the contemporary artwork of Brazilian brothers Fernando and Humberto Campana; plus Greek and Roman artifacts revealing the myth of Aphrodite.

Such packaging has helped the museum to secure sponsorships and underwriting, especially for important shows that might have less popular appeal. It also has helped with budgeting and financial management, as revenues are known in advance. According to staff, this approach has been highly successful and appreciated by funders.

As Philbrook's core activities have become more visible and essential to the city, it has benefited from increased private-sector philanthropy, which in Tulsa is "deep and remarkable," said business executive and museum trustee Bill Thomas. He explained that despite Tulsa's 2011 rank as the 54th largest city in the nation, the Tulsa Area United Way per capita giving ranked 19th in the United Way's national campaign.[4] Further, Tulsa has the "largest community foundation in the nation[5], which is maintained by second-, third-, and fourth-generation families," even though it was only established in 1998. There also is "strong corporate philanthropy," said Bill Major, because "people come from all over the country to work here [and] there is a responsibility from the community to support a good quality of life." This sentiment is echoed by Dan Harrison, Senior Vice President of ONEOK, an international utility company

headquartered in Tulsa and presenting sponsor of "Second Saturdays." "We want a strong city and vibrant downtown for our workforce."

The museum has worked hard to gain credibility, demonstrate results, and be a good cultural steward while earning the trust of its supporters. Last year, Thomas and his wife chaired the signature Wine Experience Weekend, which raised an unprecedented $2.4 million in general support. As the biennial wine and food festival took shape, "the story of Philbrook unfolded through board and staff leadership," he said. "We were able to use the event to talk about the museum's activities and tell the story of change…We secured support from 29 groups at $25,000 and above, and half were new donors," all because of having a compelling story to tell, more engaged trustees and staff sharing their part in the story, and a broadened network of people interested in listening.

There has been a palpable shift on the board over the past several years. "We had to overcome the impression of Philbrook as elitist," said Vice President Larry Lee. "We made a conscious decision to build diversity among the trustees" to better reflect the breadth of the community. "We have brought in new blood and rotated others to emeritus status… [which] took some selling."

The rejuvenation of the board, coupled with "the vision and power of the message," said Thomas, is having its intended impact. "Diversity…is a big part of the change." Plus, the board understands the need to do its part to support the museum's community engagement agenda. "Board commitment and follow-through is essential," Lee asserted. "Seventy-five percent of the money comes from or through the board, so [we] must be committed."

Suffolk expressed gratitude for inheriting "a very generous board of trustees, who understand their leadership role and have a refreshing sense of responsibility and community-focused perspective." They are committed to the long-term preservation of the organization, infused by a sense of "aspiration and opportunity" that is shared by the staff.

Philbrook's ascendency had already come to the attention of civic leaders reviving the downtown Brady Arts District as a destination for cultural entertainment and shopping. In a prominently situated former warehouse, real estate developers and architects have been working with the museum since Suffolk's arrival in 2007 to create a 30,000-square-foot satellite space to house

the Eugene B. Adkins Collection and Study Center, an outstanding collection of 20th-century Native American Art, as well as modern and contemporary art. Slated to open in 2013, the new cultural center is designed to be a bridge between Philbrook's campus and the burgeoning downtown, serving as an economic development catalyst and capitalizing on the youthful energy already apparent in the revitalized area.[6] "There is an art community renaissance in Tulsa with the new arts district, which has taken the museum out of the mansion to a broader audience," said Harrison.

How has the new Philbrook reached this broadened audience? According to Milford-Hoyt, in addition to compelling programming, the museum has intentionally highlighted social media as a cost-effective connecting tool. In 2009, Suffolk hired a new staff member to oversee online communications. But he sought a writer, not a techie, for the position and asked him to "own the space," according to Milford-Hoyt. Own it he has and with Jeff Martin's storytelling prowess, social interaction has exploded, soaring from zero to nearly 22,000 Facebook fans and 3,700 Twitter followers in two years. Social media has allowed a "non-traditional entrée to the Philbrook," she asserted. "We have many 'silent observers' who are choosing to engage. When we ask how they learned about an event or an opening, they say, 'I saw it on Facebook.'"

One of the most successful online marketing campaigns involved the Philbrook's two cats, Acer and Perilla. Last summer, a garden manager suggested that the animals be equipped with small cameras (mounted unobtrusively on collars around their necks) and their wanderings be video-captured and posted to Facebook. No sooner had the first cat-roaming entry been made than the story went viral, attracting thousands of comments far and wide, even from out of state; nearly every media outlet in town, including the local CBS and ABC affiliates, showed up to capture the story.

As Martin recounted, the museum issued no press release, made no phone calls, sent no emails. The "cat cam"[7] provided a tantalizing glimpse into the museum and the gardens that visitors normally didn't see and it captivated people's attention. Rather than regard this as straying from mission, Philbrook viewed the interactions as community building. "We...have a responsibility to use every available means to stay connected on a human level to those who make what we do possible," wrote Martin.[8] Resident felines notwithstanding,

Philbrook's messaging and communications have intentionally changed to emphasize "human interactions," said Milford-Hoyt.

Philbrook staff also would say that they have a responsibility to keep things fresh and new, or as Suffolk implores, to be "inspiring and compelling in all that we do, always." Education Coordinator Roselle Tyner paraphrased Suffolk paraphrasing former Army Chief of Staff Eric Shinseki, saying, "You may not like change, but you will hate irrelevance."[9]

"We want the community to expect change here," said Burke. "Change leads to intrigue, leads to curiosity, leads to repeat visits," Martin summarized, ticking each off on his fingertips.

Taken together, these various but integrated initiatives have produced steady growth in attendance, which has increased 50 percent between FY2007 and FY2011, from nearly 100,000 visitors to just under 150,000 annually. Perhaps more importantly, there also has been expansive growth in audience diversity. Between 2008 and 2010, minority participation has increased from 10 percent of overall attendance to over 40 percent, well above the national average of nine percent. And membership has grown 21 percent, from 4,250 in FY2005 to 5,130 by FY2011.

Board Chair Casey Cooper asserted that being "intentional about opening our doors has caused change" at the formerly sleepy institution. Fellow trustee Larry Lee affirmed that "organizational change doesn't happen without leadership. It's difficult for the board to lead this change—it must come from the staff, [who] then sell it to the board, which is prior to selling it to the community." While being charismatic and socially skilled certainly helps any director, "needed leadership traits are focus and dedication. The leader's job is to identify the vision and maintain it…[and the Philbrook under Rand Suffolk] "has been good about taking [its] vision into the community." Trustee Bill Thomas concurred. "Rand brings passion to the organization… and he is everywhere, continually doing outreach [to realize] our vision for the museum."

Lee noted that while Brian Ferriso's departure after only three years was at first difficult to accept, the institution has stabilized its board and senior staff leadership. Through this process, they have learned not to be "fearful of transition…We've been through it and know what to do," he said.

Suffolk revealed that his directive to himself is to "create ownership [and] lead through others." And that management style has permeated the organization. Milford-Hoyt said that Philbrook embodies a "leadership 360" model. "There is leadership at all levels. It is ingrained in our culture… [We even consider that] a member or a free guest is our leader. Staff can talk directly to trustees. Everyone gets to be a part of the place. Because Rand sets a high standard for engagement, it elevates everyone's performance." According to Facility Manager Charisse Cooper, "When Rand came, we grew up. The museum became more professional and accountable, we had better programming, the art was made primary."

Sharon Terry has served with Suffolk on the board of the Tulsa-based John Hope Franklin Center for Reconciliation,[10] a nonprofit that seeks to transform long-seated anger and mistrust caused by racial division into hope for the future. Because Suffolk isn't a native Tulsan, he "has the freedom to challenge people to do more. He says the unspoken. And he's heard because people make the assumption of good will…but he pushes," she said. "He is never satisfied with just growing the audience at Philbrook."

And that's because Suffolk and his team care foremost about community building, on- and off-site. "What has happened in Tulsa—the coming together of the community—comes from the Philbrook, not from the city itself," said Bill Major. Author Malcolm Gladwell would assert that the Philbrook and its staff are "people with a special gift of bringing the world together."[11] They have an uncanny "ability to span many different worlds…[while also acting as] translators. They take ideas and information from a highly specialized world and translate them into a language the rest of us can understand."[12] Philbrook was recognized in 2012 for its impact on the city of Tulsa and received the prestigious Governor's Art Award for Community Service.

"We are a living, breathing place," reflected Roselle Tyner when asked to describe Philbrook now as opposed to 10 years ago. Trustee Bill Thomas went one step further, intimating that Philbrook was formerly "known as a place…and that has shifted to being known for what we do," repeating one of Suffolk's mantras. "The coming shift is being known for what we want to be," an organization deeply rooted in and of service to its community.

SIX MAGNETIC TIPS
FOR BUILDING CORE ALIGNMENT

1. Be sensitive to internal and external forces that signal a need for new vision.

2. Listen to your inner voice and encourage others to listen to theirs. True vision often comes unbidden as an insight, opportunity, idea, or need.

3. Enlist a core group with shared values and diverse perspectives to nurture, shape, and champion a vision in its early stages. This group's level of energy and enthusiasm for the journey sets the tone.

4. Go slow in order to go to fast. Take the time to involve stakeholders throughout the organization in shaping the vision and creating true ownership rather than seeking after-the-fact buy-in. Monitor staff resistance to change, as it can reflect community resistance to change.

5. Convey vision in simple, concrete, visual terms; develop a mantra, metaphor, or name to make vision memorable. Communicate it often and consistently.

6. Translate ideas into actions and seek early wins that make vision visible. Share those wins with everyone.

Chapter 2 Notes

1. John Sherrill, "Bruce Renfroe," *Guideposts,* Jan. 2001, http://www.hudsonsclass.com/Documents/ Freshman/Renfroe.pdf (accessed 21 Dec. 2013).

2. Clemente Lisi, "A-Train Riders are Rising Up In Defense of Elevator Man," *New York Post,* 20 Mar. 2001, http://www.nypost.com/p/news/item_aRXzlSyoSHUAy4mvhCkgjO (accessed 20 Dec. 2013).

3. Sherrill, *op cit.*

4. Lisi, *op. cit.*

5. Nicole Breskin, "Washington Heights Exhibit Recalls Days When Subway Elevators Were Art Galleries," *DNAinfo.com New York,* 1 Dec. 2009, http://www.dnainfo.com/new-york/20091201/manhattan/ washington-heights-exhibit-recalls-days-when-subway-elevators-were-art-galleries (accessed 30 Dec. 2012).

6. James C. Collins, *Good to Great and the Social Sectors: Why Business Thinking Is Not the Answer* (New York: Random House Business, 2006), 19.

7. James C. Collins and Jerry I. Porras, *Built to Last: Successful Habits of Visionary Companies* (New York: Harper Business, 2002), 95.

8. *Ibid,* 114.

9. *Ibid,* 97-98.

10. Natural Science Center of Greensboro Website, http://www.natsci.org/about/index.shtml (accessed 24 Dec. 2012).

11. Author interview with Daniel P. Jordan, Ph.D., former president, The Thomas Jefferson Foundation, 1 Feb. 2010.

12. Simon Sinek, *Start With Why: How Great Leaders Inspire Everyone to Take Action* (New York: Penguin Group, 2009), 6.

13. *Ibid,* 41.

14. Simon Sinek, "How Great Leaders Inspire Action." TEDx Talk, http://www.ted.com/talks/simon_ sinek_how_great_leaders_inspire_action.html (accessed 4 Jan. 2013).

15. John P. Kotter, *Leading Change* (Boston: Harvard Business School Press, 1996), 57.

16. Anne Bergeron, Beth Tuttle and Jennifer Wells Green, "Secrets of the Magnetic Museum: Turning Moments of Success into Momentum," American Association of Museums Annual Meeting (Los Angeles: 2010).

17. *Ibid.*

18. Peter Senge, *The Fifth Discipline: The Art and Practice of the Learning* Organization (New York: Doubleday, 2006), 9.

19. Jeffrey Pfeffer and Robert I. Sutton, *The Knowing Doing Gap* (Boston: Harvard Business School Press, 2000), 1.

20. Author interview with Jeff Harrison, Chrysler Museum of Art, 21 Jun. 2012.

21. Jeffrey Pfeffer and Robert I. Sutton, *op. cit.,* 2.

22. Author interview with Children's Museum Pittsburgh staff, 24 Jul. 2012.

23. Author interview with Conner Prairie Interactive History Park staff, 27 Sept. 2012.

24. Author interview with Randall Suffolk, director, Philbrook Museum of Art, 30 Jul. 2012.

25. Author correspondence from Dennis Wint, president and CEO, The Franklin Institute, 13 Dec. 2012.

Chapter 2 Case Study Notes

1. The information and quotations presented in this case study are taken directly from author interviews with Philbrook Museum of Art staff, trustees and stakeholders, or from internal or publicly accessible organizational data.

2. Oklahoma Historical Society, "Philbrook Museum of Art," *Encyclopedia of Oklahoma History and Culture*, http://digital.library.okstate.edu/encyclopedia/entries/P/PH002.html (accessed 20 Sept. 2012).

3. Rick Wells, "Philbrook Garden Helps Tulsa Food Bank," *The News on 6*, 16 Jun. 2009, http://www.newson6.com/global/story.asp?s=10543695 (accessed 18 Sept. 2012).

4. Author correspondence with Randall Suffolk confirming information via Cynthia Quails, Campaign Director, Tulsa Area United Way, 8 Dec. 2012.

5. Tulsa Community Foundation, "History of TCF," http://www.tulsacf.org/index.php?option=com_content&view=article&id=48&Itemid=74 (accessed 21 Sept. 2012).

6. James D. Watts Jr., "Philbrook Branching Out," *Tulsa World*, 15 Sept. 2010, http://www.tulsaworld.com/scene/article.aspx?subjectid=272&articleid=20100915_272_D2_CUTLIN466825 (accessed 8 Sept. 2012).

7. YouTube, *Cat Cam Footage: The Photo Shoot*, http://www.youtube.com/watch?v=2kRdEM1_aXg, (accessed 20 Sept. 2012).

8. Jeff Martin, "Its Not About the Cat Cams," *Center for the Future of Museums* Blog, 28 Jun 2011, http://futureofmuseums.blogspot.com/2011/06/its-not-about-cat-cams.html (accessed 21 Sept. 2012).

9. The actual quote—"If you dislike change, you're going to dislike irrelevance even more"—is attributed to four-star general Eric Shinseki, who served as the Army Chief of Staff from 1999 to 2003 and was an outspoken proponent of transforming the tradition-bound military. From Mackubin Thomas Owens, "Marines Turned Soldiers," *National Review Online*, 10 Dec. 2011, http://old.nationalreview.com/comment/comment-owens121001.shtml (accessed 22 Sept. 2012).

10. The late John Hope Franklin was an acclaimed African-American historian and author who sought to combat racism through his academic research and teaching. His best-known work, *From Slavery to Freedom: A History of African-Americans*, originally published in 1947 with co-author Alfred A. Moss, Jr., is now in its seventh printing. The Center is named in his honor. From Duke University Library, *John Hope Franklin Research Center*, http://library.duke.edu/rubenstein/franklin/bio.html (accessed 2 Nov. 2012).

11. Malcolm Gladwell, *The Tipping Point* (Boston: Little, Brown and Company, 2002), 38.

12. Malcolm Gladwell, "On Connectors, Mavens, And Salesmen: How New Ideas Spread Like Seeds," *Fast Company*, 7 Dec. 2011, http://www.fastcompany.com/1799410/connectors-mavens-and-salesmen-how-new-ideas-spread-seeds (accessed 22 Sept. 2012).

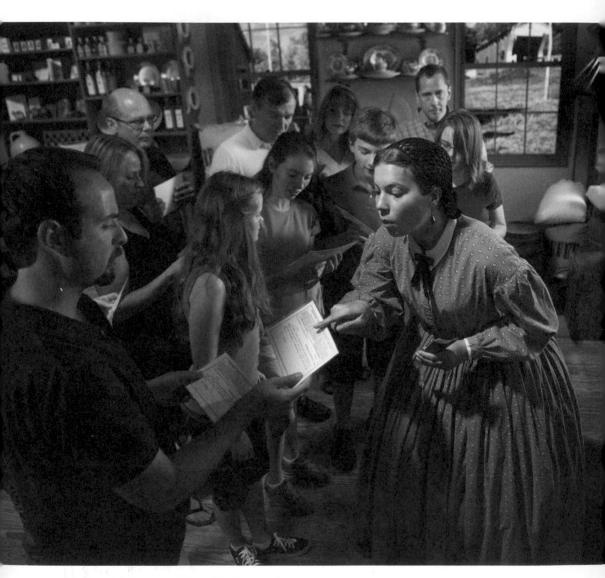

First person interpreters at Conner Prairie re-enact
moments in Indiana history, putting guests at the center
of every experience.
Photo: Conner Prairie Interactive History Park

chapter 3

Embrace 360 Engagement
Conner Prairie Interactive History Park

Emotional Value and Engagement / Creating Meaning
Start with Staff / Engage the Board / Involve Donors
Activate Audiences / Connect with Community
Focus on Customer Service

Emotions, as we all know, often overpower our ability to think and act rationally, a fact that recent neuroscience research has linked directly to our evolutionary past. As it turns out, humans experience the world through two intelligences, one "rational" and one "emotional." The "emotional" or mammalian brain is responsible for our instinctive responses of anger, fear, joy, and sadness. Our rational brain is designed to temper the potential emotional turbulence that would result if our bodies were receiving nonstop "fight or flight" messages from our brains. It's a smart design for sure and one that has played a significant role in the survival of our species over the eons.

Still, to suggest that our two intelligences operate as perfectly or even as moderately balanced counterpoints to one another would be a stretch. The fact is, our rational side frequently loses this neurological tug-of-war. In Chip and Dan Heath's book, *Switch: How to Change Things When Change is Hard,* they share University of Virginia psychologist Jonathan Haidt's depiction of this struggle as akin to a rational person riding an emotional elephant. "Perched atop the elephant…the Rider's control is precarious because the Rider is so small relative to the Elephant…Anytime the six-ton Elephant and the Rider disagree about which direction to go, the Rider is going to lose."[1]

Clearly, the power of our basic emotional responses to move us to action offers ample commercial opportunity in a consumer society. But what may not be well appreciated by most museums and many other organizations is how well positioned they are to use the fundamental power of emotionally charged experience to build engagement and even

inspire "loyalty beyond reason," as Kevin Roberts calls such elevated levels of customer commitment in his book, *Lovemarks.*[2]

The Magnetic Museums discussed in this book have discovered their own pathways to access these emotional triggers and, in doing so, have turned up the emotional heat in their institutions. We found, anecdotally, that they have built strong relationships with individuals and groups by seeking to infuse experiences with purpose and meaning for all their stakeholders . They have nurtured a strong spirit of customer service that makes their institutions highly responsive to the needs of others. The end result, according to interviewees, is that their employees, supporters, and audiences feel loyal and connected, and these stakeholders increasingly take positive action on their institutions' behalf, born out of respect, admiration, love, and passionate devotion.

While the word "engagement" is used constantly in museums today, its meaning changes relative to the context in which it is used. Eleven sessions at the 2012 American Association of Museums meeting dealt with topics ranging from narrative as public engagement, civic engagement, community engagement, audience engagement, tools for engagement, and more. In relation to Magnetic Museums, we define engagement as *the myriad ways that institutions build trust and loyalty, create meaningful experiences and learning, and invite, enable, and nurture relationships with and among people.*

EMOTIONAL VALUE AND ENGAGEMENT

Sherene Suchy, author of *Leading with Passion: Change Management in the 21st Century Museum*, also has explored the subject of emotional value and museum community engagement. She cites a range of emotional value drivers developed by Janelle Barlow and Dianna Maul in *Emotional Value: Creating Strong Bonds with Your Customers*, which include, "trustworthiness, reliable information, flexibility, no-hassle service, unique value adds, truthfulness, speed, knowledge of the consumer, entertainment, and education."[3] Suchy concludes, "In theory, the perception of emotional value puts a museum (any size or type) on a cultural consumer's social radar screen. In practice, emotional value paves the way for community engagement reflected in repeat visits, donations, membership, and volunteer labor."[4]

Our observations support Suchy's premise, but they also provided us with another provocative insight. She asserts, "From a museum's point of view, using emotional intelligence skills to create social capital is a good investment. Social capital is the foundation for economic exchange."[5] While we wouldn't disagree with this conclusion, (nor, we suspect, would the museums in our study), we would challenge it as only a partial motivation.

Engagement is not just a savvy business strategy for Magnetic Museums. If it were, we doubt they would actually be "magnetic" in the ways that they are.

Engagement in Magnetic Museums goes far beyond the deployment of "outreach" or "audience and stakeholder cultivation" as part of a business model. Instead, these institutions exhibit a holistic and organic approach that springs from the core of the museum, in which people are engaged at every point of contact with the organization. Magnetic Museums exhibit a strong people orientation, in which they engage their boards and staff from the top down and the bottom up, as well as their audiences and communities from the inside out and the outside in. Engagement is a comprehensive guiding construct and institutional mindset that operates at the systems level within Magnetic Museums. The consistent thread we heard throughout our interviews was how *meaningful* people's relationships with the institution had become as a result.

The 360 approach to engagement that we witnessed is rooted in a people-oriented service ethic that guides Magnetic Museums and is motivated by the intrinsic mission of these institutions. As you will read in Chapter 4, this people-first, service-first ethic focuses on understanding and meeting the needs of others, and empowering them to achieve their full potential. Customer service, as the staff at Magnetic Museums would say, means service to colleagues and to anyone they come in contact with, whether at the museum or not. It's not something that they do; it is what they believe.

The intrinsic mission of museums is to create a deeper human experience by connecting people more profoundly to the world around them and to the meaning at the heart of the collections they keep, the experiences they create, and the stories they tell. So whether the interaction is between a historical interpreter taking a guest back in time at Conner Prairie, or a robotics engineer turning a child's sights to the future in the MAKE-SHOP™ at the Children's Museum Pittsburgh, or the gardening staff at the Philbrook Museum of Art and the Tulsa food bank workers focused on the immediate needs of the hungry, there are myriad points of connection and engagement being made. All of this occurs via museums creating moments of meaning in service to the public.

CREATING MEANING

The concept of "meaning" in museums is critically important. Meaning is the product of communication, and communication is at the heart of any dialogue between visitor and museum media. Organizational theorists have long thought of communications as simply the transmission of information from one person to another.[6] But more recently, scholars have defined communication as "the process by which people acting together create, sustain, and manage meaning."[7]

Lois Silverman, a professor in the Department of Recreation and Park Administration at Indiana University, Bloomington, Ind., conducted a helpful review of the literature on communication and meaning in the context of exhibition design. She concluded that the shift from the "information exchange" to the "making meaning" paradigm caused theorists and practitioners to ask, "what and how do visitors make of messages" that the museum sends. This has led to an acknowledgement "that there is a spectrum of meanings and consequences beyond information gain [that] is now seen as fundamental to the present and future of museums."[8]

Those "meanings and consequences beyond information gain" are more central to our examination of Magnetic Museums. It can be hard to pinpoint exactly what infuses an experience with emotional value or meaning, but two brief stories will illustrate the profound effect it can have when a meaningful interaction occurs.

Sippin' + Paintin'

Our friend Lara shared the following story with us. She and her young-adult daughter Anna had attended a workshop called "Sippin' + Paintin'" that was organized, as the title suggests, around painting while enjoying a glass of wine. The exercise for the day was to paint a copy of Monet's *Boating at Argenteuil*, with an instructor's guidance. (If the painting got too hard, participants could just get a glass of wine.)

Lara was fascinated by the teacher's deconstruction of the painting and followed every direction to the letter. Anna was bored and frustrated. Rather than following the instructor's lead, Anna covered her entire canvas with paint until the inevitable brownish-black of a kindergarten masterpiece emerged. Just before the canvas was completely ruined, the teacher stopped by and offered a suggestion. Anna scraped the paint off the canvas to reveal a hint of Monet's boats against the painting's horizon line, which she had sketched in at the beginning of the exercise, hidden beneath the layers of pigment.

Lara recalled, "The painting was dark and fascinating, but thinking that Anna might be upset with it, I began to praise her work. But Anna cut me off and said with a big smile, 'You know, I really love this painting. I just figured if I copied Monet then all I was going to get was a bad copy of a good painting. This one is mine.'"

And that's how an easy, entertaining, social experience became a highly personal and meaningful one. Here was a workshop where painting instruction and wine were offered as lubricants for social interaction among strangers. Sure, the wine was good and everyone got to play with paint, and it was fun. But the experience was made meaningful in a

number of subtle yet important ways. It was designed to fulfill the fundamental need that everyone has to be creative. It was structured with enough tools and instruction to make the participants feel supported and competent throughout the experience. And, most importantly, it gave Lara and Anna a sense of personal expression and a connection to one another through what will likely prove to be a lasting memory.

A Field Trip to Remember

The second story came from a teacher who visited the Chrysler Museum with a group of 15 children. Her class and parent chaperones had preceded her into a gallery where a rare 1880 Erard piano in an elaborately decorated case on permanent loan to the museum sits surrounded by French academic paintings of the period. Looking like the exquisite museum artifact that it is, parents and teachers often urge children not to touch.

The teacher wrote, "I ended up being one of the last people to enter the room, only to find that the museum staffer near the piano had been speaking to the children and asked them [if anyone played the instrument]. They all volunteered our best player, a young 6th grader…I was in complete awe as she [took the seat offered] and played on this amazing work of art and so beautifully, too! I have never seen anything like this in all my years of museum going. It was such a special moment. Thank you so much for giving one of our students, who is a prodigy in her own right, the opportunity to play in your museum and have one of the most memorable experiences of her and all our lifetimes."[9]

The first story was a well-designed experience and the second was well facilitated. Both meaningful outcomes were the result of intentional actions and attitudes that are centered on others. Not coincidentally, both the for-profit and nonprofit businesses involved are doing well by doing something good for others (which returns us to Suchy's point about economic exchange).

In *Making Meaning*, authors Steve Diller, Nathan Shedroff, and Darrel Rhea, experts in the field of experiential design, draw on interviews with more than 100,000 individuals to offer 15 universal "meanings" that resonate with people from all over the world. This useful list includes: Accomplishment, Beauty, Community, Creation, Duty, Enlightenment, Freedom, Harmony, Justice, Oneness, Redemption, Security, Truth, Validation and Wonder.[10] What an incredible set of words to describe the experiences that many of us in the museum field seek to deliver!

While *Making Meaning* was written to help businesses learn how to enhance consumer product and service innovation with these meanings, museums have the advantage of

having them hardwired into their content and purpose. Diller, Shedroff, and Rhea write:

"If you innovate with an eye to what is meaningful in your customers' lives, your products and services are more likely to be adopted and retained, not tossed aside when the next new sensation arrives. If you identify the core meanings that your product, service, or brand convey, you are more capable of translating the experience into multiple cultures—again, a timely and reasonable pursuit, given our increasingly globalized economy. And if you approach innovation with meaning at the center of your process, you are better able to foster open and transparent collaboration among departments and functions. This saves costs, saves time, and produces real value for your customer, your shareholders, and the people with whom you work.

"For customers, the value is conveyed through a positive product experience and lasting brand loyalty. For shareholders, it comes in the form of ongoing profitability and a return on their financial investment in the company. For employees, the value of their work is also expressed as a return on their investment—of time and creativity, labor and a commitment to quality, and their identification with and loyalty to the company and its offerings."[11]

Now replace the business references with museum-appropriate language and the potential value of meaningful engagement as it is practiced in Magnetic Museums is easy to see:

For visitors, the value is conveyed through a positive experience and a lasting relationship with the museum. For stakeholders, it comes in the form of organizational sustainability and enhanced community impact. For employees, the value of their work is expressed as a return on investment—of time and creativity, hard work and commitment to quality, and their identification with and loyalty to the organization and its offerings.

360 ENGAGEMENT

Magnetic Museums practice 360 engagement by involving five stakeholder groups — staff, board, donors, audiences, and community leadership—and activating them on behalf of the institution. (For the purposes of this book, we include volunteers, docents, security, and other individuals who work in museums in any references to "staff.") Our observations indicate that this practice sets in motion a positive and self-reinforcing cycle in which an enthusiastic workforce dedicated to bettering the institution provides

inspiration to a corps of loyal supporters and ambassadors who share their experiences with others and generate financial, reputational, and social resources in support of the museum. As the positive buzz grows among external audiences, internal stakeholders are motivated to continue their own high level of effort, which produces even more publicly visible results.[12] Magnetic Museums propel this cycle by implementing "customer-centric" practices that deliver high quality experiences for stakeholders in every category.

Start with the Staff

Three-sixty engagement begins with attracting the right people to work in and with an organization. Jim Collins, author of *Good to Great: Why Some Companies Make the Leap and Others Don't*, introduced the notion of "getting the right people on the bus." He writes, "Leaders of companies that go from good to great start not with 'where,' but with 'who.' They start by getting the right people on the bus, the wrong people off the bus, and the right people in the right seats. And they stick with that discipline—first the people, then the direction—no matter how dire the circumstances."[13]

The "right people" are those who share the organization's values and have a passion for its mission. The "right people" are talented, energetic, and committed. The "right people" in Magnetic Museums also are individuals who care at a fundamental level about developing and relating to other people; they are natural "engagers." These engagers are embedded in every department of the museum, both in frontline and back-office positions.

So how do Magnetic Museums ensure they have the right people? Several organizations spoke of recruiting for "fit," "culture" or "relate-ability," along with appropriate knowledge and skills. The Franklin Institute shared its rubric for evaluating potential new employees, which includes a section on "Relating to Others," with a set of specific competencies to seek, in addition to "Getting Results," "Thinking and Solving Problems," and "Leading and Managing Others."

Once they have the right people, Magnetic Museums fully engage them in contributing to the work of the organization by communicating openly and frequently, involving them in decisions, empowering them to take action, and allowing them to explore and develop their own interests in relation to the institution's work. Not only is this good human resources practice, it is good business, as several studies show.

A 2007 report on employee engagement by PeopleMetrics identified eight aspects of work environments that drive employee engagement. Only two of these, Rewards (compensation) and Resources (tools and training), are functional in nature, while six are emotional: Recognition, Customer Focus, Fun, Growth, Trust, and Purpose.[14]

Daniel Pink, author of *Drive: The Surprising Truth About What Motivates Us*, offers a new paradigm-changing perspective on what motivates people, especially in the workplace. Underscoring the PeopleMetrics study findings, Pink concurs that external rewards like money, what he calls the "carrot-and-stick approach," don't work.[15] Instead, he writes, "the secret to high performance and satisfaction—at work, at school, and at home—is the deeply human need to direct our own lives, to learn and create new things, and to better ourselves and our world." [16] He frames these three needs as "autonomy, mastery, and purpose."[17] As you will see, Magnetic Museums are delivering all three.

Diane Ragsdale, in her "Jumper" column on ArtsJournal.com, provides a pointed challenge to cultural organizations that overlook caring for their employees and nurturing organizational excellence, even as they strive for artistic excellence. In a post entitled, "It May be Excellent Work … But is it Good?" she writes, "If I had a dime for every time a nonprofit arts admin staffer said to me, 'Our organization is filled with people under 35 who have great ideas, but the artistic and managing directors have no interest in what we have to say,' I'd be able to buy a round-trip ticket from Amsterdam to NYC. Similarly, actors, musicians, dancers, and other artists (unless they are celebrities) are rarely invited to share their opinions on programming or marketing or fundraising strategies … This all strikes me as wrong. It seems that nonprofits should hold themselves accountable for being places where process matters as much as product and where 'good work' reliably happens."[18]

Magnetic Museums are consciously changing their processes and engaging their staffs more equitably. Bill Hennessey, director of the Chrysler Museum of Art, spoke with clarity on this issue. "Too often, we in the museum world tend to relegate the members of our staff who have the most regular contact with our constituents to a lower status than the people who focus on objects … [At the Chrysler], we are doing something to fix this self-defeating practice."[19]

The sense of belonging, loyalty, and fulfillment that results from this intentional practice was readily apparent among staff at Magnetic Museums. Youth Programs Manager Juwanda Thurmond described the leadership at the Children's Museum Pittsburgh, saying, "They make each of us feel like a valued member of the team, not just as an employee. That trickles down to the way we perform and our feeling of cohesion."[20] Staff members we interviewed at other museums in our study used similar phrases, such as, "Everyone has a voice;" "I feel inspired here;" "The work environment is based on camaraderie;" "The culture of trust and mutual respect is self-perpetuating;" and "We get it done if we work together."

A happy, energetic, and engaged staff contributes to the impression and to the realization of organizational health and vitality. The Franklin Institute trustee Don Morel makes this point by saying, "It's a credit to [the organization] to see the staff so fully engaged. This is not just a way to earn a living, everyone seems totally thrilled to be here."[21] The staff members we spoke with validated this impression, exhibiting a sense of involvement, pride, and fulfillment with their work. Dale McCreedy, director of gender and family learning programs at the science center, says, "There's an identity attachment to being a member of The Franklin Institute staff that reflects what the Institute stands for and has done in the field."[22]

Even audiences notice when museums serve the interests of their staffs and engender this kind of loyalty and sense of purpose. "The staff was friendly and helpful," read one Chrysler Museum of Art visitor comment card. "The customer service at this museum needs to be extended to the whole region," read another. "If I had a staff like this, business would be booming!" a third visitor observed.

Engage the Board

Meaningful involvement is equally important in terms of nonprofit board recruitment, retention, and activation. It also has an impact on executive leadership's satisfaction with board performance and board members' satisfaction with their volunteer service. A self-assessment study of nonprofit boards published by BoardSource reported that trustees believe that increasing their effectiveness hinges on improving board capacity in four areas: 1. fully understanding the organization's financial situation; 2. participating in strategic planning; 3. periodically reviewing and gaining better understanding of programs and services; and 4. enhancing board recruitment and development efforts. Board members indicate a strong desire for increased clarity of roles and responsibilities and increased communication between themselves and various constituencies—the chief executive, staff, affiliates, and the community at large. In addition, board members express a desire to work hard and add value.[23] The BoardSource study suggests that nonprofit trustees crave the opportunity to make a difference.

Our interviews corroborated these findings. Peter Meredith, board chair of the Chrysler Museum of Art, was gratified to know that his professional expertise would be helpful. "I, like so many others, have to feel that I can make a difference with my skill set if I'm going to get involved. I am a developer and construction manager...and [they] assured me that my talents would really make a difference," as the museum began a significant renovation and expansion project.[24]

Museum directors, in turn, rely on their boards for many things, including lending their expertise, leveraging their relationships, and contributing to an organization's financial health. A 2011 study of 3,000 nonprofit leaders found a direct correlation between the amounts of time an executive spends on board activities and his/her level of satisfaction with board performance. The report cites findings showing that leaders who spend 20 percent of their time on board-related activity report higher rates of satisfaction with board performance than those who invest only five to 10 percent of their time.[25] All of the Magnetic Museum directors whom we interviewed indicate that they spend more than 20 hours per month on board activities and describe themselves as very satisfied with board performance.

In Magnetic Museums, this investment in board involvement has translated into increased commitment, advocacy, and giving from their trustees. As you will soon hear from the Conner Prairie Interactive History Park, the more that board members felt engaged by the museum's leadership, the more of themselves they invested in the museum. You will read how this helped to strengthen both the mission impact and the financial sustainability of the organization.

Involve Donors

"Moves management" has long been accepted as best practice in fundraising. Developed in the 1970s by G.T. "Buck" Smith and David Dunlop, president and chief development officer, respectively, at Cornell University, it is a disciplined and intentional process of relationship management (primarily focused on major gifts fundraising) that strategically guides prospects through a laddered progression of steps.[26] It begins with awareness and moves through knowledge, interest, and involvement, towards commitment to an institution and its mission, followed by meaningful stewardship before the cycle begins again. In other words, it is a purposeful practice that shifts perspectives and attitudes so that individuals choose to be engaged with and support an organization.

While "moves management" can be perceived as routine, it was designed to be personalized, customized, and high-touch. When practiced naturally and organically by Magnetic Museums, it actively engages donors and prospects in the vision and aspirations of the institution, welcoming patrons into conversation in the early stages of planning, inviting their insights and feedback. Requests for support target the points of intersection between a supporter's interests and passions and the museum's goals and needs. Engaging donors in a purposeful and intentional way that is aligned with community-centered,

organizational objectives has enabled Magnetic Museums to attract substantially increased contributions from a broader network of contributors.

Jay Ricker, president of Ricker Oil Company in Anderson, Ind., tells how his company came to sponsor Conner Prairie's helium balloon exhibit celebrating the circa 1859 first airmail delivery flight that you'll read about below. He was introduced to the museum through a mutual colleague. "Ricker is a family business," he said, "and we liked how Conner Prairie fit with our…values. My wife and I both grew up on farms in central Indiana, so it's important for us to preserve our history. It's also important to give back to the communities where we became successful…This dovetails with Conner Prairie, which gives back to its community…Ricker's and Conner Prairie's core values are in alignment."[27]

Activate Audiences

Research and reports abound exploring the impact of museum efforts to educate, engage, and activate audiences. For purposes of this book, we have relied on first-hand observations, prior audience, visitor, or member studies conducted by the museums, and anecdotal interviews to gain insight into the audience dynamics and impact of Magnetic Museums. Each of the case studies provides illustrations of how Magnetic Museums seek to create connections, meaning, and fulfilling experiences for their audiences. For two of the museums, the Chrysler Museum of Art (Chapter 4) and Connor Prairie Interactive History Park (below), audience engagement has been a principal driver of their institutional transformations. For the rest, engaging audiences in deeper dialogue, participation, and interaction with their museums is also an integral part of their overall approach.

A recent report by the Irvine Foundation, *Making Sense of Arts Engagement*, examined more than 70 examples of participatory arts programs and found a range of motivations behind these programs. "Some arts groups see active arts programs as a means of gaining a more favorable profile in the community, or as a long-term investment in audience development. Others use active arts programming to cultivate donors. The association between participatory arts practice and increased attendance is positive, but it is a byproduct of a fulfilling expressive experience, not a direct result. While any number of secondary benefits may accrue to the institution, participatory arts programs are intrinsically worthwhile, and essential to a healthy arts ecosystem."[28]

By putting people first, Magnetic Museums are fulfilling their intrinsic missions, while at the same time enhancing their organizational performance. They are, as the Irvine Foundation report concludes, creating "a healthy arts ecosystem" within their institutions and within their communities at large.

Connect with Community Leaders

It might go without saying, but each Magnetic Museum's relationship to its community is of fundamental importance to its success and sustainability. This relationship is created in two ways. The first relates to ensuring relevancy and embracing a public service agenda that is mission-centric and aligned with community needs. In Chapter 6, we will explore these concepts further with the story of the National Science Center of Greensboro (NSC). Responding to the needs of a city profoundly impacted by the recession, NSC became a catalyst for economic development through cultural tourism. At the same time, the Science Center endeavored to support the public school educational agenda, exponentially expanding its outreach to schools and its relationships with teachers. The museum's outward-focused vision—what its director calls a true "public/private partnership"—was manifest by NSC listening, engaging, and responding to the community through ongoing conversation and interaction with elected officials, civic groups, school administrators, peer institutions, and the like.

The second way Magnetic Museums create relationships is through community building, what we call "widening the circle," through collaborations and partnerships, and by inviting a range of constituents to participate in and contribute to realizing institutional vision. (See Chapter 5.) Widening the circle also involves activating social networks in traditional and technology-savvy ways. This is accomplished both at an individual level by staff tapping into a personal community of peers or a professional community of influential individuals, and at an organizational level by utilizing social and other media to reach an active online community hungry to make and sustain connections.

Focus on Customer Service

Magnetic Museums have an unrelenting focus on visitor experience, and on internal and external customer satisfaction. This is a key to their successful engagement of stakeholders within and outside their organizations. They truly are "customer-centric" in that "customers are part of the mission," "customers are highly loyal," and "customers are invited to give feedback."[29] They also are "employee-oriented" inasmuch as "employees are empowered to handle customer issues, invited to give ideas on the customer experience, provided customer feedback, and told when they have done a good job serving customers."[30] And this combination of customer and employee orientation has important and positive implications for organizational health and business vitality.

These museums enlist everyone inside their organizations in the customer service

mission and they believe that the duty of service does not end with audience but extends to their peers, as well. Over and over, we heard comments such as, "Staff help one another," "Everything in the museum must be service-oriented or nothing will be," and "We treat each other like family." These comments reflect internal bonds and a sense of staff camaraderie.

Magnetic Museums celebrate customer service successes and troubleshoot shortfalls. Colleen Higgenbotham, director of visitor services for the Chrysler, shared an internal practice, by way of example. "When we receive comments from visitors and tales of good service, I save them in a folder called 'Hats Off.' [This recognition effort] started when a visitor who loved his experience so much loudly proclaimed, 'Hats off to you! This is a fantastic museum!'"[31] Higgenbotham shares these "Hats Off" moments with the staff on a regular basis.

Being a customer-centric museum also can have important organizational benefits. More than twice as many employees in customer-centric organizations (compared to company-centric companies) say that "it would take a lot to get them to leave their current employer; they are motivated by the work to give extra effort; they recommend their current company as a great place to work; and they love their current organization."[32]

The staff in Magnetic Museums echoed these same attitudes and feelings of loyalty that PeopleMetrics documented in customer-centric, employee-oriented organizations. The people-first, service-first climate is contributing to satisfaction and long tenure among employees (which you will read about in more depth in Chapter 4.) The turnover rate for nonprofits in general has been reported at 16 percent. According to a 2010 *Nonprofit Retention and Vacancy* report, the highest turnover rates are reported by arts, culture, and humanities organizations, followed by health care, youth development, and human services, where the jobs are often lower paid and demanding.[33] The reasons most often cited for leaving a job include, in order, layoff, termination, another competitive job offer, and dissatisfaction with a current position.[34] Magnetic Museums are overcoming these industry odds by fostering a strong service-oriented culture and work ethic within their institutions.

The next case study, which shares the story of Conner Prairie Interactive History Park, reflects this holistic approach to people-focused engagement, perhaps one of the most important elements of Magnetism that we found. A commitment to public service, engagement, and making meaningful experiences for visitors and the community has expanded the institution's reach and deepened its impact while serving as the guiding compass for staff and trustees.

Conner Prairie develops strong emotional bonds with its audiences, equally engaging members of multi-generational family and social groups.
Photo: Conner Prairie Interactive History Park

∩

case study

CONNER PRAIRIE INTERACTIVE HISTORY PARK

OPENING DOORS

What would it take to transform a living history museum in a small city of less than 80,000 people into one of the area's most beloved and most visited sites for families in the region? And how dramatic would it be if this was accomplished in the midst of a governance crisis that lasted over two years, during which time the entire board and the museum president were fired?

This is the remarkable story of Conner Prairie Interactive History Park[1] in Fishers, Ind., a suburban community 30 minutes northeast of downtown Indianapolis. Rated the 12th best small city in the U.S. by *CNN Money Magazine*[2], Fishers boasts affordable homes, great public schools, 500 acres of parkland, and ample activities for families. "Most of what we do in Fishers is directed towards kids," said Town Council President Scott Faultless. In other words, it's the perfect location for an outdoor living history museum designed for families to experience the state's early 19th-century past.

The museum's current 800-acre campus, 200 acres of which are developed, includes the original homestead of Indiana fur trader and politician William Conner (1777–1845); a circa 1836 village called "Prairietown" replete with general store, inn, blacksmith shop, carpenter shop, animal barn, and other accoutrements of early agrarian Midwestern life; a Lenape Indian camp; and several other features that a visitor might not expect to encounter. As an early adopter of first–person interpretation, the museum showcases staff or volunteers often in costume depicting real and fictional characters in historically accurate, recreated settings.

However, to truly understand Conner Prairie's dramatic journey requires a walk back in time to the purchase of the museum's property in 1934 by

pharmaceutical magnate and philanthropist Eli Lilly II (1885–1977). This is a story of how a community nurtured, supported, and ultimately transformed an institution that has afforded memorable experiences to generations of visitors. It's also a story of how the once innovative museum grew stale, threatening its very survival, and what transpired to reinvigorate the cherished local institution.

In the 1930s, Eli Lilly adopted a conservation approach to social history that was progressive for its time. It was an approach that focused on preserving land, buildings, and artifacts from Indiana's early days and hosting reenactments for the public to "connect people with history in ways that books cannot."[3] The site also featured a working farm, displaying advancements in animal husbandry and agriculture.

In 1968, Lilly gifted the restored Conner house and its 1,600 acres to Earlham College, a small Quaker-based liberal arts school located 70 miles east in the town of Richmond. Lilly's donation included an endowment for the site's upkeep and public access. Earlham assumed a governance role for Conner Prairie, managing its reserves and finances, while the on-site staff and advisory board assumed a stewardship role, caring for the property, overseeing its public programs, and planning to institutionalize Lilly's vision into a museum.

The 1970s ushered in a new phase of Conner Prairie's "living history" approach to the past with the creation and opening of "Prairietown" under the directorship of Myron Vourax aided by renowned folklorist Henry Glassie. This approach—re-enacting history *in situ* and connecting it to the present—has continued unabated for the ensuing decades.

In 1988, the museum built a welcome center to create an accessible entry point for visitors. Capital fundraising proved challenging to the organization, however, leading it to borrow against the endowment and earning the displeasure of Earlham's frugal board. Tensions that had been simmering between the two institutions intensified. By the mid-1990s, the museum's programming, basically unchanged for 20 years, had become stale, attracting only the obligatory family outings or requisite fourth-grade field trips. Like many other museums of its type across the country, Conner Prairie began to experience significantly declining attendance and was strapped for cash.

That's when John Herbst, who had made his mark reconstituting the Historical Society of Western Pennsylvania into the acclaimed John Heinz

Pittsburgh Regional History Center, was hired to reinvigorate the museum. Herbst arrived with innovative ideas to expand programming responsive to visitors. He soon recruited as vice president his former Pittsburgh colleague, Ellen Rosenthal, to apply her skills in strategic planning, visitor engagement, and market research-based approaches to learning[4] to gain an understanding of the museum's audiences and experiences.

Conner Prairie began to take a serious look at the experience it was delivering to visitors. Its leadership asked, "Whom are we reaching? How satisfied are they? What are they learning?" And most importantly, "Are they having any fun?" What the museum learned sparked a revolution in visitor engagement.

This is a story of how a community nurtured, supported and ultimately transformed an institution that has afforded memorable experiences to generations of visitors.

Between 2000 and 2004, Conner Prairie undertook a series of research studies, guided by Rosenthal and facilitated by then Chief Operating Officer Ken Bubp with an expert in applied linguistics from nearby Ball State University, to uncover what and how visitors were learning while on-site. "We listened in on conversations that occurred within family groups from entry to exit … by attaching lapel microphones and digital recording devices to one person … [in the group. And then we] … transcribed and analyzed" the recordings.[5]

Even though Conner Prairie's intent was to afford visitors a firsthand, educational experience of Indiana's rural history, the studies revealed that the museum "… was not encouraging learning for families," said Rosenthal. She explained that, at the time, first-person interpreters were positioned throughout the site and role played in character, portraying, for example, Doctor Campbell and his wife; Mr. Curtis, the blacksmith; Mrs. Zimmerman, the innkeeper; and Mr. Whitaker, the general store owner. The interpreters had "post goals," or certain bits of historical information they were mandated to share with the public and then were evaluated on their ability to impart this information. Each post—the doctor's office, the blacksmith shop, the inn, etc.—contained historic artifacts, which the interpreters literally had to guard, requiring them to stay in one place. They often admonished young children for touching the objects.

"We talked to them, not with them—we delivered a one-way lecture with little interaction with our [visitors]," said Guest Services Manager Vinona

Christianson, a veteran of more than 20 years at Conner Prairie and former staff interpreter. In other words, "…the culture of the museum was not…one of conversation and interaction [with audiences], but rather monologue and demonstration."[6]

"The frontline staff believed they had an educational mandate—almost a religious conviction—to share information," said Rosenthal. But "the studies were…evidence that we weren't engaging people…[and] the task was to show [the staff] that the public asked more meaty questions when they were engaged [rather] than when they were just listening…[Visitors also] expressed a lot of misunderstanding about what they'd just heard. We were doing the exact opposite of what we thought."

Focusing on their primary audience of families, Rosenthal distilled the research results into a framework entitled *Eight Things We Learned from the Learning Study*, which included the following:

1. Families used the Conner Prairie experience to help their children better understand what they learned in school, read in a book, saw on television, or heard in conversation.

2. Parents used the Conner Prairie environment to model curiosity and coach learning behaviors in their children.

3. Visitors didn't always understand the first-person approach and were uncertain how to behave and interact with interpreters, which at times interfered with their enjoyment of the environment.

4. Families talked with each other constantly throughout their visit.

5. Learning was most likely to occur when the entire family had been engaged with the interpreter.

6. The entire family was most likely to be engaged when the children were engaged.

7. Conner Prairie defined engagement as any interaction evoking an emotional response in the visitor.

8. Learning didn't always rely on material presented by the interpreters and often involved information shared by visitors.[7]

Using this framework as a guide, senior and mid-management staff began

in 2002 to enact changes to enhance informal learning on-site and reorient the museum towards the visitor—what Conner Prairie calls "putting the guest at the center." They worked to perfect the craft of live interpretation through an iterative process of staff retraining that developed from inter-departmental teamwork, dialogue, and peer-to-peer learning.

"We borrowed any good ideas we could find, whether they were from [theaters], theme parks, science museums, or retail clothing operations," explained Bubp and former Experience Design Manager Dave Allison. "We developed new training programs [that focused on content, operations and communication skills], restructured how we deployed staff on a daily basis," and continually assessed visitor feedback to fine-tune the new methods. Establishing engagement as "an essential component of good interpretation" resulted in Conner Prairie's award-winning approach known as *Opening Doors to Great Guest Experiences.*[8]

Aided by a generous grant from the Institute of Museum and Library Services, Conner Prairie was able to adopt, test, refine, and document this new methodology.[9] It involves practices as simple as greeting people upon their arrival and making them feel welcome, to "reading and responding" to their verbal and nonverbal cues. Ken Bubp likened an aspect of the technique to fly-fishing, where "you throw out a bunch of different hooks at the beginning and see what people bite on," and then reel them in by sharing information that meets their interests. When engaging families, the staff also learned to "give control to kids in the group… [because] if you engage the children, you'll engage the parents, too," said Volunteer Interpreter Bill Wiebenga.

Perhaps the biggest change involved perceiving visitors as guests, which "implies a kind of hospitality," said Director of Programs Chris Petrelli. "I come from a theater background. We are creating a world of wonder [at Conner Prairie], not just displaying information. [And we're making] an emotional connection [with our guests], not just a cerebral one." As Wiebenga explained, "We [had been] working out of a defensive posture and what we were able to shift to was an invitational posture."

Frontline staff assumed responsibility for "becoming ambassadors to the past and facilitators of learning experiences… not simply live versions of bloated text panels that forced guests to learn by passive listening," Bubp and Allison related.[10] The Conner Prairie staff collectively rewrote its mission

statement and posted it throughout the campus to serve as a daily reminder of its new guest-centric approach. The organization refined its purpose from serving "as a local, regional, and national center for research and education about ... early 19th-century [Indiana] settlers" to an organization that "inspires curiosity and fosters learning about Indiana's past by providing engaging, individualized, and unique experiences."[11]

The internal attitudinal shift that was required to indoctrinate this new approach institution-wide was not without its challenges. "There was a lot of resistance on the part of some long-time staff. *Opening Doors* was a different way of thinking—a process that built on itself. It was not an overnight transition," said Christianson. "Getting research to frontline staff to show impact" (or lack thereof) was key to the transition, explained Rosenthal. Now, however, "the guest is at the center of our decisions and all staff members know this, [which] supports decision-making on every level," said Vice President of Exhibits, Programs, and Facilities Cathy Ferree.

In the early stages of this reorientation, the relationship between Conner Prairie and Earlham College reached a breaking point. Without warning in 2003, the school trustees fired John Herbst and his advisory board, setting off a legal dispute that took two years to resolve only with intervention by the state's Attorney General. Shocked and outraged by this action, the museum's advisory board immediately formed a new nonprofit called Save the Prairie to wrest control of the site from Earlham.

In late 2005, Conner Prairie was granted its independence and its sizeable holdings and property were split between the museum and the college (some say disproportionately privileging the school). In the end, two new co-operating organizations were formed: Conner Prairie Museum, Inc., which manages the educational programs, operations, and facilities; and Conner Prairie Foundation, Inc., which owns the museum's

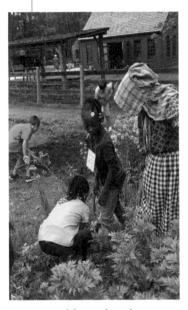

Experiencing life in early 19th century rural Indiana, visitors to Conner Prairie participate in authentic tasks like gardening, guided by staff interpreters who cultivate conversation and interaction, as well as vegetables.
Photo: Conner Prairie Interactive History Park

capital assets (land, buildings and endowment) and manages its investments on behalf of the museum.

The board of the newly formed Conner Prairie Museum asked Ellen Rosenthal to remain in the leadership role she had filled since Herbst's termination and she sustained the organization's guest-centered path. "Ellen's view was 'evolve or die,'" said Christianson. "Previously, we were stagnant. *Opening Doors* was designed to keep people coming back, and it's been proved through the [steadily rising attendance] numbers. Between 2002 and 2008, general attendance rose 58 percent, from nearly 56,000 visitors to just under 90,000, and membership has increased 22 percent in that same time period, from 3,750 to 4,560. In addition, key measures of visitor satisfaction and quality of experience have improved by over 40 percent since the initiative was launched.

"The governance blow up gave Conner Prairie license to reinvent itself," Rosenthal reflected, a sentiment shared by Board Vice President Christopher Clapp. "The transition to an independent organization was the main driver of change…We use[d] the crisis and need to be independent as a way to accomplish organizational objectives; the crisis [drove us] to think and act differently."

One critical way that Conner Prairie needed to think and act differently related to its business model. Previously, the museum had relied solely on its endowment and modest admissions revenue to make ends meet. Now on its own with a reduced investment portfolio, the museum had to quickly learn to be self-sufficient and financially viable, which also forced it to be entrepreneurial. In 2007, the staff and board engaged in a strategic planning process to map the museum's next five years. This resulted in a new approach to diversify the museum's portfolio of experiences designed to engage the public and encourage repeat visits, a renewed focus on land conservation to stress stewardship, an emphasis on human resource development of both board and staff, and a commitment to financial sustainability through new revenue streams, including fundraising.

To readily convey this renewed sense of self, Conner Prairie changed its name, from Museum to Interactive History Park, solidifying its brand as a place for both education and entertainment. In addition, the museum enhanced its website with interactive maps and microsites for select programs, helping to

orient guests before a visit, and providing post-visit educational resources for teachers, students, and families. And it invested more heavily in its marketing and advertising to attract audiences beyond the county.

Exhibits and programs became a much more hands-on experience for guests. For example, the "Prairietown" farm area morphed into "Animal Encounters," where visitors young and old can personally interact with the cows, chickens, sheep, lambs, and goats in residence. The breeding program launched by Livestock Manager Kevyn Miller has become a crowd-pleasing favorite, ensuring that baby animals are always on site at any given time.[12] Miller's expertise with farm animals was readily apparent. As he cradled a baby goat in his left hand and stroked the cheek of its mother with his right, he noted how calm they were. "Now we are even breeding our animals for the temperament to engage with our guests," he said.

And remember those historic artifacts that "Prairietown" interpreters formerly had to guard? They were carefully packed away in storage and replaced with facsimiles so that guests, especially children, could handle the potter's tools and assist Mr. Barker in making a clay mug, or pick up cooking implements and help Mrs. Curtis bake a pie, or learn how to make fire from flint, steel, and straw.

In order to entice a broad audience, well-established programs were refreshed, like *Symphony on the Prairie*, summer concerts on the lawn offered in conjunction with the Indianapolis Symphony Orchestra; or *Follow the North Star*, a participatory experience that allows visitors and school groups to encounter life as a fugitive slave on the Underground Railroad. And new programs were launched, like *History on Tap*, a craft beer event designed by and for young professionals. Conner Prairie also continued its outreach to schools and was "intentional about [meeting needs posed by] changing demographics in Indiana—for example, Latinos, immigrants, and refugees—as well as suburban, urban, and charter public and private schools," said Michael Twyman, a program officer at the Nina Mason Pulliam Trust, which funds Conner Prairie.

More dramatically, Conner Prairie extended its content focus beyond 1836 (the frozen-in-time period of "Prairietown") through an expanded exhibits program designed to continually renew on-site offerings. In 2009, after raising $2.2 million in an inaugural fundraising campaign, the museum opened the

1859 Balloon Voyage to commemorate the first attempt at airmail delivery from Lafayette, Ind., by aeronaut John Wise. The 105-foot-tall orange and yellow helium-filled balloon, with a gondola that can comfortably hold 20 people, rises 350 feet in the air on its sturdy steel tether. Providing a panoramic view of greater Indianapolis, it has become a regional icon and a popular attraction for both children and adults, plus an important source of earned revenue. In 2010, it won the prestigious Pinnacle Award from the Public Relations Society of America for Best in Show. That same year, Conner Prairie was honored with a National Medal for Museum and Library Service bestowed by IMLS.

Bolstered by this success, Conner Prairie in 2011 opened its next major exhibit, the *1863 Civil War Journey: Raid on Indiana*, which depicts the summer attack on the small town of Dupont led by Confederate General John Hunt Morgan during the Civil War. Through advanced set design and high-tech video projection, the four-part exhibit immerses the visitor inside the gripping story told through the eyes of three characters—a frightened 16-year-old girl, a determined, though weary, former slave, and a defiant Morgan himself—as well as first-person interpreters. The museum raised $4.4 million to add this multi-sensory experience to its array of offerings. It, too, draws crowds, and in 2011 received the American Association of State and Local History Award of Merit.

In the midst of this strategic realignment and growth, Conner Prairie, like many U.S. museums, was hit by the tsunami of recession. The value of its endowment precipitously dropped from $116 million in 2007 to $72 million in 2009, severely constraining the operating budget. Cost-cutting measures were swiftly instituted across-the-board, which included a painful 15 percent reduction in full-time staff. Rosenthal turned to her trustees and staff, communicating with them regularly and transparently in town-hall-like meetings, seeking collective wisdom and action to weather the recessionary storm.

Rosenthal also held frequent small meetings with influential staff in each department to discuss the museum's finances, the impact of the crisis, and the plans for resolution, and then asked each of them to communicate with their colleagues. The staff was empowered to streamline programs through a cross-divisional examination that used a scorecard approach, evaluating each on qualitative and quantitative measures to determine their return on investment. In short order, the entire staff became financially literate and invested in

keeping the organization afloat. They also looked for new, non-traditional sources of support, securing approval, for example, for a timber harvest on undeveloped land, as well as for the erection of a mobile phone tower, both of which met the organization's environmental conservation mandate.

Throughout the ordeal, Conner Prairie never lost sight of its mission of public engagement. "Our survival was internally driven," said Christopher Clapp. "In addition to the hardness and toughness that the [economic] downturn brought to the board, the vision of the kind of experience that we want the visitors to have kept people focused on the long term."

The financial crisis served to galvanize the board and underscored the realignment that was already underway. Term limits were enforced in a "conscious decision for the board to replace itself," said Trustee Terry Anker, and the committee structure was strengthened and activated. The nominations process for new board members purposefully identified those with the skills and networks needed to support growth. And philanthropic expectations were clarified. Management staff took a similar tack with trustees as they did with guests, making them feel that "they are part of something meaningful and are contributing to the organization," said Board Chair Tim Hassinger. "There is a collective feeling of ownership." In recounting his own board experience, he noted that as "... [his] interest level increased and [his] satisfaction level increased, ... [his] engagement level increased proportionally as time went on." Clapp echoed this sentiment: "The more involved I got, the more involved I got." When asked what worked in rejuvenating the board, Ellen Rosenthal replied, simply, "Patience."

"The more involved I got, the more involved I got," remarked a Connor Prairie trustee.

Not one to rest on its laurels, Conner Prairie knows the work is far from over. Although successful at raising project funds, the museum has recognized the need to build its fundraising capacity in ways that will deliver ongoing and renewable general support over the long term. It has embarked on a donor engagement approach similar to *Opening Doors* to meet ambitious contributed revenue goals in a state where individual giving is dwarfed by the $200-plus million distributed annually by the $5 billion Lilly Endowment. And the museum has just completed a new strategic plan that focuses on the next eight years, with an emphasis on serving community needs.

The highlight of this plan responds to the nation's critical need for STEM-based learning (Science, Technology, Engineering and Mathematics): a new indoor/outdoor interactive experience, which will explore scientific invention and discovery in Indiana. This initiative just received a $2.3 million award from the National Science Foundation to co-develop and co-disseminate, in partnership with the Science Museum of Minnesota, an open-source model for integrating informal science into programs at historic sites and museums.

Conner Prairie remains on its trailblazing path. As Trustee Bill Corley remarked, "To start a revolution, you need a team of believers," and the museum has them in droves. Director of Exhibits Brian Mancuso, a recent transplant from Texas, is typical of the impassioned group that supports the museum. "I was attracted to Conner Prairie due to the sheer diversity of experience—a history museum with a hot air balloon, sheep, guns, fire… We break the mold. [The audience's relationship to us] is no longer based on nostalgia. Conner Prairie facilitates social conversations and interactions. There are no solitary visitors. We are noisy, smelly, dirty, *real*." And that's why people come, again and again and again.

SIX MAGNETIC TIPS
FOR EMBRACING 360 ENGAGEMENT

1. Take a holistic approach to engagement that involves your internal and external communities. Routinely stand in the shoes of staff, board, and audiences, and ask, "What are they thinking, feeling, saying, and doing?" Pay particular attention to your staff and board, because how they feel about and relate to your organization resonates and reflects outward to your audiences.

2. Be fervently "people-focused," "customer-centric," and "service-oriented." Invest in customer service training for your employees to strengthen staff culture and enhance the visitor experience. Be patient as new ways of thinking and acting take hold, because change doesn't happen overnight.

3. Invite meaningful participation. Provide well-structured opportunities for constituents to offer opinions and insights. Respect and respond to their input, and share what results from their efforts.

4. Welcome the personal passions and interests of staff and board that intersect with the museum mission and vision. When vocation and avocation meet, everyone benefits.

5. Know your audiences and community. Seek understanding and insight through conversations, surveys, comment cards, online reviews, or other research. Share customer feedback with staff and board members to inform planning and ensure responsiveness.

6. Think of your visitors as your "guests" and make emotional connections, affording them the care, hospitality, and memorable experience that you would offer to good friends in your home.

Chapter 3 Notes

1. Chip Heath and Dan Heath, *Switch: How to Change Things When Change Is Hard* (New York: Broadway, 2010), 7.

2. Kevin Roberts, *Lovemarks: The Future Beyond Brands* (New York: PowerHouse Books, 2007), 66.

3. Sherene Suchy, "Museums Management: Emotional Value and Community Engagement," presentation at INTERCOM 2006 conference, Taiwan, p. 3, http://www.intercom.museum/documents/3-1Suchy.pdf (accessed 3 Jan. 2013).

4. *Ibid.*

5. *Ibid. 2.*

6. Stephen Axley, "Managerial and Organizational Communication in terms of the Conduit Metaphor", 1984. *The Academy of Management Review*, Vol. 9, No. 3, Jul. 1984, http://www.jstor.org/discover/10.2307/258283?uid=3739584&uid=2&uid=4&uid=3739256&sid=21101544004503 (accessed 12 Dec. 2012).

7. Charles R. Conrad and Marshall Scott Poole, *Strategic Organizational Communication In a Global Economy* (New York: John Wiley & Sons. 2011), 5.

8. Lois H. Silverman, "Meaning Making Matters: Communication, Consequence, and Exhibit Design." *Exhibitionist*, 18, no. 2 (Fall 1999), 12, http://name-aam.org/uploads/downloadables/EXH.fall_99/EXH_fall_99_Meaning%20Making%20Matters%20Communication%20consequences%20and%20Exhibit%20Design_Silverman.pdf (accessed 15 Dec. 2012).

9. Visitor email to Chrysler Museum of Art, N.D.

10. Steve Diller, Nathan Shedroff, and Darrel Rhea, *Making Meaning: How Successful Businesses Deliver Meaningful Customer Experiences* (Berkeley: New Riders Publishing, 2006), 33-37.

11. *Ibid. 3*

12. Jim Collins describes this phenomenon as the "Flywheel" in his monograph *Good to Great and the Social Sectors,* 26.

13. Jim Collins, "Good to Great," *Fast Company*, Oct. 2001, http://www.jimcollins.com/article_topics/articles/good-to-great.html (accessed 4 Jan. 2013).

14. PeopleMetrics.com, "2011 Employee Engagement Trends Report," (Philadelphia: PeopleMetrics, 2011), 6, http://www.peoplemetrics.com/wp-content/uploads/2012/06/2011-Employee-Engagement-Trends-Report_PeopleMetrics.pdf (accessed 3 Jan. 2013).

15. DanPink.com, *Drive: The Surprising Truth About What Motivates Us,* http://www.danpink.com/books/drive (accessed 20 Jan 2013).

16. *Ibid.*

17. *Ibid.*

18. Ragsdale, Diane. "It May be Excellent Work … But is it Good?," *Jumper*, 20 Jun. 2011, http://www.artsjournal.com/jumper/2011/06/it-may-be-excellent-work-…-but-is-*it*-good/ (accessed 13 Dec. 2012).

19. Author email from William Hennessey, Chrysler Museum of Art, 26 Nov. 2012.

20. Author interview with Children's Museum Pittsburgh staff, 24 Jul. 2012.

21. Author interview with Donald E. Morel, Jr., trustee, The Franklin Institute, 3 Aug. 2012.

22. Author interview with senior staff, The Franklin Institute, 2 Aug. 2012.

23. Judith L. Millesen and Berit M. Lakey, Ph.D., *The Nonprofit Board Self-Assessment Process: Lessons from the Field* (Washington, DC: BoardSource, 1999), 7, http://www.boardsource.org/dl.asp?document_id=22 (accessed 31 Dec. 2012).

24. Author interview with Peter Meredith, trustee, Chrysler Museum of Art, 22 Jun. 2012.

25. Maria Cornelius, Rick Moyers, and Jeanne Bell, *Daring to Lead 2011: A National Study of Nonprofit Executive Leadership* (Washington, DC: CompassPoint Nonprofit Services and the Meyer Foundation, 2011), 11, http://daringtolead.org/reports-briefs/full-report/ (accessed 17 Dec. 2012).

26. Jerold Panas and William T. Sturdivant, *The Moves Management Manual: A Fall-Proof System for Major and Planned Gift Fundraising* (Chicago: The Institute for Charitable Giving, 2012).

27. Author interview with Jay Ricker, trustee, Conner Prairie Interactive History Park, 28 Sept. 12.

28. Alan Brown and Rebecca Ratzkin, *Making Sense of Audience Engagement* (San Francisco: The San Francisco Foundation, Grants for the Arts with the support of The Wallace Foundation, 2011), 10, http://www.wolfbrown.com/images/articles/Making_Sense_of_Audience_Engagement.pdf (accessed 17 Dec. 2012).

29. PeopleMetrics.com, *op. cit.*, 4.

30. *Ibid.*

31. Author interview with Chrysler Museum of Art senior staff, 21 Jun. 2012.

32. PeopleMetrics.com, *op.cit.*, 14.

33. Opportunity Knocks.org, *Opportunity Knocks Nonprofit Retention and Vacancy Report 2010* (Atlanta: Opportunity Knocks, 2010), http://www.commongoodcareers.org/assets/pdf/Retention_Vacancy_Report.pdf (accessed 8 Jan. 13).

34. *Ibid.*

Chapter 3 Case Study Notes

1. The information and quotations presented in this case study are taken directly from author interviews with Conner Prairie staff, trustees and stakeholders, or from internal or publicly accessible organizational data.

2. *CNN Money*, "Best Places to Live," Sept. 2012. http://money.cnn.com/magazines/moneymag/best-places/2012/snapshots/PL1823278.html (accessed 18 Oct. 2012).

3. Eli Lilly, *The Republican Ledger* (Noblesville, IN, 1935).

4. Trained as a curator, Rosenthal worked at the Minnesota Historical Society and The Frick Art & Historical Center before joining the Historical Society of Western Pennsylvania as chief curator.

While in Pittsburgh, Rosenthal earned a second master's degree in public management at Carnegie Mellon University, and later participated in museum research conducted by the Learning Research and Development Center at the University of Pittsburgh. By her own admission, she became "a convert to research and learning."

5. Mary Theresa Seig and Ken Bubp, "The Culture of Empowerment: Driving and Sustaining Change at Conner Prairie," *Curator*, Apr. 2008.

6. *Ibid.*

7. Conner Prairie Interactive History Park, *Eight Things We Learned from the Learning Study*, 2000.

8. Ken Bubp and Dave Allison, "Opening Doors to Great Guest Experiences," *Conner Prairie.org*, http://www.connerprairie.org/About-Us/Who-We-Are/Opening-Doors-to-Great-Guest-Experiences.aspx (accessed 23 Oct. 2012).

9. Conner Prairie produced a training resource available on DVD and CD-ROM to share findings and best practices with the field. For more information, please see www.OpeningDoors.ConnerPrairie.org.

10. Bubp and Allison, *op. cit.*

11. *Ibid.*

12. When the authors visited Conner Prairie in late September, there were three adorable, six-week old baby goats, which ate, pranced around and nuzzled each other and the guests, enthralling toddlers, grandparents and middle-aged researchers alike!

Chrysler Museum gallery hosts welcome guests,
empower visitors with knowledge about the works on
view, and ensure the safety of both visitors and art.
Photo: Kathy Keeney for the Chrysler Museum of Art

chapter 4

Empower Others
Chrysler Museum of Art

Put People and Service First / Shared Leadership is Strong Leadership
Build Bench Strength / Empowered and Empowering Boards
A Ripple Effect through Audience and Community

The late Dr. Wangari Maathai, Nobel Peace Prize winner and founder of Kenya's Green Belt Movement (GBM), was fondly known as "Mama Trees." In 1977, she launched GBM, a simple tree-planting program to address rural issues of lack of water, deforestation, and soil erosion, as a personal crusade to reforest Kenya. Focusing her efforts on providing seedlings and small financial incentives to women who would plant them, Maathai grew GBM into an international platform for the empowerment of African women and a touchstone for environmental stewardship of the continent's natural resources. Some 50 million trees later, Maathai's work is hailed for not only stemming the tide of deforestation in Kenya, but also for improving the lives of millions of women.[1]

So how was one woman able to achieve so much? While we might assume that Dr. Maathai succeeded because of her charisma—after all, she was a brilliant and well-educated scholar, a gifted orator, and a persuasive advocate—we would be overlooking the simple fact that no one individual could personally plant 50 million trees and touch the lives of so many women. Clearly, in Dr. Maathai's case she had the help of many hands all planting trees and motivated by a compelling mission—"to create a values-driven society of people who consciously work for continued improvement of their livelihoods and a greener, cleaner world."[2]

Maathai, who died in September 2011, was an inspiring leader. She was dedicated, intentional, ethical, and inclusive. She was motivated not by personal ambition, but by a selfless desire to improve the lives of others and make the world a healthier place. She

cared about the environment, but most importantly, she cared about people, their well-being, their human dignity and how they are affected by—and affect—the world around them. In this regard, "her environmental activism was part of a holistic approach to empowering women, advocating for democracy and protecting the earth."[3] Our research for this book found that Magnetic Museums mirror this holistic leadership philosophy and illustrate an inclusive approach that successfully empowers others.

PUT PEOPLE AND SERVICE FIRST

Magnetic Museums give "power to the people," as John Lennon defiantly urged in his 1971 anthem.[4] But they do more than simply "give" power. Magnetic Museums create a culture of empowerment built on the values of service, respect, reciprocity, and trust. This philosophy echoes Peter Senge's work (introduced in Chapter 2), in which he describes "learning organizations" as people-centered and people-empowered workplaces, where individuals "continually expand their capacity to create the results they truly desire, where new and expansive patterns of thinking are nurtured, where collective aspiration is set free, and where people are continually learning to see the whole together."[5] In these organizations, leaders continually seek to develop and help others to grow.

Magnetic Museum directors model a "servant-leader" approach that encourages and enables others to achieve their full potential and abilities. "Servant-leadership," as originally defined by Robert K. Greenleaf in 1970, "begins with the natural feeling that one wants…to serve first. Then conscious choice brings one to aspire to lead…the difference [between leader-first and servant-first leadership] manifests itself in the care taken by the servant-first to make sure that other people's highest priority needs are being served."[6]

We observed that the leaders of Magnetic Museums freely share their authority and knowledge with others in order to allow many to contribute more fully to the organization's success. These leaders work to increase board, executive, and staff capacity to think and act strategically, and they reap the benefits of that enhanced capability in terms of overall organizational performance. These leaders also provide a directional framework that enables their internal stakeholders to innovate and take action—to be entrepreneurs and problem-solvers who help move an organization towards its envisioned destination.

Kimberly Bracken's story is a perfect example of how people—and gardens—can grow when the conditions are right.[7] In 2008, Bracken, a 25-year-old neighborhood resident, joined Children's Museum Pittsburgh as a part-time coordinator of afterschool and summer volunteer programs for middle- and high-school youth. As Bracken tells it, she

"fell in love with the museum," and wanted to do more to help both the organization and her community. In Bracken's case, "more" turned out to be quite a lot more.

One of Bracken's passions was gardening and when she spotted a green space outdoors that was host to nothing but grass, the idea of a garden on the museum's grounds captured her imagination. On her own initiative, she researched and identified three grant opportunities that could potentially fund a garden project. She brought her idea to Jane Werner and Chris Siefert, the museum's director and deputy director, and received an enthusiastic response: "Sure, go for it!" At the time, CMP's development department was experiencing staff transitions and couldn't assume any additional grant-writing responsibility, so Bracken, who had never previously applied for institutional funding, was encouraged to try her hand at the applications. Inexperience was apparently no barrier to success, because the museum won all three grants that she submitted.

If Bracken's story ended here it would be worth relating simply to illustrate the power of initiative, sheer pluck, and staff emboldened to "do" by superiors. But CMP's empowering management approach added an even more enlightening chapter. Instead of delegating the project to someone else, Bracken recalls, "Jane and Chris said, 'It's your vision, so go ahead and make it happen.'"

But they didn't leave her to fend for herself. Siefert, who is a landscape architect, advised Bracken on her garden plan—the first she had ever attempted—and helped her to incorporate the design principals that guide the museum's facility, exhibition, and experience development.

"This was a huge part of my personal and professional journey," Bracken said, "as I am now designing more garden spaces on-site here, as well as museum-funded community gardens for the neighborhood." The creation of the initial garden was the catalyst for a number of new programs, most notably, the Food City Fellows, a neighborhood teen employment and food education program. In addition to maintaining CMP's three on-site demonstration gardens, the Fellows have created two community gardens on previously vacant lots, one of which is a quarter-acre permaculture forest garden that hosts hands-on workshops for the neighborhood about how to grow and prepare fresh food. "These gardens and the youth learning and working in them are connecting CMP to the community and the community to CMP."

Bracken added, "This never would have happened were it not for the culture and management of CMP. I was never micro-managed; I was guided with advice and principles and given the opportunity to learn." She became a full-time employee and manager in 2011 with a broader set of responsibilities encompassing teen, garden, and community

outreach activities. And here's the best part of the story: she pays it forward. "Now that I am a manager, when I see passion and motivation in one of my people, but little experience, I tell myself, 'Give them room to try, and grow. Just wait, and see what happens.'"

As Kimberly Bracken's story illustrates, Magnetic Museums empower their people to envision and create the future. They allow their employees to express and explore their personal passions in relation to their work. The directors we studied are transparent and inclusive in their planning and decision-making, and respect and tap the knowledge, insights, and creativity resident within their organizations. Magnetic Museums recognize that if their employees are doing well, their organizations also will do well. These institutions have confidence in their staff, and provide the necessary support to help them develop new capabilities. As Bracken noted, "Trusting someone as young and inexperienced as me was risky, but they saw something in me—my interest, passion for the mission, and my work ethic—and they said, 'Let's take a chance on that.'" As we saw in Chapter 2, trust and confidence are bolstered when leadership knows its managers and staff are operating in alignment with the organization's vision and values.

Conner Prairie staff was similarly empowered to adopt an entrepreneurial approach to reinventing its relationship with visitors. Appropriating ideas from theaters to theme parks, they developed staff-led training to reorient their signature live interpretation towards their audiences, which they now call their "guests." And then they produced a CD-ROM called *Opening Doors to Great Guest Experiences* and sold it online to share their research, findings, and award-winning methodology with the field.

Peter Senge documents an organizational mind-shift that occurs within the learning organization, from "seeing parts to seeing wholes, from seeing people as helpless reactors to seeing them as active participants in shaping their reality, from reacting to the present to creating the future."[8] Kimberly Bracken has helped to shape the future for CMP. At The Franklin Institute, Steve Snyder, vice president of exhibit and program development, has done the same. After he and his team envisioned and successfully realized several new core exhibits without the help of external exhibition designers, the "shift" that Senge describes happened for the Institute. The trustees gained confidence that the staff had the requisite capabilities to create world-class experiences. "Based on our past success and the strength of our staff team, we are now positioned for the board to get behind whatever new vision we come up with," Snyder related.[9]

SHARED LEADERSHIP IS STRONG LEADERSHIP

Alan Keith of biotech firm Genentech describes leadership as "creating a way for people to contribute to making something extraordinary happen."[10] The museums that we studied reflect this type of broadly distributed approach to leadership. This is not to suggest that their directors or presidents are not highly effective—these institutions have succeeded precisely because of the vision, commitment, and sound management of their top executives. What we found, however, is that many people throughout these organizations think of themselves and take action as "leaders," even if they don't carry an executive title. The effect of this empowerment puts more players on the field and authorizes them to act, thereby extending the organization's reach through networks, partnerships, and new initiatives. As authors Leslie Crutchfield and Heather McLeod write in their book, *Forces For Good*, "Although we can't prove a simple cause-and-effect link...we have come to believe that sharing leadership has in fact enabled these nonprofits to have more impact."[11] Shared leadership also allows an institution to tap a broader range of skills than might be embodied in a single person.[12]

BUILD BENCH STRENGTH

Magnetic Museums excel by building "bench strength." Just as a baseball team carries a roster of strong substitute players, the directors of these museums have a trusted deputy, second-in-command or "kitchen cabinet," as well as a team of executives who all share in leading the organization.

This is in contrast to the early experience of the San Francisco-based Exploratorium, which Crutchfield and Grant examined in *Forces for Good*. "The Exploratorium...illustrates the dangers of not developing a strong executive team as an organization grows. In fact, it took the founder's death and the hiring of a new executive director before the Exploratorium evolved to a more collective leadership model...The nonprofit was thrown into chaos when founder, Frank Oppenheimer, died in 1985. There was no formal management structure...or empowered leadership team—and no succession plan."[13] It took five years, two subsequent directors, and the museum nearly going out of business for the Exploratorium to right itself.

Our interviews revealed that Magnetic Museums not only nurture top talent, they successfully retain it. The longevity of their executives' tenures is driven by loyalty, passionate devotion to the museum's mission, and feelings of personal belonging as part of a team, rather than the inertia borne of long tenancy and position.

At The Franklin Institute, four of the eight senior executives have tenures longer than 11 years, and only three have been with the Institute fewer than four years. For example, Larry Dubinski, executive vice president of the Institute, joined the organization 12 years ago, left the museum to practice law, and returned four years later in a new capacity.

David Singleton, chief operating officer at the Philbrook Museum of Art and a 23-year veteran of the organization, is highly regarded by both trustees and staff, and is viewed as a calming influence on the museum. His constancy and steadiness have provided stability even through difficult leadership transitions.

Senior members of Magnetic Museums are in demand and several indicated that they had been approached about jobs at other institutions over the years, but had decided to stay put. The reasons they cited included feeling that there was "more work to be done," and not wanting to disappoint their staff and board members, and the larger community that they serve. (In Chapter 7, you will read similar findings about long-tenured directors.)

In fact, when we spoke with external observers of the study museums and asked about institutional leadership, interviewees always mentioned the names of board members and management staff in addition to that of the director or president. Meryl Levitz, president and CEO of the Greater Philadelphia Tourism and Marketing Corporation, commented, "We see folks from The Franklin Institute at everything. They are at the table for most of the important conversations in Philadelphia about education, culture, and tourism."

Gregg Behr, executive director of the Grable Foundation in Pittsburgh, says of Children's Museum staff and leadership, "[They] are always present in the community and this communicates and reaffirms their interest in community issues that extend beyond their parochial concerns…This starts a positive cycle of people from all quarters of the city telling the positive story of the museum and its value."

"The point of the collaborative leadership paradigm is not that leaders are unnecessary," writes leadership scholar Greg Markus. "Rather…organizations are more likely to thrive within complex, continuously changing environments when leadership comes from many places within the organization, drawing upon the complementary assets of group members and not confusing leadership with formal authority."[14] Magnetic Museums have improved their ability to manage on multiple fronts by identifying and playing to each team member's strengths. They are clear on the distinction between leadership and management, and they encourage both.

EMPOWERED AND EMPOWERING BOARDS

Every leader we interviewed made clear that his or her relationship with the museum's governing board was critical to institutional success. A strong partnership between a board chair and director can be great, and a weak one can be disastrous. Outside observers whom we interviewed were acutely attuned to the quality of this relationship, and when a positive partnership did exist, it enhanced their overall confidence in the organization.

Daniel P. Jordan, former president of the Thomas Jefferson Foundation in Virginia, which manages the Founding Father's magnificent homestead, Monticello, knows this from experience. "The power of an amazing board cannot be overemphasized. The capacity of the board determines the capacity of the institution, and mediocre boards deliver mediocre results. We wanted *big* people so that we could deliver a *big* program."[15]

Capacity in this context means more than financial net worth. It also means intellectual, social, and networking capacity. Rather than holding his board at arm's length, Jordan fully engaged them and their networks. Over two decades, they collectively increased Monticello's endowment from zero to $142 million, and raised more than $200 million for programmatic and capital expansion in four campaigns, in addition to exponentially growing and funding the institution's annual operating budget.

Executive and volunteer leadership in Magnetic Museums share responsibility and mutually empower one another. Each plays a clearly defined role and has distinct areas of accountability. While the board approves the overall direction of the organization, the executive team sets and contributes to that vision and determines how best to realize it.

In a dramatic example recounted in Chapter 3, Conner Prairie's museum advisory board members were incited to action when the Earlham College board, which managed the museum's endowment, fired them over a governance dispute. As long-tenured trustee Marjorie Mayer recalled, "That [governance] fight made us what we are today. We were so endangered, so threatened, that we fought [for our independence] until we won."[16] The crisis empowered the board to take ownership and they remain invested today. They have reached a new level of trust and partnership since securing the museum's independence. The board "has stepped up to secure the financial vibrancy of the organization," says President and CEO Ellen Rosenthal, and the staff has developed greater financial literacy to manage its funds effectively.[17]

The board of the Chrysler Museum of Art, whose story follows, had to take a serious look at its own performance when the organization suffered financial missteps before

Director Bill Hennessey's arrival. Board Chair Peter Meredith recounts, "After the financial difficulties, we all had to invest to turn this place around. That period of cleaning up was a time that required us to put good ground rules in place and build levels of internal trust in new management. It resulted in [the board] gaining a sense of ownership in the museum."[18]

A RIPPLE EFFECT THROUGH AUDIENCE AND COMMUNITY

As you will read in Chapter 5, inclusive and participatory practices that involve broader audiences and communities are gaining traction in museums. These practices often take the form of empowering external constituencies, as well, which can have a profound ripple effect on the community. In 1994, just one year after the Washington, DC-based United States Holocaust Memorial Museum (USHMM) opened to international acclaim and millions of visitors, many questioned its relevance to the local community, which had a majority African American population. Lynn Williams, the museum's education director, along with Bill Parsons, chief of staff, and Sara Bloomfield, now the museum's director, began to envision a community outreach and education program called "Bringing the Lessons Home," designed to connect local high school students with the museum's mission of remembrance, preservation, and education.[19]

"Bringing the Lessons Home" focused on the important lessons of the Holocaust and the need for citizens to be actively engaged in building a more just world. Elements of the program included classes that teach Holocaust history and lessons for the future, as well as after-school programs, peer interactions, and mentoring by museum staff and Holocaust survivors At the end of the program, participants were encouraged to invite their families to tour the museum, become volunteer tour guides, or apply for paid summer employment.

"Bringing the Lessons Home" grew to include a seven-week summer program for 100 "Youth Ambassadors" from around the country and abroad. By 2010, the program had inspired nearly 500 youth ambassadors, 76 percent of whom are African American. Each participant is challenged to commit to going home and reaching 100 people with a message about the lessons of the Holocaust and its relevance for today. This "100 reach 10,000" program is spreading the museum's message broadly and with a greater sense of urgency and depth borne of the students' personal experiences.

Although USHMM has a powerfully compelling international mission and operates

from a sense of moral imperative, they could easily have failed to make that mission magnetic to others. Instead, they created mission-based programming that activated their core audience of Holocaust survivors as mentors and ambassadors to build bridges to a new audience—African American teens. They engaged this youth audience to such a degree that 54 percent of participants said it was one of the most important experiences of their lives. And then they activated this newly bonded audience to build bridges to new audiences by empowering them as guides, educators, and ambassadors.

In the following case story, you will see how an empowering leadership approach that puts people and service first has taken the Chrysler Museum of Art to an entirely new level of performance and value to its community.

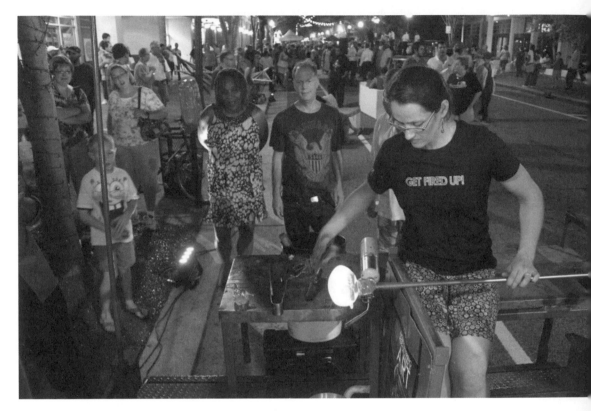

*The mobile Hot Shop lets the Chrysler Museum Glass
Studio take its show on the road. The Studio Team
performs live demos at schools, street festivals (shown),
and special events across Hampton Roads.*
Photo: Chrysler Museum of Art

case study

THE CHRYSLER MUSEUM OF ART

SERVE FIRST. LEAD SECOND.

Molly Marder, registrar for loans and exhibitions at the Chrysler Museum of Art in Norfolk, Va., considers herself a leader at the museum. So does Gary Marshall, a former journalist turned art museum web master. Dawn Penney, assistant to the director of the museum, describes herself as a leader, too. "All of us have leadership positions here," said Visitor Services Supervisor Christine Gamache, a digital media artist who joined the museum in 2003 as a temp conducting visitor surveys. "The key is that the museum trusts us to make good decisions and we trust that the museum will support our choices. We are invited and allowed to take a high degree of ownership here...and so we do."[1]

This kind of talk is not necessarily something one normally hears from museum staff, let alone from non-curatorial staff in art museums where academic credentials often equate to stature. At the Chrysler, it is the norm and the direct result of the people-focused, service-oriented culture and empowering approach to management that director Bill Hennessey has nurtured over 16 years.

Nowhere is the Chrysler's participatory style of leadership more evident than in the museum's gallery host program, which disperses informally attired staff educators throughout the complex to welcome visitors and facilitate fulfilling on-site experiences.

During a weekday morning tour of the "30 Americans" exhibition showcasing contemporary works by 30 African American artists, a chance encounter illustrated the potential of an empowered staff. A small gallery in the exhibition featured a single installation, *Duck Duck Noose*, by Gary Simmons, which consists of eight, three-legged wooden stools arranged in a circle around

a suspended noose. Each of the stools is topped with a pristine Ku Klux Klan hood.

Nearby, an African American gallery host was engaged in conversation with a white visitor in her 20s. As the conversation progressed, the host nodded toward the Simmons installation and said, "Walk with me into the gallery." When they reached the artwork, the host turned to the guest and said quietly, "Now, imagine you are me."

What makes this encounter notable, especially considering its racially charged potential, is the fact that this discussion happened in a city whose population is almost equally divided between white and African American residents, with less than 10 percent representation of other ethnicities.[2] It is a city that has worked hard to overcome a legacy of racial inequality. Moreover, it happened in an art museum that until the last decade was an exclusive institution serving a predominantly white, wealthy, and educated audience. So this exchange was only partly about ethnicity; it also was about how museums overcome differences in levels of education, affluence, and relative comfort in the presence of art. This encounter was a striking display of the staff competence and confidence made possible by a trusting and empowering environment.

Founded in 1933 as the Norfolk Museum of Arts and Sciences, the Italian Renaissance-style building in The Hague neighborhood of central Norfolk was expanded and renamed the Chrysler Museum of Art in 1971. That same year, it received the 30,000-piece art collection of Walter P. Chrysler, Jr., son of the automotive corporation founder. Chrysler served as the museum's president from 1971 to 1980 and as its chairman until 1984. He was, by all accounts, patrician by nature, an art connoisseur with a discerning eye, but not necessarily a man of the people.

The Chrysler is one of the leading art museums in the Southeast. Among its permanent holdings are works by European masters like Tintoretto and Peter Paul Rubens; Impressionist painters Mary Cassat, Edouard Manet, and Paul Cézanne; and contemporary artists Edward Hopper, Jackson Pollock, and Andy Warhol. The Chrysler also has one of America's preeminent collections of art glass, including outstanding works by Louis Comfort Tiffany, as well as one of the world's largest collections of American neoclassical sculpture.

In 1997, the trustees hired Bill Hennessey as the Chrysler's sixth director.

Hennessey is a witty, genteel, somewhat quiet and thoughtful man. His style is anything but that of the stereotypical, larger-than-life art museum director or corporate CEO. Hennessey focuses on meeting the needs of the staff and the museum's guests in a way that provides them with security and support while at the same time freeing them to explore and take action. This philosophy, perhaps more than anything else, has proven to be charismatic in its own way.

Despite longtime municipal funding for the maintenance and operations of the museum's city-owned building (which had been a condition of Chrysler's gift) and strong philanthropic support, the Chrysler was at the time of Hennessey's hiring recovering from a management crisis and related financial instability resulting from two previous undercapitalized expansions.

Hennessey diplomatically said that the museum "had gotten ahead of itself." By this he means that the board, half of which is appointed by the City of Norfolk and half selected by the museum, had become complacent and disengaged and had lost hold of the financial reins in the late 1980s and early 1990s.

A 1995 report by planning consultants Bill Keens and Nancy Pressly describes the situation more starkly. They found "profound confusion around direction, purpose, and mission" among the board members they interviewed.[3] In terms of audience, the report described little sense of community ownership of the museum and a feeling that many were not "comfortable" visiting because "the museum may be more intimidating than welcoming to the average visitor."[4]

Although the Board had taken decisive steps to right the financial situation and reevaluate their roles and responsibilities before hiring Hennessey, there was a significant need for sure and steady leadership to guide the museum forward. Angelica Light, past president of the Hampton Roads Community Foundation, recalled that, "Bill brought a kind of leadership that the museum needed, which was visionary, inclusive and empowering."

A strategic planning initiative early in Hennessey's tenure also proved to be catalytic in the Chrysler's transformation. Macon Brock, former board chair, related, "The board and staff emerged not only with a new understanding of our mission, but more importantly, with a real sense of connection, ownership, and responsibility for the future."

Three key agreements resulted from those planning meetings that have

guided the museum's trajectory. First, the organization adopted a simply stated, yet highly motivating mission: "The Chrysler Museum exists to enrich and transform lives. We bring art and people together through experiences that delight, inform, and inspire."

Second, the board and staff leadership committed to greater fiscal accountability and pledged that the museum would maintain a balanced budget going forward, a promise it has since kept. Third, they defined the museum's audience as the 1.5 million people living within a 50-mile radius and made a genuine commitment to serving and engaging all of them, not just the slice of well-to-do, educated residents who were accustomed to attending.

"We started with a mission that was almost exclusively focused on objects, the old 'collect, preserve, display, interpret' paradigm," said Hennessey. "But it struck us that we could do all those things, and even do them well, but still be a pretty boring place … [so] we systematically shifted our focus to be more and more about people and the ways that we can ensure that these works of art make a difference in their lives."

Today, in addition to remaining committed to excellence in collection stewardship, the Chrysler's primary goal is providing a high-quality visitor experience that connects people with art in meaningful ways. The collection, rather than being the focal point and an end in and of itself, is instead just one of the critical means to achieving the institution's mission. This transition to a guest-and service-centered organization has required a substantive evolution of programs, approaches, and policies, as well as a significant shift in the museum's curatorial and management philosophy and staff culture. It also has required creating a dramatically increased sense of shared responsibility and accountability among all staff.

"We started by moving all uniformed security guards out of the galleries. In their place we deployed gallery hosts, specially recruited and trained guest service representatives whose purpose is to make people feel welcomed, relaxed, and comfortable in the presence of art," Hennessey related.

Launched in 2007, the gallery hosts program provides staff with extensive training, not just in security and safety, but also in how to engage guests with art through inquiry and meaningful, shared conversation. The hosts move throughout the galleries, offering the opportunity for visitors to have a

personalized experience of the art with someone readily available to answer questions or provoke insights.

Colleen Higgenbotham, director of visitor services, provided some insight. "Engagement is the thread that runs through everything…we began by teaching our gallery hosts to 'read' people—their body language, their level of comfort and their interests…Over the years," she continued, "the program has grown and improved because we have really listened to and observed the visitors. We also listen to the gallery hosts' insights into visitor behaviors and needs."

The key to making this program work is that the gallery hosts are empowered and authorized to do whatever is required to meet a visitor's needs, short of potential injury to him or herself, another person, or to the art. One heroic host jumped into the fountain outside the museum's doors to rescue a fallen mother and child, and another created an email account on the spot so that a visitor could use his iPhone to take and email a photo of a favorite painting. Another out-of-town guest trying to locate a Velasquez portrait sought help from a host, who tracked down the painting and escorted the visitor to the administrative floor where the work was hanging…in the director's office. "We try to ensure that no one leaves unsatisfied," said Higgenbotham.

Jeff Harrison, chief curator and a 30-year veteran of the Chrysler, explained, "This kind of change requires a leap of faith. You need to have strong leaders and trust at every level and all across the board…In the '80s, the assumption was that the curators knew best. Now we have shifted our thinking so that we trust and support and listen to the staff on the floor. Our curators are always on call for the gallery hosts and will come down to the floor immediately if a visitor has a question. It would not be acceptable here for a curator to say 'no' to such a request."

Registrar Molly Marder concurred. "The customer-service thing is not just about seeing our visitors or participants as 'customers.' It's about seeing each other, internal as well as external, as a priority. We are in it together, trying to create the best experience for everyone."

The staff members felt so strongly about the kind of culture they wanted at the Chrysler that they wrote a joint statement of commitment to one

another to memorialize the core values that guide them. Included among their commitments are:

"We treat each other with consideration and kindness. We reject rudeness and treat one another with courtesy and respect at all times."

"We have adopted a culture of continuous improvement, and will continue to strive to be better for our organization and for our colleagues."

"We will exceed our visitors' and members' expectations at every point of contact… We will extend the same commitment of service to our colleagues."

The Chrysler has become a place where everyone—visitors and staff alike—feels welcome and open to the transformative potential of art. Hennessey said, "We try to make everyone as comfortable as possible, because no one learns when they are anxious or uneasy… By suggesting to our visitors that we are all in this business [together] of figuring out what to make of works of art, we take an important step in empowering them to gain some insights of their own."

The museum prompts dialogue with its visitors by creating talkback areas, where guests may post sticky notes with comments or insights on walls within an exhibition. One such wall incorporated into the "30 Americans" exhibition contained literally hundreds of guest responses. The museum also allows non-flash photography in all the galleries and seeks permission for public photography as part of all loan and exhibition agreements. Hennessey recalled of this decision, "Once we saw how powerful it is to empower people to remember a favorite work or to capture and share their experience with family or friends, we decided to try to enable that experience."

The Chrysler's holistic approach to empowering staff and visitors appears to be working for the community and the visitors. One guest wrote in an email, "[The Chrysler] changed my way of thinking about museums." Another expressed, "I feel so welcome and invited here now. A big change from the past." Dozens of visitor comments also echo the sentiments of the guest who wrote, "An unusually happy staff here. Must be a great place to work. It wasn't just the size of the museum, which was perfect, but the warm tone the staff set."

To measure its progress, the Chrysler began in 2007 to track a Net Promoter Score as its key metric. A Net Promoter Score measures consumer loyalty and likelihood to recommend the experience to someone else.[5] During

The opening of "30 Americans, Masterpieces of Contemporary African American Art from the Rubell Collection," built bridges with the Black community across Hampton Roads. More than 1,100 guests, many first-time visitors, attended an opening block party at the Chrysler.
Photo: Charlie Gunter for the Chrysler Museum of Art

the first year, the museum's average score was 77 out of 100. Now the museum consistently ranks in the 90s.

Deepening relationships with visitors once they arrived at the museum, however, was only one of the Chrysler's goals. A second goal was to reach out to and serve the local and regional population, and this required diversifying audiences and removing barriers to attendance.

Despite the fact that 43 percent of the population of Norfolk is African American, the Chrysler, like many art museums, historically attracted an almost exclusively white, affluent audience.[6] Hennessey said that while the museum did not actively track or study the demographics of its visitors in the 1990s, he thought it "fair to say that African American faces (except for school children) were not frequently seen."

In 2002, the Chrysler created a Friends of African American Art group to connect with a new community of collectors. Since that time, the museum has markedly increased its acquisition and presentation of works by non-white artists. As a result of diversifying its content and programs, and conducting consistent outreach efforts over time, the Chrysler's four-year average (2006 through 2010) attendance by African American visitors was 19.4 percent.

Nationally, only 5.9 percent of African Americans report attending art museums.[7]

Maurice Jones, former publisher of *The Virginian-Pilot* newspaper and a past board member of the Chrysler (currently Deputy Secretary of the U.S. Department of Housing and Urban Development), who is African American, cited the "30 Americans" exhibition as a perfect illustration of the museum's efforts to serve non-white visitors. "There was and is a significant portion of the community that has never set foot in the Chrysler," Jones said. "'30 Americans' was a very bold programming move that touched the African American community."

In addition to creating a community advisory committee to advise the museum on programs, interpretation, and outreach related to the exhibition, the opening night party was free to everyone. More than 1,500 guests attended. Angelica Light observed that the Chrysler has taken a "purposeful approach to programming in order to reflect the community and serve as a catalyst and provocation of community conversation. [The museum has] made us all think."

In an effort to remove remaining barriers to attendance, the Chrysler board, at the urging of Hennessey and the staff, approved a recommendation to offer admission to the museum's permanent collections free of charge for an initial three-year trial period. The announcement was made in 2008 and the admission charge was dropped in September 2009. "It was seen as a bold and inclusive gesture," recalled Hennessey. "The city leaders, who are in effect our landlords, loved it."

The public apparently loved the move, as well. Attendance jumped 33 percent in that first year. Gratifyingly, the Chrysler also experienced increased diversity among visitors—more African Americans, younger adults, and families were coming. And although people spent less time on-site during each visit, their visits became more frequent.

The move to free general admission had a surprising ripple effect. "Our members and patrons developed a stronger sense of philanthropy and connection to the museum as a result of our going free," reported Edwina Bell, director of development and communications. Although admissions had represented an important source of earned income, more critical to long-term growth was the pipeline of donors and funding generated by the Chrysler's members, for whom free admission was a key benefit of participation.

"We decided to go with the message, 'Joining the Chrysler is an act of philanthropy,' because every membership contribution makes it possible for us to be free to everyone, and it worked!" Bell said. While they have seen increased volatility and churn at the lower levels, this approach, which empowers members to enable the participation of others, has netted a 53 percent retention rate among members overall and 90 percent retention in their top giving levels. Membership has remained steady at around 4,000 households.

The ripples extended beyond membership to higher-level supporters, as well. At the end of the three-year trial period, a major donor stepped forward to establish an endowment, the income from which enables the Chrysler to offer free admission on a permanent basis. "We have to demonstrate every day in very tangible ways why we add value and why we deserve support," said Hennessey. "When people's lives are, in ways large and small, changed by the experiences they have at our museum, then they become more naturally inclined to say, 'This institution is very important in my life and deserves my support.'"

Bell reported that the response to the Chrysler's capital campaign launched in 2010—a three-part initiative to fund the new Chrysler Museum Glass Studio, a building expansion and renovation, and endowments for programs and operations—has been particularly strong and is a testament to the Chrysler's commitment to board and community engagement. The museum surpassed the initial target goal of $40 million by $1 million during the quiet phase of the campaign. They increased the goal to $45 million based on this early success. Only two years into the campaign, free admission had been funded in perpetuity, the Glass Studio had been built and opened, the curatorial department had doubled in size with three of four curatorial salaries endowed, and the finish line is in sight. All this for a museum with 2010 operating expenses of $6.5 million.

Hennessey and Brock also believe that the decision 15 years ago to maintain a balanced budget has paid dividends. "This commitment to financial stability, no matter how painful, has been a North Star principle," said Brock. "Because we have practiced such sound fiscal management, it has built trust [with the community and the City.]" Hennessey added, "In addition to maintaining the City's support, we have been able to consistently attract board

representation and increasing support from the principal corporations in the region. Most telling is the relative ease with which we have been able to generate support for such things as going free and for our current capital and endowment campaign even in the midst of the downturn."

Reflecting on the Chrysler's transformation, Maurice Jones said, "It's all about the people and the approach … Bill's vision, patience, and energy have combined to attract a team that is getting stronger, more diverse, and more willing to take risks, and an evolving board which now trusts and supports the team unequivocally. These factors have conspired to make this moment of opportunity."

No organization can experiment, take risks, or learn from its mistakes without secure, stable, empowering leadership in place. More than anything else, a sense of joyful shared purpose, ownership, and accountability for results permeates the Chrysler. "Bill has a broad vision and he encourages the staff to keep generating ideas for more and more engagement—with the visitors, the community and each other," said Trustee Henry Light.

Board Chair Peter Meredith agreed. "Bill brought this vision of a highly accessible and relevant museum to the Chrysler. He has done a terrific job partnering with the board and guiding us along the path. Our approach is to spread the responsibility."

Members of the staff also credit Hennessey's approach. Glass Studio Manager Charlotte Potter said with a glint in her eye, "I've honestly never heard Bill say 'no' to anything. Instead, he's wonderful at channeling our enthusiasms in ways that let each of us contribute to the Chrysler's success." Chief Curator Jeff Harrison agreed. "The mission has been to bring art and people together to enrich and transform lives … It is simple, understandable, and each one of us can say, 'Here's how I am going to help achieve [the mission].' It activates everyone's potential." Christine Gamache summarized this sentiment by acknowledging that it is a matter of openness and inclusiveness. "If Bill or my direct boss were … closed off, it would be much harder. Because they are so open, it allows the staff under them to be … open, and that translates to the visitor."

In 2011, the Chrysler realized another aspect of its vision for empowering people with art by opening a 7,000 square foot, state-of-the-art glass blowing studio, which offers daily demonstrations and an array of hands-on classes and

workshops. The idea for the studio emerged on the heels of two successful Art of Glass festivals created by the Chrysler in collaboration with more than 20 regional museums, galleries, and educational institutions in 1999 and 2009. During the festivals, designed to attract audiences throughout the region, emerging and established glass artists exhibited their work and lectured at dozens of venues. Two mobile glass blowing studios at the 2009 festival drew huge crowds. Witnessing the level of public fascination inspired by the interactive and participatory nature of the glassblowing process (which was much greater than that generated by the Chrysler's 10,000-work glass collection) got Hennessey and his board thinking. When a bank building adjacent to the museum became available, the idea for a studio in which visitors could be engaged as glass artists became a reality.

Charlotte Potter, a glass and multimedia artist and Rhode Island School of Design alumna, manages the studio with Robin Rogers, the technician or "gaffer." They epitomize the Chrysler's commitment to engagement, education, and entertainment. As young working artists, they and the rest of the studio staff have an appetite for seeing how far they can take the medium. Under Potter's guidance, they have created a program that teaches and engages visitors in a highly technical craft, empowers students with mentoring and job training opportunities, and attracts international visiting artists and audiences. The studio also offers lunchtime demonstrations that are part performance art, part conversation, and part science lab. In its inaugural year, the studio drew nearly 20,000 visitors.

Rogers teaches while demonstrating how the blowpipe is inserted into a glowing 2,150-degree furnace containing nearly 600 pounds of molten glass. As 50 to 60 visitors looked on, he blew through the pipe to form a bubble, keeping the material supple by inserting it frequently into a second, slightly cooler oven called the "glory hole." The process continued as the piece was shaped and finished. Then, as onlookers held their breath, spellbound, as if to ward off the seemingly inevitable sound of crashing glass, Rogers and the hot-shop assistant carefully tapped on the blowpipe to send vibrations up the stem. With a gentle snap, the glass vessel broke off at the precise point into waiting hands accompanied by rounds of applause and exhaled breaths.

"When you see it being done, you can tell it's a dance," Charlotte Potter related in an interview with *The Virginian-Pilot* at the time of the

studio's opening. "It involves practice and working with a team, and there's choreography to it."[8]

"The energy from the glass studio launched the next phase of engagement and growth," said Macon Brock. "[It] has been transformational … and has drawn thousands of people who might never have visited the Chrysler before."

To understand the Chrysler's success, one need only hear the staff talk about what it means to be trusted and supported, or watch what happens when curators Jeff Harrison and Amy Brandt happily apply their scholarship in service to visitor enjoyment, or feel the excitement of a young visitor engaged in hands-on learning in the glass studio. Each of these is a moment of empowerment when the institution acts in service to others, involving them as equal partners in developing their skills, interests, and insights through experiences with art. Angelica Light perhaps captured it best, saying, "[a] visionary and participatory style … is at the core of what makes this such a vibrant place. "

SIX MAGNETIC TIPS
FOR EMPOWERING OTHERS

1. Serve first, lead second. Commit to developing and serving the needs of your people, your partners, your audiences, and your community and leadership will follow.

2. Ensure autonomy, mastery, and purpose.[1] Give people the freedom to decide and then act; provide the necessary training and tools; and make the work meaningful and important.

3. Think like a maestro and conduct rather than control; bring out the best in everyone.

4. Be unequivocal in supporting your staff and volunteers. Applaud initiative and support decisive action whatever the outcomes.

5. Remove barriers to empowerment. Ensure that structures, skills, systems, and supervisors support employees.[2]

6. Above all else, show respect and appreciation, again and again.

Chapter 4 Notes

1. The Green Belt Movement, http://www.greenbeltmovement.org/node/363 (accessed 28 Nov. 2012).

2. The Green Belt Movement, http://www.greenbeltmovement.org/who-we-are (accessed 28 Nov. 2012).

3. Kerry Kennedy, "Wangari Maathai: A 'Mighty Woman' Who Spoke Truth to Power," TheHuffingtonPost.com, 26 Sep. 2011, http://www.huffingtonpost.com/kerry-kennedy/wangari-maathai-a-mighty-_b_982139.html (accessed 28 Nov. 2012).

4. John Lennon and Plastic Ono Band, *Power to the People* (London: Apple Records, 1971).

5. Peter M. Senge, *The Fifth Discipline: The Art and Practice of the Learning Organization* (New York: Doubleday/Currency, 1990), 3.

6. The Greenleaf Center for Servant Leadership, http://www.greenleaf.org/whatissl/ (accessed 26 Dec. 2012).

7. Author interview with Kimberly Bracken, Children's Museum of Pittsburgh. 14 Jan. 2013.

8. Senge, *op. cit.,* 69.

9. Author interview with The Franklin Institute, senior staff, 2 Aug. 2012.

10. Alan Keith as quoted in "Five Practices of Exemplary Leaders," http://www.lipscomb.edu/execed/Page/Index/6927 (accessed 18 Jan. 2013).

11. Leslie R. Crutchfield and Heather McLeod Grant, *Forces for Good: The Six Practices of High-impact Nonprofits* (San Francisco: Jossey-Bass, 2008), 178.

12. *Ibid., 179.*

13. *Ibid., 189.*

14. Greg Markus, *Building Leadership: Findings from a Longitudinal Evaluation of the Kellogg National Fellowship Program.* (Battle Creek, Mich.: W. K. Kellogg Foundation, 2001). Cited in B. Hubbard, *Investing in Leadership: Vol. 1. A Grantmaker's Framework for Understanding Nonprofit Leadership Development* (Washington, DC: Grantmakers for Effective Organizations, 2005) 11. Cited in Crutchfield and Grant, *Forces for Good: The Six Practices of High-Impact Nonprofits.* (San Francisco: Wiley/Jossey-Bass, 2008) 180.

15. Author interview with Daniel P. Jordan, Thomas Jefferson Foundation., 10 Feb. 2010.

16. Author interview with Marjory Mayer, trustee, Conner Prairie Interactive History Park, 28 Sep. 2012.

17. Author interview with Ellen Rosenthal, president and CEO, Conner Prairie Interactive History Park, 27 Sep. 2012.

18. Author interview with Peter Meredith, trustee, Chrysler Museum of Art, 22 Jun. 2012.

19. Anne Bergeron, Beth Tuttle and Jennifer Wells Green, "Secrets of the Magnetic Museum: Turning Moments of Success into Momentum," American Association of Museums Annual Meeting, Los Angeles, CA, 23 May 2010.

Chapter 4 Case Study Notes

1. The information and quotations presented in this case study are taken directly from author interviews with Chrysler Museum of Art staff, trustees and stakeholders, or from internal or publicly accessible organizational data.

2. United States Census Bureau of the Census (2010) http://quickfacts.census.gov/qfd/states/51/51710.html (accessed 10 Oct. 2012).

3. Nancy L. Pressly and Associates and the Keens Company, "The Chrysler Museum of Art: A Situational Analysis" (1995), 6.

4. *Ibid.,* 10.

5. To learn more about Net Promoter Scores, see www.netpromoter.com

6. United States Census Bureau of the Census, *op.cit.*

7. National Endowment for the Arts, "2008 Survey of Public Participation in the Arts." http://www.nea.gov/research/2008-sppa.pdf (2008), 27 (accessed 5 Jan. 2013).

8. Teresa Annas, "Scenes: Chrysler Museum's glass studio opens Wednesday." *The Virginian-Pilot*, 1 Nov. 2011, http://hamptonroads.com/2011/11/scenes-chrysler-museums-glass-studio-opens-wednesday (accesed 5 Jan. 2013).

Chapter 4 Tip Notes

1. Daniel Pink, "The Puzzle of Motivation," July 2009, http://www.ted.com/talks/dan_pink_on_motivation.html (TEDGlobal).
2. John Kotter, *Leading Change* (Boston: Harvard Business School Press, 1996), 102.

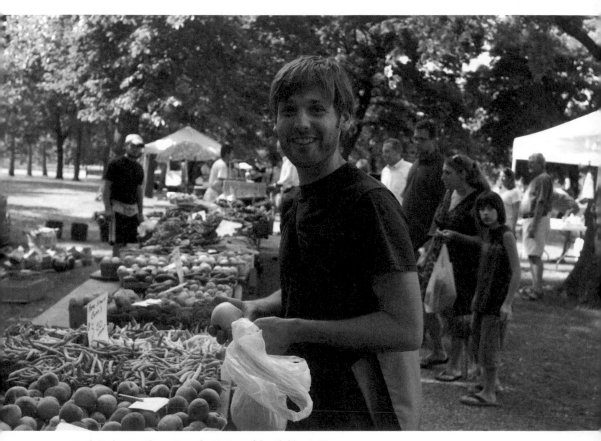

Fresh Fridays, a Charm Bracelet Project of the Children's Museum
Pittsburgh, features guest chefs, cooking demonstrations, youth
performances and art activities at the Northside Farmers Market.
Photo: Renee Rosensteel for the Children's Museum Pittsburgh

chapter 5

Widen the Circle
and Invite the Outside In

Children's Museum Pittsburgh

Widen the Circle of Participation / Enlist Your "Peeps"
Mobilize Strong Networks / Invite the Outside In

In his influential book from 2000, *Bowling Alone: The Collapse and Revival of American Community*,[1] Robert Putnam laments that Americans have become "increasingly disconnected from family, friends, neighbors, and…democratic structures,"[2] and less active in public sector life. He cites alarming statistics since the 1950s and '60s reflecting declining participation in social clubs and athletic leagues, involvement in local politics, attendance at church, even gathering for nightly family dinners.

Putnam advocates for civic reinvention to avoid what he envisions as dire consequences for contemporary society. He reintroduces the term "social capital," which he defines as "features of social organization, such as networks, norms, and social trust that facilitate coordination and cooperation for mutual benefit."[3] He describes the benefits that accrue from being in community—among them, mutual trust, reciprocity, information exchange, and cooperation. "Social capital…[is] simultaneously a 'private good' and a 'public good'…[and] social connections are…important for the rules of conduct that they sustain."[4] More importantly, Putnam reminds us that the networks formed "involve (almost by definition) mutual obligations… Networks of community engagement foster sturdy norms of reciprocity."[5]

Putnam speaks to the need for a kind of communitarianism that, more than a decade later, we are seeing emerge in the form of social networks in action at the local level. These range from a neighborhood watch group that keeps a subdivision safe from harm and benefits all residents to a parents group that rallies taxpayer support behind building a much-needed new public school, enhancing educational opportunities and property values. The rise of farm-to-table commerce is connecting locally raised produce directly

with consumers in a way that benefits both farmers and families. The social capital that is created through these networks serves to bond individuals within a group more closely together and helps to build bridges that connect one group to another, all of which strengthens the social fabric of a community.

In 2007, Pepperidge Farm® Cookies tapped into the growing need for community when it created a marketing campaign and dedicated website called "Connecting through Cookies."[6] The company launched the site to help women—its target customers—improve their social lives. Michael Simon, vice president and general manager at the company, spoke about the campaign in a 2007 *New York Times* interview. He said his marketing team had created the program after listening to its customers talk about "this notion of connection … [how] hectic lifestyles, life in general, has gotten in the way" of women forging and strengthening ties with friends.[7]

Neuroscientists also have been curious about the beneficial effects of community connections. In 2011, specialists from the University of Oxford demonstrated a direct relationship between cognitive abilities and the size of one's social network.[8] By examining the magnetic resonance imaging (MRI) scans of 23 rhesus macaques for over a year, before and after being placed in various sized social groups, the scientists concluded that brain function relating to sensory perception and abstract reasoning increased in proportion to a monkey's social network. Another research study—this time conducted with human subjects—published in 2010 by the Department of Gerontology at Brigham Young University proved this same causal link between social relationships and mental and physical well-being.[9]

Social connection, then, has important benefits for individuals and the communities in which they live. But does widening the circle of connections really make a difference for organizations? Acclaimed author and staff writer for *The New Yorker* Malcolm Gladwell thinks so and he addresses the issue directly in his 2000 bestseller *The Tipping Point*. To start a social epidemic, he says—to launch a new idea, establish a trend, or spread a message by word of mouth—requires "people with an extraordinary knack for making friends and acquaintances," people whom he calls "connectors."[10]

Magnetic Museums are tapping into the power of "connection" and finding that as they grow their circles of friends, they also grow their circles of influence, impact, and support. These museums take three approaches to drawing a large and inclusive circle of participation: they build and connect communities of true believers; they nurture and mobilize a variety of networks; and they create meaningful opportunities for external stakeholders and audiences to participate in the life and work of the museum.

WIDEN THE CIRCLE OF PARTICIPATION

Reaching out to others and inviting them in enhances magnetism and strengthens organizational performance in a number of ways. The most direct and obvious result of what is commonly referred to as "community outreach," "audience development," or "partnership building" is broader reach to expanded audiences. Like those Rhesus monkeys, most organizations benefit from an extended social circle. Yet Magnetic Museums don't simply communicate with and raise awareness among new audiences. They engage them with personally relevant, meaningful, and participatory experiences. In 2003, the Dallas Museum of Art sought to create just this kind of personalized and meaningful experience for visitors. Using its 100th anniversary as a rallying point, the museum embarked on a multiyear initiative to better connect the institution with the community, and the community with art.[11] Over the course of seven years, the DMA conducted a series of research studies in partnership with Randi Korn & Associates to examine how people engage with art. From this, the museum developed a Framework for Engagement with Art describing four visitor "clusters"—tentative observers, curious participants, discerning independents, and committed enthusiasts—that became a guiding institutional strategy for connecting audiences with art and art with audiences.[12] Using the framework and working in an integrated, cross-disciplinary manner that involved everyone on the staff, DMA thoughtfully developed exhibitions, programs, and interpretive strategies to ensure that the museum was reaching each audience cluster in meaningful ways.

The DMA's 100 Hours program, which kicked off the initiative, is now legendary. In January 2004, the museum stayed open around-the-clock for 100 hours in honor of its centennial. The event attracted more than 45,000 people and offered a broad array of programs and activities designed to appeal to visitors from every corner of the city and every point along the spectrum, from cautious newcomer to seasoned art lover.[13] This experiment soon evolved into the successful Late Nights program, when the museum is open until midnight one Friday every month for lectures, readings, performances, and family events.

Nine years later, Late Nights is still going strong and is a mainstay of the museum's public programs. Attracting 3,000 to 5,000 visitors each month, this program has contributed to a 200 percent increase in visitation over the past decade.[14] Nearly half of the audience surveyed during Late Nights in 2011 were first time visitors to the museum, and reflected greater diversity than during daytime hours, with nine percent African American, 12 percent Hispanic and 68 percent Caucasian visitors.[15]

Focus groups conducted at the same time found that the top two reasons cited for coming to a Late Night event were "to look at art" and "to see an exhibition," followed by "date night" and "socializing."[16] Visitors expressed the meaning of Late Nights in their lives, describing the experience as "wide open adventure, anything could happen," and "you traditionally think of art as…a solitary one-on-one [experience], you and the art communing with each other. And Late Night is the antithesis of that…the contrast is a lot of fun."[17] Most importantly, participants expressed a desire for an opportunity where they could meet new people and engage in deeper conversation in a quiet, small-group setting, much like a salon or the focus group roundtable itself.[18]

Even following a change in senior leadership in 2012—Maxwell L. Anderson joined the DMA as director in the wake of Bonnie Pitman's retirement—the museum has remained on its people-centered path. Anderson recently announced a return to free general admission to foster greater public accessibility and the launch of an innovation called DMA Friends, a free membership program designed to heighten audience participation through engagement and technology.[19]

After-hours programs and the corollary for kids, overnight sleep-ins, are now common fare at many museums. These programs have been successful, in part, because they offer audiences singular experiences that are saturated with meaning—the excitement of having privileged access to something special and not readily available; social fulfillment spending leisure time with friends or family; and personal enrichment derived from the learning experience. Due to the popularity and market orientation of these programs, some museums have experienced negative consequences from an imbalance between social interaction and meaningful experience of museum content. But what the DMA and other Magnetic Museums have done well is to design their programs with the visitor experience and community needs foremost, rather than primarily to achieve a financial or attendance goal. The most successful programs reflect the way that Magnetic Museums approach all of their work: They are a holistic mix of "mission, market, and margin," one of the institutional mantras of The Franklin Institute (see Chapter 7). These thoughtfully curated programs are built on a content-laden base and combine mission-related interpretive, educational, and participatory programming in a social context. As one Late Night focus group respondent said, "I like it especially when the events really correlate well with the exhibit because it…opens up that experience…To have everything revolve around [the exhibition]…puts you more in…that line of thinking…so there's a theme and [the programming is] not…random."[20] The resulting flow of increased visitors seems to be a natural outcome of being inclusive and intentional about creating thoughtful, personalized museum experiences.

ENLIST YOUR "PEEPS"

Author Seth Godin writing in his 2008 book, *Tribes: We Need You to Lead Us*, calls "a group of people connected to one another, connected to a leader, and connected to an idea" a "tribe."[21] In keeping with the friendly nature of Magnetic Museums (and we hope of this book), we refer to the individuals and groups who gravitate to and support Magnetic Museums as "peeps"—shorthand for the "people" who are connected to the institution and to each other by a shared belief in its mission and purpose.

Of course, one expects an organization's staff and volunteer board to be among its most bonded "peeps." But Magnetic Museums inspire, engage, and activate much larger communities beyond these internal stakeholders. The Hammer Museum in Los Angeles, which has been transformed from a sleepy university gallery to the "it" organization of Southern California's contemporary art scene, tapped into the local community of artists to broaden its reach, increase its social relevancy, and enhance its programmatic impact. Director Anne Philbin says, "Artists are the best and hippest tastemakers. They are not only great makers of objects and experiences, but they are also terrific problem solvers… If they are doing things that they're interested in, then we know it will catch on with everyone else."[22]

Artists are involved at every level of the museum, from curating exhibitions to giving talks to rethinking the Hammer's online presence. They have been the guiding force behind an ambitious slate of public programs that are offered free of charge to visitors. By appealing to the artistic community, giving them a say in the museum's program, and inviting the community at large to enjoy experiences designed by and for artists, the Hammer has become "the salon of the city," with an engaging array of films, readings by world-renowned writers, conversations about art, politics, and other issues facing contemporary society, that are presented to packed houses.

It is easy to see why artists might naturally gravitate to a contemporary art museum. But by engaging, activating, and enabling this community, the Hammer has turned a disconnected group of individuals into an influential band of advocates. Not only do they meet often at the museum, lending their creative perspective and cachet to its programs, they also take the museum into their communities, spreading awareness and building the Hammer's reach through their personal and professional relationships.

Because artists are true believers in what the museum stands for, they are credible advocates who feel a sense of belonging and help to create that for others. Patrick Hanlon, an award-winning advertising creative director and author of *Primal Branding:*

Create Zealots for Your Brand, Your Company, and Your Future, writes, "Believing is belonging. When you are able to create brands that people believe in, you also create groups of people who feel that they belong."[23] These groups ultimately become communities, he concludes, because "...we all want to belong to something larger than ourselves."[24] Hammer audiences have come to trust that if a program features an unfamiliar speaker, it will likely be thought-provoking and lively. They know that if they attend, other people interested in similar kinds of perspective-broadening conversation are likely to be there. Some of these individuals become active "peeps," readily taking advantage of online tools that the Hammer provides, including Facebook, Twitter, Pinterest, and Flickr, to connect to one another and invite others to join them. (A visit to the Hammer Facebook page reveals that 10,988 fans visited the page on a certain day, 18,917 people "liked" it and 387 were "talking about" the museum's posts.[25]) Many volunteer as "Hammer Ambassadors" who welcome and orient visitors to the museum and special events.[26]

The external stakeholders we interviewed were excited to share stories about their museums. They were proud of their accomplishments and expressed a sense of ownership for aspects of its success. We would say that "enlisting your peeps" makes all the difference.

MOBILIZE STRONG NETWORKS

Widening the circle also means tapping into, contributing to, and mobilizing networks of influence and support. The last decade has witnessed an explosion in the use and applications of technology. Not only has smart technology allowed users to customize and tailor their access to information, experiences and people, it also has enabled them to create and tap into social networks and forge powerful connections among them.

Beth Kanter and Alison Fine introduced the concept of the "networked nonprofit" in their 2010 book by the same name. They describe such organizations as "simple and transparent...easy for outsiders to get in and insiders to get out. They engage people in shaping and sharing their work."[27] The authors further depict networked organizations as ones in which a "network mindset exercises leadership through active participation, openness, decentralized decision-making, and collective action. It means operating with an awareness of the networks the organization is embedded in, and listening to and cultivating these networks to achieve impact. It means sharing by default and communicating through a network model, rather than a broadcast model—finding where the conversations are happening and taking part."[28]

Magnetic Museums connect to a range of networks through social media and other channels. The Children's Museum Pittsburgh, for example, is connected to the active Maker and DIY communities nationwide. The Chrysler has enlisted glass artists who perform at the museum's Glass Studio to create blogs for their followers and link those back to its site. The Franklin Institute is a partner in the IMLS-funded Communities of Learning for Urban Environments and Science, a five-year program that teaches science to families in the Philadelphia-Camden region. It is a collaboration among The Franklin Institute, the New Jersey Academy for Aquatic Sciences, the Philadelphia Zoo, the Academy of Natural Sciences, and 10 community-based organizations, which include churches, schools, cultural heritage organizations, and youth development and community service organizations.

Magnetic Museums also are guided by networked leaders and staffed by networked employees. In a 2007 *Harvard Business Review* article, business school professors Herminia Ibarra and Mark Hunter identified three types of networks that leaders access. There are *operational* networks, comprised largely of individuals internal to the organization, who work together to get things done; *personal* networks, ones that enhance an individual's personal and professional life and development; and *strategic* networks, involving people who are important to the organization or who can be influential on its behalf in setting priorities, meeting challenges, accomplishing tasks, benefiting from collaboration, and securing stakeholder support for critical initiatives.[29]

Every museum director with whom we spoke acknowledged the power of his or her network, especially the deep connections shared with civic and community leaders. For these individuals, networking is not just a means to achieving their own agendas. Instead it serves to nurture close ties with others who share similar values and priorities.

Often networks are the foundation for collective action on a significant issue of community concern. As examined in Chapter 6, Glenn Dobrogosz, executive director of the Natural Science Center of Greensboro, forged relationships with municipal and business leadership, connecting the community's concerns about economic and educational development with the future direction and focus of the organization. Dennis Wint of The Franklin Institute participates in a group called the "Worriers"—a dozen professionals from government, business, education, and nonprofits who meet to discuss the issues relating to the City of Philadelphia, the Commonwealth of Pennsylvania, and a range of other topics of current interest to the group.[30]

And as the case that follows illustrates, the Children's Museum Pittsburgh is so fundamentally rooted in its community network and shared vision for kids that its director,

Jane Werner, can't imagine CMP working in any other way. "I don't think I could have accomplished what we did here in any other city. Pittsburgh is just a city where everyone is connected to everyone else."[31]

For Magnetic Museums, being networked also means developing high-tech tools to complement high-touch relationships. They use technology to push their content out while at the same time attracting input and ideas from ever-expanding audiences. For example, the Chrysler Museum of Art invited members through on online poll to select works from its collection to be replicated in glass-blowing demonstrations by artists taking part in the opening of the Chrysler Glass Studio. About a half-dozen objects were recreated during the celebrations.

Similarly, the Smithsonian American Art Museum used crowd sourcing to select the content for its 2012 exhibition, "The Art of Video Games." Visitors were invited to vote for the 80 most influential games from a pool of 240, and the winners were then featured in the show.[32] As Nina Simon notes in *The Participatory Museum*, contributory projects such as these "are also in many cases the only type of participatory experience in which visitors can seamlessly move from functioning as participants to audience and back again. Visitors can…immediately experience the excitement of seeing how they have contributed to the institution."[33]

INVITE THE OUTSIDE IN

Experience in new product innovation shows that considering alternative points of view and using cross-disciplinary approaches can lead to more and better ideas.[34] Involving outside stakeholders to help envision or achieve goals also can create a heightened sense of investment and ownership among participants. Both of these outcomes contribute to enhanced creativity and stronger organizational relationships.

The Chrysler Museum of Art serves a community which is home to more than 100,000 military families.[35] When the museum began to develop an exhibition featuring portraits of veterans affected by post-traumatic stress disorder, the curatorial team invited members of the armed services and mental health communities to advise them on interpretation.[36] Although the community advisors initially expressed some concerns about the exhibition, the open and inclusive process helped the museum to develop creative and sensitive approaches to address this burgeoning health issue. As a result of the dialogue and new relationships that developed between the Chrysler and the military community, the museum advanced its goals of creating a meaningful exhibition experience and connecting with a previously underserved segment of its community.

The Museum of Science and Industry in Chicago (MSI) undertook an experimental approach to institutional planning as it neared its 75th anniversary.[37] Faced with aging infrastructure and outdated exhibits, the museum had insufficiently cultivated relationships with key stakeholders to generate the creative energy and donor excitement needed to fuel a major facilities overhaul.

Rather than turn inward during its planning process, MSI threw its deliberations open and invited a range of external stakeholders—scientific content experts, educators, philanthropists, civic leaders, even an astronaut and an explorer—to serve alongside staff as active members of planning task forces. The decision to bring in these "peeps," according to President and CEO David Mosena, was in part because "we were inundated with stories about scientists and doctors ... who were inspired by our museum or others like it [to pursue their careers.]" Over a period of 18 months, the groups met, developed, discarded, and refined ideas for ways the museum could achieve its vision.

As the task force members became more engaged in the planning, they also became more invested in its outcomes. Soon they formed the backbone of a $200 million capital campaign to transform the institution. By 2011, the MSI had achieved its objectives and engaged more than 5,000 donors, closing the campaign $8 million over goal, despite the economic downturn. Shannon Alexander, then vice president of development, indicated that stakeholder engagement has become part of MSI's business model. "This integrated approach to stakeholder engagement—bonding them to us and to each other and building bridges through them to new people—is now part of who we are," said Alexander. "By opening ourselves up and bringing new people in, we achieved a whole new level of creativity, as well as national and community ownership."

If we accept what the primate and human research tells us as applicable to museums, then an important key to programmatic and operational health is to engage with a broadened social network. As the following story of the Children's Museum Pittsburgh illustrates, widening its circle of influence and enlisting the help of like-minded people has helped this organization to weave a strong and resilient community fabric in support of children, youth, and neighborhood life.

*Visitors "Play With Real Stuff" in a woodworking workshop
in MAKESHOP at Children's Museum Pittsburgh.*
Photo: Larry Rippel for Children's Museum Pittsburgh

case study

CHILDREN'S MUSEUM PITTSBURGH

THE POWER OF 'YES'

The glass front of the Children's Museum Pittsburgh (CMP) looks out onto a newly opened park with more than 100 native oak, red maple, and river birch trees. The windows create a sense of welcome and permeability between inside and outside, as does the museum's signage, which emphasizes the friendly "hi" sitting squarely in the middle of the word "children."

Since 2000, CMP has quadrupled in size, increased its visitation by nearly 280 percent, and grown its budget from $2 million to more than $5 million.[1] As enviable as this growth may be, especially in the middle of a worldwide economic meltdown second only to the Great Depression, it is only part of the story. More impressive is how what was once a tiny museum for children in a formerly decaying urban neighborhood has become a nationally recognized model for engaging children and adults in innovative play-based learning experiences. It also has become the centerpiece for a revitalized neighborhood and a catalyst for creative public-private partnerships that have generated nearly $10 million in funding for redevelopment projects, over and above the $29 million raised for its own expansion.

Ask museum Director Jane Werner how this came about and her response is deceptively simple. Success, she says, is found in the word "yes" and in the notion that people learn best when they "Play With Real Stuff." Listen to the voices of the museum's most important patrons echoing around its open, light-filled spaces and the word's impressive power can be heard playing out in myriad ways:

"Is it okay if I get wet?" "Yes."

"Can my grandma make something too?" "Yes."

"Are these a real hammer and nails?" "Yes, they are!"

Ask the museum's staff, board, partners, or funders to describe the museum's transformation, and they, too, point to its "bias towards yes," and its eagerness to invite others in and extend itself out as collaborators, advisors, and co-creators. Ironically, one of the museum's key turning points was a very carefully considered decision to say "no" to the opportunity to move the museum away from its challenging North Side location, an area marooned by a failed 1960s urban renewal project and the continuing impact of a declining economy. To understand the significance of that decision, some historical context is needed.

Located in the city's North Side neighborhood, Children's Museum Pittsburgh was founded in 1983. For its first 21 years, the museum was housed in a 20,000-square-foot space inside a grand Italianate building that had once been a post office on Allegheny Diamond, where philanthropist Andrew Carnegie also chose to commission the first free Carnegie public library. Joining the post office and library on the city square was Allegheny City Hall, which later became the Buhl Planetarium, a park, and a public market—all of which combined to make a vibrant city center. However, 1960s-era "urban renewal" efforts, which included the introduction of highways and the removal of historic urban street grid patterns, decimated the area and served to disconnect it from the rest of the city. By the mid-1990s, the economic situation and educational achievement statistics for Pittsburgh and the North Side, in particular, were grim. An estimated 35 percent of all Pittsburgh high school students were dropping out before graduation and only 59 percent of African-American students were graduating after five years.[2]

During this same time period, Pittsburgh was reinventing itself as a leader in technology, education, and medicine, seeking to ameliorate negative perceptions of the city and generate greater prosperity for its residents. And interestingly enough, it was the museum's decision to confront and engage with those very same challenges that changed the course for both the museum and the neighborhood.

After joining the organization in 1991 as the director of exhibits and programs, Werner mounted an exhibition that was focused on the powerful potential of communities, neighborhoods, and relationships. An art major who had previously been assistant director of exhibits at The Franklin Institute in

Philadelphia, Werner conceived the exhibition in reference to Pittsburgh native Fred Rogers's iconic children's television program, *Mister Rogers' Neighborhood*. The exhibition was a resounding success and brought in 86,000 visitors in six months, far outpacing any other show or period in the museum's history.

While the success was welcomed, it did reveal a critical need for increased space and organizational capacity to meet the growing demand for more high quality educational experiences. A few board members urged Werner, who had been appointed director in 1999, to consider leaving the North Side location for a safer and more thriving area. Werner and some of the trustees, however, were committed to serving the children and families on the North Side and in the region. As Werner recalled, making the decision to continue the museum's commitment to the neighborhood was straightforward and simple: "If we don't stay [here], who will?"

Seeking the first of many creative collaborators to help re-envision the museum and revitalize the North Side, Werner secured support from the National Endowment for the Arts for a national architectural competition to frame the museum's expansion. CMP selected Koning Eizenberg Architecture, whose plan stressed adaptive reuse of the existing post office and the planetarium through modern design and sustainable building principles. The museum then embarked on an inclusive process that engaged community stakeholders, funders, plus board and staff in a series of collaborative design charettes. Pittsburgh City Council President Darlene Harris, who grew up in the North Side and was involved in the design process, said, "The Children's Museum reached out, invited in, and listened to the community. They understood and respected historic values that the community cherishes, and they built community strength."

What emerged from the effort was a dramatic vision to transform the historic center of Allegheny into a "campus for children and families." As the cornerstone for this project, CMP became the catalyst bringing together a range of youth-serving and educational organizations and resources. The museum, the architects, and the community envisioned an expanded facility that would repurpose and connect the historic post office with the unused Buhl Planetarium lying dormant next door.

With the goals of forging cross-disciplinary relationships, incubating and testing new ideas, and facilitating collaboration, CMP imagined a multi-use

space in which child-centered organizations could be co-located within the museum. Engaging key stakeholders in the creative process and gaining outside perspective from the outset helped CMP to raise $29 million in five years. (This was an exponential increase over modest prior capital fundraising efforts, which had required less than one million dollars.) The expanded museum opened in November 2004, on time, under budget, and with $6 million in hand for an endowment, which currently generates income for an annual operating reserve.

Speaking to the power of a relevant and community-informed vision, Janet Sarbaugh, senior programs director of the Heinz Endowments, said, "Ultimately, everyone who invested in this museum was investing in the vision [s/he] had for the children and families of Pittsburgh and for the North Side."

Today, five partner nonprofits are housed at the museum, including Child Watch, a child advocacy group; Reading is Fundamental Pittsburgh; Saturday Light Brigade, a family radio production company that uses the tools of radio and audio production to help youth sharpen their skills in self expression and literacy; an office for graduate students in the University of Pittsburgh Center for Learning in Out of School Environments; and two Pittsburgh Public Schools pre-K/Head Start classrooms. Each organization pays CMP rent at below-market rates and serves, studies, or otherwise interacts with many of the museum's 250,000 annual visitors or with children and families from the surrounding area.

Larry Berger, co-founder of Saturday Light Brigade (SLB), and one the museum's original tenants, said his organization's partnership with CMP has been a "win-win" that started with Werner inviting SLB in, and saying "yes" to the idea of a long-term collaboration.

"My wife and I were producing the [SLB] show out of a local public radio station on a budget of about $7,500, when we were recognized with a national award for excellence. We saw the opportunity to expand our reach, but needed to grow our financial base in order to do that." Berger approached Werner about a possible sponsorship and proposed creating a children's radio experience at the museum. Seizing on an opportunity to collaborate, Werner instead offered SLB space to create a studio in exchange for contributing program content, audio-visual services, and broadcast media exposure for the museum. The partnership was cemented within 12 months and the Saturday Light Brigade

has since grown to a 13-person organization with a $400,000 annual budget.

Berger characterized CMP as providing an important venue for families with children that goes well beyond being a museum, a place to learn, and have fun. "Whether it's the 'Kindergarten Here I Come' fair, [with CMP hosting an information and familiarization day bringing together dozens of school-related organizations, parents, and rising kindergarteners], the Head Start classrooms housed here, or the University of Pittsburgh students conducting child development studies on the floor, the museum is the place that brings the community together with the…youth serving nonprofits."

CMP also has attracted a diverse group of staff, volunteers, and partners—including artists, engineers, industrial designers, technologists, educators, and cognitive development specialists—from some of Pittsburgh's leading universities and corporations. Accomplished in their professional fields, this group is drawn to CMP by its commitment to audience-responsive, design-centered thinking, and an ethos of respect for craft, creativity, and collaboration.

Children's Museum Pittsburgh became the catalyst bringing together a range of youth-serving and educational organizations to create a "campus for children and families."

Exhibits Design Manager Lisa Carvajal, whose background is in product design, said, "I took a salary cut to come work at the Children's Museum because I was inspired by the quality of the work … and by being able to focus on the individual user experience rather than mass production."

The staff exhibits a palpable sense of wonder, playfulness, intellectual curiosity, and personal engagement. This positive culture emanates from their passionate belief in the museum's mission and their respect for the children they serve. Deputy Director Chris Siefert described the staff as being like a world-class soccer team. "We have a lot of skilled individuals playing together as a collective with a common purpose in mind." That purpose? To see children learn and succeed.

In keeping with its "Play With Real Stuff" program philosophy, collaboratively developing ideas and exhibitions and creative tinkering are a way of life for the museum's staff. They described their workplace in terms that are generally reserved for the most innovative corporations. Staff talked about cross–disciplinary teams "figuring things out," "prototyping and inventing on

Top: Allegheny Public Square, before and after revitalization efforts by Children's Museum Pittsburgh.

Below: Buhl Community Park at Allegheny Square, designed by Andrea Cochran Landscape Architecture, with Cloud Arbor by Ned Kahn.

Photos: Chris Seifert courtesy of Children's Museum Pittsburgh

the floor," "watching and listening to visitors play" to understand their needs, and being "comfortable" with failure as part of the discovery process. They were describing a high performing, learning organization with the ability to innovate consistently over time.

Christian Tsu-Ruan, a teaching artist in the Museum's MAKESHOP™ experience, explained, "Because of the emphasis on real design process, real teaching, and real experiences, working at the Children's Museum can be a real career builder, so we get a higher level of education and competence in our floor staff than you might expect." Education Program Manager Angela Seals

concurred. "I was really intrigued by this community of people who weren't just settling for being here just for children, but saw that as just the beginning of being here for people—people of all ages." Jen Roach, admissions and membership manager, spoke for many when she said, "This place sucks you in with the creative environment and the fact that every day there is something new to learn."

Not only has CMP enhanced its own organizational capacity and audience impact by drawing on diverse talents and perspectives in the past dozen years, it also has contributed in significant ways to the redevelopment of the North Side. In 2004, CMP joined with the Andy Warhol Museum, the North Side Leadership Conference, and the City of Pittsburgh to raise more than $2.6 million to renovate the original turn-of-the-century Carnegie Music Hall and reopen it as the New Hazlett Theater. This independent, self-sustaining nonprofit now offers a diverse program of theater, dance, and music for audiences of all ages.

Moving further outside the boundaries of the Allegheny Diamond, the museum initiated a dialogue in 2006 with North Side civic and cultural leaders to identify key issues facing the community and explore ways they might work together to address pressing needs. The group forged a robust network of cultural, educational, and recreational assets, which they called the "Charm Bracelet Project." Each participating organization (called "Charms") has joined CMP in extending its cultural mission into the community.

The Charm Bracelet Project focuses on public programs and cultural initiatives, educational and youth programming, improving neighborhood mobility and cohesion, and environmental sustainability. Through an evolving series of joint projects—Poetry on North Side Streets; Charm School Dinners; a public art gallery, which repurposed a neglected underpass; a fresh food market; and a Peace Garden—the Charm Bracelet Project has taken culture to the streets. It has markedly improved the quality of life in the North Side, creating a safer place for kids to grow up and strengthening the social fabric of the neighborhood.

"The beauty of the Charm Bracelet Project is the variety of perspectives, skills, and experiences that mix and match to create fresh approaches to community development," said Alida Baker, director of the Allegheny Commons Initiative. "Outdoor enthusiasts plus historic preservationists;

theater majors plus arts educators; artists plus merchants—the combinations are many, and result not only in worthwhile community projects, but authentic relationships and greater organizational capacity, as well."[3]

In 2012, Children's Museum Pittsburgh joined with city officials, community development representatives, artists, and landscape architects to realize the dream of redeveloping the neglected city park that sits immediately outside the museum's front door. The park design, chosen through a national competition and refined with input from more than 25 community meetings, includes native plants, environmentally sensitive lighting, and a contemporary water sculpture designed by MacArthur Fellow artist Ned Kahn.

While some funders might see Children's Museum Pittsburgh's community-based efforts as "mission creep," leaders of Pittsburgh foundations view it another way. Fred Thieman, president of the Buhl Foundation, said, "The museum has a pretty unique dual mission: on the one hand, it has a core museum education mission, but on the other, it has a commitment to the community and being a hub for the kids. I think the question here is, 'Why do all this stuff?' The answer is, 'Because everything feeds back into making this a better museum.'" By finding the intersection between the museum's mission and the city's needs to invest in educational achievement and neighborhood redevelopment, and inviting others to collaborate and contribute to accomplishing those goals, CMP has built social capital by linking stakeholders more closely to the institution and by building bridges between formerly disconnected people, organizations, and communities.[4]

Thieman traced the arc of CMP's trajectory as a result of its civic collaborations: "First, the Children's Museum was a key partner in the community, then it became a necessary partner, and now it's the 'go-to' partner. They influence at least 20 to 30 percent of [Buhl Foundation] grant making decisions…CMP's participation in partnership with other groups will enhance our desire to fund those other organizations or joint projects."

Gregg Behr, director of the Grable Foundation and principal funder of Pittsburgh's Kids and Creativity initiative agreed. "The museum has proven itself to be a good steward of the funding it receives. More importantly, [its] staff and leadership are present in the community and this communicates a community consciousness and dedication to a mission that extends far beyond their parochial concerns as a museum. It also starts a 'virtuous cycle' of people

from all quarters of the city telling the positive story of the museum and its value."

Inevitably, the question turns to the importance of Jane Werner's leadership style. She is an artist for whom creative thinking, open mindedness, and the inclination to explore multiple perspectives come naturally. Saleem Ghubril, president of The Pittsburgh Promise, who values Werner as both friend and professional colleague, commented that her leadership is much more than her management approach. "Jane is an advocate for all that is right, good, and beautiful in the world. She is a woman of conviction, who follows those convictions with grace and action."

The museum is guided by 14 thoughtfully worded strategic principles, one of which seems to characterize Werner's leadership style: "Hard Head, Soft Heart: We will make tough-minded business decisions, but with great sensitivity to their effect on people."

Staffer Jen Roach recalled a story about the organization's response to the recession. "Jane called this meeting and said we need everyone's ideas to pull everything down on expenses as tight as possible. Every idea is on the table. It was big stuff and little stuff like putting the daily schedule on half-sheets of paper and signs reminding people to turn out the restroom lights … Although Jane called the meeting, it wasn't about her telling us what to do … it was [about her asking] and we knew that we all could make a difference. It was a bottom-up effort. At the end of the year, we celebrated how much we'd saved and we finished in the black. What was important was that we were invited in to be scrappy and part of making it work." Roach's colleagues agreed that bringing together the staff in an important and empowering way was a pivotal moment, which resulted in even greater feelings of pride of association, ownership, and loyalty.

Staff, board, collaborators, and funders also noted that Werner invests heavily in relationships and has built tremendous reserves of trust over the years. Larry Berger said, "Jane has helped the Museum earn its reputation … by consistently delivering for almost 20 years. If you are going to work on a basis of relationships and depth, rather than charisma and flash … you have to be in it for the long run and be about putting down the roots."

Werner also has engaged the staff, board, and the museum's community partners and funders with a compelling vision for Pittsburgh's children and

families. Kim Bracken, who leads the Museum's garden and environmental education initiatives, summed it up in saying, "The mission anchors and grounds us, especially when there are so many ideas and opportunities we could be chasing. The mission also empowers us because I can really see how my garden project contributes to furthering our work of inspiring joy, creativity, and curiosity."

When asked what makes Children's Museum Pittsburgh magnetic, Roach perhaps said it best. "Jane is magnetic, but the rest of us are, too, because of how we are invited in. The audiences who come love it and the artists who come here to work with us and the community organizations we partner with love it, too, because we invite them in to be part of the process. [CMP] is not a huge ship that we all get to ride on. It needs us. We are all part of the crew."

SIX MAGNETIC TIPS
FOR WIDENING THE CIRCLE

1. Activate your inner circle and motivate those most committed to your museum to leverage their networks on your behalf.

2. Be generous to a fault, open and easy to work with, and above all, non-bureaucratic. Give more credit than you take.

3. Seek strategic partnerships and collaborations built around shared values and vision in order to extend your museum's reach and audience impact.

4. Invest in building and engaging real and virtual communities. Be a catalyst and a forum for community conversation. Use technology to enable broader participation.

5. Enlist the right people, as they can measurably change the trajectory of your museum.

6. Seek inspiration and ideas outside your walls. Regularly consult with and involve "non-museum" people with different knowledge, interests, and perspectives.

Chapter 5 Notes

1. Robert D. Putnam, *Bowling Alone: The Collapse and Revival of American Community* (New York: Simon & Schuster, 2000).

2. Bowling Alone.com, *Bowling Alone,* http://bowlingalone.com (accessed 1 Jan. 2013).

3. Robert Putnam, "Bowling Alone: America's Declining Social Capital." *Journal of Democracy* (1995), 67.

4. *Ibid.*

5. Putnam, 2000, *op. cit.,* 20.

6. Stuart Elliott, "Making Social Connections and Selling Cookies," *The New York Times,* 21 Nov 2007, http://www.nytimes.com/2007/11/21/business/media/21adco.html?_r=1& (accessed 1 Jan. 2013).

7. *Ibid.*

8. Jerome Sallet, et al, "Social Network Size Affects Neural Circuits in Macaques," *Science,* 4 Nov. 2011.

9. Juilianne Holt-Lunstad, Timothy B. Smith and J. Bradley Layton, "Social Relationships and Mortality Risk: A Meta-analytic Review," *PLOS,* 27 Jul 2010, http://www.plosmedicine.org/article/info%3Adoi%2F10.1371%2Fjournal.pmed.1000316#top, (accessed 3 Jan. 2013).

10. Malcolm Gladwell, *The Tipping Point* (Boston: Little, Brown and Company, 2000), 41.

11. Anne Bergeron, Beth Tuttle and Jennifer Wells Green, "Secrets of the Magnetic Museum: Turning Moments of Success into Momentum," American Association of Museums Annual Meeting, Los Angeles, CA, 23 May 2010.

12. Bonnie Pitman and Ellen Hirzy, *Ignite the Power of Art: Advancing Visitor Engagement in Museums* (New Haven: Yale University Press, 2011).

13. Dallas Museum of Art. *Dallas Museum of Art's Late Night Program Celebrates Eight Years of Friday Nightlife in Dallas with Its New YouTube Video,* 17 Mar 2011, http://www.prweb.com/releases/dallas-museum-of-art/late-night-anniversary/prweb8215046.htm (accessed 4 Jan. 2013).

14. Bergeron, et al, *op. cit.*

15. Dallas Museum of Art. *Late Night Evaluation,* 6 Jul. 2011.

16. *Ibid.*

17. *Ibid.*

18. *Ibid.*

19. DMA.org, *Dallas Museum of Art to Offer Free Membership and a Return to Free General Admission Starting January 2013,* http://www.dma.org/PressRoom/dma_506718 (accessed 13 Jan. 2013).

20. Dallas Museum of Art, *op. cit.*

21. Seth Godin, *Tribes: We Need You to Lead Us* (New York: Penguin Group, 2008), 1.

22. Bergeron, *et al, op. cit.*

23. Patrick Hanlon, *Primal Branding: Create Zealots for Your Brand, Your Company, and Your Future* (New York: Free Press, 2006), 7.

24. *Ibid.*

25. Hammer Museum website, "Get Involved," http://hammer.ucla.edu/get_involved/index.html (accessed 3 Jan. 2013).

26. Facebook.com/Hammer Museum, https://www.facebook.com/HammerMuseum (accessed10 Jan. 2013).

27. Beth Kanter and Allison H. Fine, *The Networked Nonprofit: Connecting with Social Media to Drive Change* (San Francisco: Jossey-Bass, 2010), 3.

28. Beth Kanter, "Becoming a Networked Nonprofit," *Stanford Social Innovation Review*, 30 Aug. 2012, http://www.ssireview.org/blog/entry/becoming_a_networked_nonprofit (accessed 12 Jan.2013).

29. Herminia Ibarra and Mark Hunter, "How Leaders Create and Use Networks," *Harvard Business Review*, Jan. 2007 http://hbr.org/2007/01/how-leaders-create-and-use-networks/ar/1 (accessed 12 Jan. 2013).

30. Author correspondence with Dennis Wint, The Franklin Institute, 11 Jan. 2013.

31. Author interview with Jane Werner, Children's Museum Pittsburgh, 23 Jul. 2012.

32. Smithsonian American Art Museum website, *The Art of Video Games*, http://americanart.si.edu/exhibitions/archive/2012/games/winninggames/ (accessed 2 Jan. 2013).

33. Nina Simon, *The Participatory Museum* (Santa Cruz, CA: Museum 2.0, 2010), http://www.participatorymuseum.org/chapter6/ (accessed 10 Jan. 2013).

34. Abbie Griffin, "PDMA Research on New Product Development Practices: Updating Trends and Benchmarking Best Practices," *Journal of Product Innovation Management*, Vol. 14, Issue 6 (November 1997), 429-458, http://onlinelibrary.wiley.com/doi/10.1111/1540-5885.1460429/abstract (accessed 10 Jan. 2013).

35. *Norfolk City Quick Facts from the US Census Bureau.* 2010. <http://quickfacts.census.gov/qfd/states/51/51710.html> (3 Jan. 2013).

36. Author interview with Chrysler Museum of Art staff, 21 Jun. 2012.

37. Bergeron, *et al, op cit.*

Chapter 5 Case Study Notes

1. The information and quotations presented in this case study are taken directly from author interviews with Children's Museum Pittsburgh staff, trustees and stakeholders, or from internal or publicly accessible organizational data.

2. John Engberg and Brian Gill, *Estimating Graduation and Dropout Rates with Longitudinal Data: A Case Study in the Pittsburgh Public Schools* (Pittsburgh, PA: RAND Education, Jul. 2006), http://www.rand.org/content/dam/rand/pubs/working_papers/2006/RAND_WR372.pdf (accessed 11 Nov. 2013).

3. Quote used with permission, from a conversation between Jane Werner, executive director, Children's Museum Pittsburgh and Alida Baker, director, Allegheny Commons Initiative.

4. Robert Putnam defines social capital as "features of social organization, such as networks, norms and social trust that facilitate coordination and cooperation for mutual benefit." From Robert Putnam, "Bowling Alone: America's Declining Social Capital," *Journal of Democracy* (1995), 67.

Pairing education and entertainment, keeper talks are
offered daily and are a hit with visitors of all ages.
© 2012 Natural Science Center of Greensboro

chapter 6

Become Essential

Natural Science Center of Greensboro

Turn Outward / Make Mission Matter / Meet Real Needs / Create Win-Wins

Richard Harwood, founder of the Harwood Institute for Public Innovation, is a noted authority on improving public life. A proponent of intentional individual and collective action rooted in community, he has been working for the past 25 years to spur innovation in politics and the social sector.[1] He offers a response to the concerns raised by political scientist Robert Putnam that we noted in Chapter 5 about the growing disinclination of Americans towards civic participation over the past decade. In a presentation entitled "From Nice to Necessary: How You Can Turn Outward and Make Hope Real," given as part of the Craigslist Foundation 2009 Bootcamp for aspiring nonprofit professionals, Harwood revealed the philosophy that is at the heart of his work to transform the public sphere.

"People are yearning to re-engage and reconnect with one another, to be a part of something larger than themselves...to make a difference in their communities and their world."[2]

Harwood insists, then, that we need to reorient ourselves. "Instead of turning inward," he told the audience, "we must turn ourselves and our minds, physically and [emotionally], towards our communities. We must literally change the direction we are facing. Instead of looking at ourselves in the mirror, we must look outward to our community." He justifies his viewpoint very simply: "To improve public life, we must see ourselves in relationship to public life."[3]

TURN OUTWARD

Our research revealed that magnetic organizations understand this core philosophy articulated by Harwood and consistently practice "turning outward," much like Buddhist monks practice mindfulness. Magnetic organizations recognize that if they expect to

increase their relevance and impact, they must be in touch with the needs and concerns of their communities, remain in an ongoing dialogue, and actively pursue meaningful relationships with their publics.

The notion of turning outward to become essential to its community is something that the St. Louis Public Library took seriously more than 15 years ago when it adopted a proactive, "tuned in" customer service stance. Focusing on what library users were experiencing in their own lives—namely, the economic downturn of the 1990s that destabilized many middle class families—the library shifted from being a place primarily for education and entertainment to one providing self-improvement, work, and survival resources.

According to Glen Holt, former executive director of the St. Louis Public Library from 1987 to 2004, the library became "an independent learning center, [a] preschoolers' door to learning, [a] community information center, [a] business and personal reference library, and [a] public work space,"[4] all in response to the growing needs of the community it served. This compelled the Library to anticipate rather than simply react to trends. And as the Library became more vital to the city, it received more resources from the very people it supported. Over the course of six years, voters approved increases in annual taxpayer support by a whopping 162 percent.[5]

The museums in our study experienced a similar dynamic when they adopted a stronger civic focus that aligned with wider community needs. As they came to be regarded as indispensable partners contributing added public value as more than museums, they also received dramatically increased financial support from both the public and private sectors.

MAKE MISSION MATTER

Based on his library experience, Holt advocates for "activist missions" that communicate an organization's fundamental, not peripheral, value that is of significance to the community. He identifies "defining core values and an essential mission"[6]—the organizational raison d'être and guiding principles that are embraced institution-wide—as the starting point for developing a community focus.

The statement of vision for the Children's Museum Pittsburgh, for example, expresses both the intrinsic and the "activist" roles that the museum has embraced: "We provide the highest quality exhibits and programs for learning and play. We are a partner and a resource for people who work with or on behalf of children."[7] Similarly, the Philbrook's

mission comprises a dual cultural and social agenda. "Philbrook strives to be an essential and exceptional participant in the cultural, educational, and economic life of a growing and diverse constituency. Defined by a unique combination of tradition and innovation, our collections, historic structures, programs, and exhibitions are dedicated to inspiring the broadest possible public engagement, access, and service."[8]

In 2010, the Fine Arts Fund of Cincinnati (now ArtsWave) issued a report entitled "The Arts Ripple Effect: A Research Strategy to Build Shared Responsibility for the Arts." This research initiative examined the public resonance of a number of communications and messaging strategies designed to engender "broadly shared public responsibility for the arts and culture in the region."[9] One of the findings in the report reveals that while people may "like" an emotionally appealing message about the arts, such as "art is a transcendent experience," these messages "do not help [people] think of art as a public good."[10] The report concludes that in order to position the arts as a public good, the sector must change four key public perceptions: 1. "The arts are a private matter... about individual tastes, experiences, and enrichment" 2. "The arts are a good to be purchased ... [and thus may] succeed or fail... in the marketplace" 3. "People expect to be passive [consumers], not active [participants]" and 4. *"The arts are a low priority."* (Emphasis added.)[11]

While "The Arts Ripple Effect" research is specific to art organizations and the perceptions of Cincinnati respondents, the findings raise pertinent questions for others to explore. Our interviews indicated a different public perception of Magnetic Museums. These institutions are increasingly viewed as community assets, which are contributing public value. Their expanding bases of public and private support and the depth of loyalty these museums engender indicates that they are moving up on the priority list.

MEET REAL NEEDS

In 2002, the American Association of Museums (AAM) published a report called *Mastering Civic Engagement* that summarized its four-year Museums & Community Initiative.[12] The report called on museums to better serve their communities and make their intellectual and physical assets more readily accessible to the public. *Mastering Civic Engagement* focused on the possibilities that might arise for museums if the field actively began to engage with community in a more responsive conversation.

Robert R. Archibald's introduction to the 2002 report quotes Rick West, founding director of the Smithsonian's National Museum of the American Indian and then-chair of AAM. "Museums have long pursued outreach as a means of reaching new audiences. But

now is the time for museums to consider *inreach*. How will museums adopt processes that encourage communities to reach into museums and significantly influence agendas?"[13]

Archibald's moment of insight comes in his realization that "the ability of museums to expand community service depends upon the creation of new and really collaborative relationships, where we do not presume to know what audiences need. In these new relationships, we will regard ourselves as reservoirs of information and expertise, and will relinquish our traditional authoritarian roles in favor of new responsibilities as both resources and facilitators of dialogue about those things that matter most to people."[14]

The *On Innovation* web portal of The Henry Ford museum features interviews with creative thinkers, designers, and change agents.[15] An interview with Dean Kamen, best known as the inventor of the Segway (those battery-powered, self-balancing vehicles often ridden by policemen or urban park rangers) illustrates the importance of being open to inspiration from outside one's own experience. Kamen recounts talking with his brother, a pediatric hematologist and oncologist, about the difficulty he was having treating premature infants born with leukemia. The only needles available were designed for adults. The inventor was moved to create a micro-delivery system for chemotherapy. Although the market for the product was small, the need was great.

As his brother began using the new needles with his patients, another doctor took note. Kamen recalls their conversation. "That's such a tiny little thing," the doctor said to him. "You could put it in your pocket if you're a full-sized adult and walk around getting a drug instead of lying in bed. I've got patients that need drugs around the clock … maybe for the rest of their lives. They're called diabetics."[16] The result was the AutoSyringe insulin pump, which has changed the lives of millions. In this case, meeting a great need created a vast market.

"Listen" is the first lesson drawn from Kamen's story. A second lesson is "meet real needs," one of the keys to successful innovation that The Henry Ford has identified through its interviews. These are two simple insights that can make a world of difference. Magnetic organizations listen to their communities in order to learn where their aspirations and needs lie. Then they focus on the points of intersection where the organization's mission or vision comes into logical contact with the larger world around it. Finding this point of intersection was often a pivotal moment for these Magnetic Museums, changing their trajectories.

As you will read in the following case, the Natural Science Center of Greensboro's pivot point occurred when it joined forces with an economic development coalition seeking to revitalize a city whose economic infrastructure was badly undermined by the re-

cession. The museum took part in hundreds of community conversations to inform and develop a strategic plan consistent with the city's vision for the future.

In another part of the country, Conner Prairie Interactive History Park is partnering with the Science Museum of Minnesota to develop new approaches to integrating science, technology, engineering, and mathematics (STEM) with history learning in museums.[17] This might seem like a surprising turn for an organization focused on Indiana history, but with pharmaceutical pioneer Eli Lilly as its founder, a science emphasis aligns with the museum's heritage. The program has secured $2.3 million from the National Science Foundation because it addresses the growing national and regional need for STEM-based educational training.

When a museum's course intersects with the public's agenda, their paths become one. This is part of the journey, as Harwood says, from "nice to necessary."

CREATE WIN-WINS

By looking for opportunities to serve both cultural and civic agendas, Magnetic Museums deliver positive results for their communities and become trusted partners in the social sector. The Children's Museum Pittsburgh (CMP), for example, whose story appears in Chapter 5, has earned a reputation for adaptive reuse and rehabilitation projects following its successful renovation of several historic buildings located around Allegheny Diamond on the old central square of Pittsburgh's North Side.

In 2013, CMP entered into an agreement with the city for yet another civic redevelopment project. CMP plans to renovate the vacant historic Carnegie Library to house the HUB, a new site for innovative, educational programs, such as its MAKESHOP+, an out-of-school experiential learning space for middle-school students ages 10 to 13. CMP Director Jane Werner related that, after successfully partnering with the city on a number of other projects, "[city leaders] just seemed to assume that we would eventually want to do something with the building [and] they were… waiting for us to be ready."[18] Not only will this project reinvigorate a previously ignored and deteriorating public facility in order to provide enhanced learning opportunities for children, it also will help CMP to attract and serve teen audiences. This is a three-way win, benefitting the city, the neighborhood and its students, and the museum.

Something similar happened in 1999 when the city of Boston awarded the Institute of Contemporary Art a parcel of land on the then undeveloped south waterfront to be the site of its new home.[19] It was a bold decision even for the edgy museum known for push-

ing boundaries—to move from its quaint but confined quarters in a 19th-century former police station on tony Newbury Street to a gravity-defying space designed by Diller Scofidio + Renfro that hovers over the water's edge in what was then a forlorn part of the city. The ICA's presence has since been the catalyst for community revitalization along the former working docks. Abandoned warehouse buildings have been repurposed as residential condominiums, new mixed-use buildings have sprung up all along the waterfront, and restaurants, cafés, and retail stores have joined the museum in reanimating what had been a derelict and unsafe area. By remaining true to its core principals of experimentation and thinking far "outside the box," and linking its aspirations to those of the city, the ICA has contributed significant economic value to the city. It also has become a hub for South Boston, a magnet for contemporary culture, and a leading venue for contemporary art recognized across the country and around the world.

case study

NATURAL SCIENCE CENTER OF GREENSBORO

TURNING OUTWARD TO MEET CIVIC NEEDS

Finishing touches are being made to the newly renovated Adventure Theater II at the Natural Science Center (NSC) of Greensboro, N.C. Although not yet open to visitors, two staff members and a guest are watching a run-through of *Kats: The Meerkat Musical* slated for debut in a few weeks. The staff has been working overtime to redesign a small in-house theater to resemble a "magical courtyard" in the Kalahari Desert of southern Africa, home to a colony of meerkats (small mammals from the mongoose family) like the ones housed at the NSC's Animal Discovery Center.

While the eight digital projection screens that circle the room cast images of the playful meerkats in their habitat, Curator of Public Programs Ron Settle, the musical's playwright, lyricist, and creative director, adjusts the volume on the sound system. The catchy, tuneful chorus of the theme song recorded by sweet-voiced local singers fills the space. The song—which also could be the theme song for NSC—emphasizes the importance of teamwork and community to the meerkats, who depend on each other for survival.

It takes a whole mob of Meerkats
To raise a little pup –
A gang of many Mongooses
To make sure each of us grows up.
It takes a whole mob of Meerkats
To help us hear the call
Of the song inside each one of us –
It is the heartbeat of us all.

Excerpted from "More than Merely One Kat," from *Kats: The Meerkat Musical*, © Ron Settle, 2012

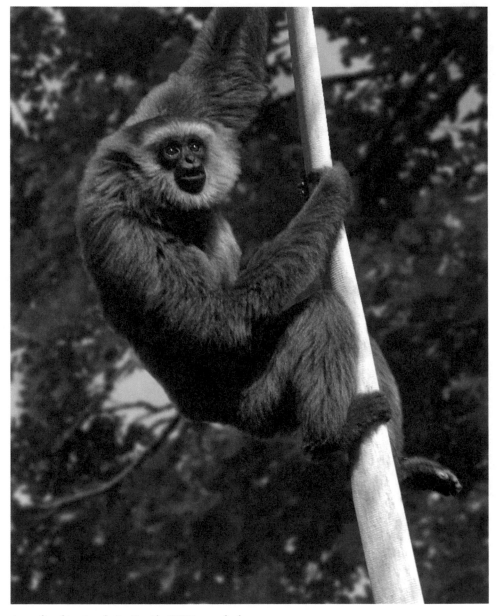

*As a cultural tourism destination, the NSC is one of only
two zoological parks in the U.S. to house Javan gibbons,
one of the rarest primate species in the world.*
© 2012 Natural Science Center of Greensboro

When the show opens to the public, it will feature live interaction by Settle sharing these values and engaging in dialogue with the children and families who come to visit. It is just this kind of educational, entertaining, and audience-pleasing program that has transformed the Natural Science Center, in the estimation of trustee Eric Calhoun, "from a beloved institution to a vital institution…that is now the heartbeat of this town."[1]

Greensboro is the third largest city in North Carolina. To many outsiders, it is synonymous with verdant rolling hills nestled midway between the Atlantic Ocean and Outer Banks to the east and the Blue Ridge and Great Smoky Mountains to the west. History buffs notwithstanding, the city may be less well known as the site of the historic battle at Guilford Courthouse that turned the tide of the Revolutionary War and led to the defeat of the British Army in 1781. In fact, Greensboro is named for Nathanael Greene, the general who heroically led the early American patriots to victory.

Today, Greensboro is in the process of redefining itself and its economy following years of economic hardship that began with the 1980s downsizing and exodus of its textile, furniture, and tobacco industries. And it continued through a decade-long decline between 2000 and 2010 that eliminated 90,000 management and service-sector jobs from its tax base.

In 1999, civic leaders responded and created Action Greensboro, a consortium of nonprofits, foundations, and business leaders dedicated to rebuilding the economic vitality of the city. Led by the Joseph M. Bryan Foundation, this group focused on expanding opportunities for higher education, nanotechnology, banking, and other businesses in the metropolitan area. These efforts are now seeing results—Honda relocated its private jet facilities here, FedEx built a hub in the area, Elon University built a law school, and the airport has attracted a substantial presence for the maintenance operations of Cessna, a small plane manufacturer, and Timco, the largest airplane refurbishing company in the United States.

The rebounding economic and cultural conditions in Greensboro were a perfect match for the Natural Science Center's director, Glenn Dobrogosz, who arrived on the scene in 2004. Gregarious and personable with a mischievous smile, Dobrogosz, a highly trained zoologist with an innate understanding of business, is brimming with energy, enthusiasm, and big visions for the future. He replaced Edward Von der Lippe, who had served as director for 37 years

since shortly after the institution's founding in 1957 as a joint venture between the Greensboro Parks & Recreation Department and the Junior League. The former director effectively guided the organization and oversaw its transition in 1989 from a city agency offering free general admission to an independent nonprofit that needed to charge admission to meet its financial obligations. But by 2000 "the museum had lost its luster," said zoo Curator of Reptiles and Invertebrates Rick Bolling, even though it had "always enjoyed strong support from the community." Skip Moore, president of the Weaver Foundation, agreed about the then declining fortunes of NSC. "The museum was stable and part of the social structure," said Moore, "but it was a staid, moribund institution."

One of the projects that Dobrogosz inherited from his predecessor was a plan to rebuild the Science Center's zoo, which at the time did not meet standards established by the Association of Zoos and Aquariums (AZA). Dobrogosz brought a fresh pair of eyes to the plan that was supported by a $3.5 million city bond and required a matching $1.5 million commitment from the private sector. After some careful reconsideration, Dobrogosz put forward a plan that put greater emphasis on economic development. He suggested exploring what might give the zoo a competitive edge over its much bigger neighbor 40 miles to the south, the North Carolina Zoo in Asheboro. He also suggested a shift in thinking towards viewing the museum as a cultural tourism driver.

Dobrogosz led the staff in conducting a Community Connection Survey that involved more than 500 families. The goal was to learn what the community enjoyed about the NSC, what they thought needed improvement, and what changes they might like to see in the future. The survey results showed clear preferences in the community and these findings became part of strategic planning sessions with the senior leadership team. They ranked public preferences in the following order: animals, dinosaurs, family fun and education, plus interactive and educational programs. Other favorites included outer space and interplanetary exploration.

In record time, the staff outlined a visitor-oriented, 10-year plan for the organization that focused on "Kids, Creatures and Communities" to "inspire scientific curiosity and encourage personal discovery about life and the natural world." Together, the staff re-envisioned the zoo as an Animal Discovery Center focused on endangered species. This not only set them apart from Asheboro

and other North American zoos, but also provided an opportunity to educate the public about conservation and the specialized adaptations that all animals make in order to survive in the harsh realities of nature.

In addition, they dreamed up a number of school- and community-focused programs, as well as a new amenity for their "'kid-cool' science campus," a 23,000-square-foot SciQuarium dedicated to the study of species that depend on diverse aquatic ecosystems for some aspect of their lives. Besides African penguins, otters, fishing cats, stingrays, moray eels, and anacondas, the new facility includes a sizeable shark tank where visitors can come within inches of treacherous snouts and razor-sharp teeth (separated by thick plate glass, of course). In short order, the vision for the NSC became clear: a natural science museum, a zoo, and an aquarium all in one.

The vision of the Natural Science Center changed from a "community mainstay" to an "economic generator."

Dobrogosz is proud to point out that in crafting its strategic plan, "we didn't use consultants…we did it all ourselves." The plan, said Director of Business Operations Lindsey Zarecky, "expresses the mission and vision and values of the whole institution." Dobrogosz is also quick to add that "the values [articulated in the plan] aren't mine, per se—they were ones already embraced by…the staff and I just wrote them down."

Another major initiative happened in 2005 soon after Dobrogosz's arrival. The museum underwent a rebranding initiative to reflect the NSC's natural sciences focus and reposition it as a science and entertainment destination. The museum's ambitions were codified in a comprehensive marketing plan that set concrete goals for enhancing brand recognition, audience segmentation, and program participation.

Taking the Science Center's show on the road, Dobrogosz made nearly 500 presentations to civic and community groups in his first three years to communicate how the organization was going to become a centerpiece of the city. The messaging changed from the NSC as a "community mainstay" to an "economic generator." Assistant City Manager Sandy Neerman recalled hearing Dobrogosz speak at a Rotary Club meeting.

"When [Glenn] first put his vision out there, there was palpable excitement. It was a shot of adrenaline." Retired computer software engineer

and NSC Board Chairman Gary Brown credited Dobrogosz with recharging the Science Center's batteries. "Glenn's energy and vision are contagious—he's a great salesperson for NCS. [He] is an outside-the-box thinker and good at reading opportunities…He communicates a vision that demands buy-in from those who see what's possible." City Manager Neerman added that Dobrogosz "frequently comes back to share progress and accomplishments," which has helped to strengthen relations with the city and its residents.

Dobrogosz also writes a monthly column for the tri-county area newspaper, the *News-Record*, connecting the Science Center and its activities to regional issues and public values. As he extols in one article, "…the scientific

The NSC created a popular blog to track the progress of three endangered maned wolf pups that were born on site in February 2011.
© 2012 Natural Science Center of Greensboro

formula behind the center… [is] hard work + vision + skilled employees + community generosity + fiscal responsibility = increased attendance = economic impact = happy visitors and donors = future scientists of America = enhanced quality of life for the [region]."[2]

A renewed sense of community engagement ensued, resulting from NSC's new vision and enhanced community connections. The Science Center easily met its fundraising goal for the required matching funds and used the public/private $5 million investment to renovate the zoo, which has since achieved AZA accreditation. In addition to the adorable meerkats, the new facility features endangered Javan gibbons, howler monkeys, and lemurs; tortoises

and crocodiles; tigers; armadillos, chinchillas, and a sloth; as well as pythons and Gila monsters. Dobrogosz's icky favorites are also present: tarantulas, black widow spiders, and walking sticks, as well as the not-so-threatened cockroaches.

The NSC strengthened its commitment to education through programming tinged with a sense of wonder and fun. "We insist that keepers must be educators, which requires a certain kind of person interested in sharing his or her knowledge," said Director of Exhibitions and Programs Rick Betton, explaining that in the zoo field most keepers prefer animals to humans.

"The tension between conservation and community outreach exists in every zoo in the world. We err on the side of community outreach." He cites the popular keeper talks that occur three times daily, which often allow up-close interaction with the animals, and the captivating blog that the NSC staff created to track the development of three maned wolf pups from South America that were recently born on site.

The museum building got a content-laden makeover and its exhibit hall was reprogrammed to attract a variety of audiences and entice repeat visits. The NSC created and installed a health and human anatomy exhibit called HealthQuest following "extensive outreach to [local] faith, medical, and other communities" to gather their insights "and tailor [the experience] to community needs," said Gary Brown. The museum also brought traveling shows that have been sell-outs, like "Bodies Revealed," which graphically explores the various skeletal, muscular, nervous, respiratory, and other bodily systems; and "Accidental Mummies of Guanajuato," which looks at the history, culture, and forensic science of this Mexican community and its burial rituals.

With funding from Time Warner Cable and the major foundations in Greensboro, the NSC installed a full-dome 3D projection system, a full-dome digital projection system, and a laser projection system that offer science-oriented shows on the universe, weather, oceans, and prehistoric sea creatures. There are also crowd-pleasing laser shows set to the music of the Beatles, Pink Floyd, Metallica, and Led Zeppelin. The teenagers who flock to these evening events might be surprised to learn that the man behind the controls, Roger Joyner, has been on staff for over 30 years and loves his job.

In addition to new middle school, high school, and college level science programs, there is a renewed emphasis on school programming and

relationship-building with teachers. Dobrogosz explains that when he became director in 2004, the Science Center "did not have an active [school-based] education program contract and was ranked 18th in the state for science-based field trips." New programs are now tied to North Carolina's curriculum standards and designed with input from teachers to enhance life science concepts taught in the classroom through hands-on demonstrations on site. The teachers have their own Facebook page to provide feedback and critique, and the NSC has responded by expanding bathrooms to accommodate school groups, improving food service, and adding parking. The NSC now ranks third in the state for field trips, having welcomed nearly 117,000 students in 2012.[3]

Overall visitation has increased, too, and attendance has been climbing every year. In 2010, the Science Center attracted just over 290,000 visitors, which is a 73 percent increase since 2000. It also has over 5,000 members, which is a 230 percent increase since 2004, and nearly 13,000 fans on Facebook. "If NSC only focused on a narrow constituency, our primary audience would be families with young kids. But we're more expansive than that and try to stretch beyond the traditional market. The traveling exhibits attract young adults, singles, and older adults with no kids; the Led Zeppelin shows attract teenagers; and the zoo attracts college students," said trustee Bob Braswell, who is CEO of a local bank. In other words, "we intentionally have something for everyone," said Animal Discovery Curator Jessica Hoffman.

The Natural Science Center quickly has become the second leading tourist attraction in the area, behind the Greensboro Coliseum. Dobrogosz believes in the "museum as an economic driver…it's a way of giving back," he said. "It's also good for public/private partnership and provides the foundation for why we exist and succeed. It's a powerful message—the citizens have stepped forward to contribute to the community." And the NSC returns that trust by delivering programming and enriching experiences that compel repeat visitation.

By the time Dobrogosz returned to the community to request support for the SciQuarium, he received a warm welcome: the citizenry responded by approving a $20 million bond with no strings attached. The new water science facility is currently under construction and slated to open in summer 2013. And for the first time in its long history, the NSC regularly asks the community

for philanthropic assistance to sponsor these and other initiatives. "We have raised $4.3 million [for various capital projects] without being in campaign mode. We have become known as good stewards," said Dobrogosz, "and this helped the city council to [approve] the increased funding."

Everyone agrees that Dobrogosz has raised the octane level of the Science Center and is encouraging positive change throughout the organization. "It is all about vision and communication…talking with conviction about what is possible," he said. "We must be passionate, animated, and challenging," qualities that his leadership has been able to unlock in the staff, qualities that they now embrace.

"There has been a profound shift in our management philosophy, which is 'constant reinvention,'" said Rick Betton. "Because so many of our visitors are repeats, we must keep [things] fresh…Just because it works doesn't mean it should stay static. If it ain't broke, we might just fix it anyway!" Dobrogosz is a bit more pragmatic on this issue and says that the museum "must be responsive to the Disneyesque mentality of the public, who always want something new. Our costs keep going up, so we need to create reasons for them to come back."

The strategic planning process was also the beginning of a shift in organizational culture at the NSC. "Glenn started board and staff retreats and created interdisciplinary task forces, both welcome new concepts at the NSC," said Betton: "The staff was anxious to be led. We had talented staff, but Glenn helped the organization [to] realize its potential."

"We gave them freedom," Dobrogosz said matter-of-factly. "…Good people [should be] allowed to do what they do best." For an organization where many of the staff members have been on the payroll for 20 to 30 years, that message is having a big impact internally. "[Glenn] has been able to leverage staff members' expertise and enthusiasm [so that they are able] to express themselves in new ways," says Board Chair Gary Brown. Director of Marketing Steffany Reeve, plus Reptiles and Invertebrates Curator Rick Bolling, and Exhibition and Program Director Rick Betton all agree with this assessment. "We [have been] given the flexibility to try new things" Reeve said, while Bolling reflected that "ownership of ideas and the ability to 'run with it'" are welcome internal improvements. Bolling added that the museum now embraces "radical risk-taking—you get credit for trying, even if it fails."

Dobrogosz positions these changes as positive. "We reward people for their passion, creativity, and hard work." He noted that staff members have gotten raises or bonuses for the past eight years, solid evidence that constructive changes have taken place during his tenure.

An open and inviting work environment supports this insistence on continuous improvement. "The Natural Science Center is a welcoming, warm place, for visitors and for staff," said Lindsey Zarecky. "Everyone has a voice." There also is a collegial atmosphere that fosters teamwork, much like the meerkat colony. "No one can be too proud to do any job," remarked Rick Betton. "Glenn models this. There are no big egos here."

Jessica Hoffman, one of the newest members of the staff, reflected on her recent hiring. "I wasn't asked how to deal with conflict, which comes up at every other job interview. That, to me, was an indication of morale...I feel inspired here. It's a place I can fly, be seen, be heard. That is rare." Ron Settle concurs: "The work environment is based on camaraderie...a sense of intimacy where we always help one another."

But to suggest that the road to the museum's current state has been without setbacks would not be accurate and would leave out the significant impact of the 2008 recession on the city of Greensboro. By the time the economic decline began, the Science Center's operating budget had grown from $2.65 million to nearly $5 million, so the severe cutbacks in city funding had a considerable impact on museum operations.

The executive team was forced to reduce the staff by 20 percent, offered attractive retirement packages to long-tenured employees, and trimmed the budget to a manageable $3.65 million. A widespread educational initiative was launched to ensure that mid-management staff understood the need for careful financial planning and balancing expenses against constrained income. All this hardship had the positive impact of increasing the staff's self-reliance. "We are proud of the fact that we do a lot with not many staff," said Director of Finance and Human Resources Beth Hemphill. "[We] are passionate about what [we] do and are not motivated by money."

Dobrogosz reinvigorated the board during the recession in a similar way to the staff, but this, too, brought its share of tribulation. He inherited an "older, de facto board" that was hesitant about some of the new strategic planning

initiatives. But a younger, vocal minority faction was ready for change. As Rick Betton related, "There was a changing of the guard with Glenn's appointment" and a group that said "we can do better."

Since Dobrogosz's arrival, there has been an 80 percent turnover in board seats. Its composition today reflects the civic dynamism exhibited by the leaders of Action Greensboro. "Glenn has re-energized the board and given them the confidence to dream big," says Bob Klepfer, executive director of a local foundation. Tara McKenzie Sandercock, senior vice president of the Community Foundation of Greater Greensboro, added that Dobrogosz "has brought new board members to the table [and] they focus on what makes a healthy nonprofit."

The change also has moved succession planning to the top of the board's agenda. "We have encouraged Glenn's involvement with AZA"—Dobrogosz was recently appointed to the international association's accreditation committee—"to keep him away and raise the internal management level while also raising the profile of the institution," said Gary Brown. "We're proceeding with the 'hit by the beer truck' theory, but we're also working as a board to encourage Glenn to stay."

A leadership change certainly doesn't seem to be in the cards, at least not for the near future. Dobrogosz is already talking about the next projects that will keep everyone busy after the SciQuarium comes online: a new interactive 4D exhibit replicating weightlessness in outer space, as well as total sensory immersion in different environments (including at the bottom of the sea) that is the centerpiece of a new program focused on astronomy and space. And under discussion is a "super park" uniting the contiguous parkland surrounding NSC's 30 acres, which includes the historic battlefields from the Revolutionary War. In his typically voluble and impassioned way, Dobrogosz has brought together neighboring Tannenbaum Historical Park, the National Park Service, and Country Park (Greensboro's first municipal park) to revive interest in reconstructing the battlegrounds and building a new interpretive center that will serve multiple purposes and audiences, including the Science Center.

By creating a powerful, collective vision focused on the community and its well-being, and by delivering inventive, informative, and crowd-pleasing educational programs that invite participation, the Natural Science Center of

Greensboro has become, as the musical meerkats intone, "the heartbeat of us all." This transformation was revealed in an informal exchange one night when the senior staff was finishing dinner at a local Italian restaurant.

"Whenever I wear my NSC shirt around town, like in line at the grocery store, people engage me all the time," says Rick Betton. "There is strong community pride in the Science Center." As if on cue, the manager of the restaurant walked over to the table and asked if the group is from the NSC. When everyone nodded, he launched into a long monologue about his wife, who gave up her management job to return to school and study zoology. He explained that she is currently interning at the zoo. "She is following her passion," the manager said, "happier than she has ever been … and I wanted to thank you for doing what you do."

SIX MAGNETIC TIPS
FOR BECOMING ESSENTIAL

1. Turn outward and meet genuine community needs; listen to what people are concerned about and act on what you hear, even if it means changing direction.

2. Find the points of intersection where community needs and organizational mission meet, where collective, strategic action can have impact on large-scale public concerns.

3. Combine "outreach" with "inreach." Help to shape the public agenda and allow the public agenda to help shape yours.

4. Be visible and outspoken in the community. Attend and participate in public meetings, share ideas freely, and solicit honest feedback.

5. Deliver on your promises and tell your story of impact in order to shift perception from "nice to necessary."

6. Never assume you have the right to exist or to receive community support. Earn your place in the world.

Chapter 6 Notes

1. The Harwood Institute website, http://www.theharwoodinstitute.org/about (accessed 2 Jan. 2013).

2. Richard Harwood, *From Nice to Necessary: How You Can Turn Outward and Make Hope Real*, Craigslist Foundation Boot Camp podcast (2009), http://craigslistfoundation.org/resources/from-nice-to-necessary-how-you-can-turn-outward-and-make-hope-real/ (accessed 3 Jan. 2013).

3. *Ibid.*

4. Glen E. Holt, "On Becoming Essential: An Agenda for Quality in 21st Century Public Libraries," *Library Trends* (Winter 1996), 546.

5. *Ibid.*, 548.

6. *Ibid.*

7. Children's Museum Pittsburgh website, https://pittsburghkids.org/about/fact-sheet (accessed 9 Jan. 2013).

8. Philbrook Museum of Art website, http://philbrook.org/about (accessed 6 Jan. 2013).

9. Topos Partnership for the Fine Arts Fund, *The Arts Ripple Effect: A Research Strategy to Build Shared Responsibility for the Arts* (Cincinnati, 2010), 1.

10. *Ibid.*, 3.

11. *Ibid.*, 3.

12. *Mastering Civic Engagement: A Challenge to Museums* (Washington, DC: American Association of Museums, 2002).

13. *Ibid.*, 3.

14. *Ibid.*, 2.

15. On Innovation website, http://www.oninnovation.com (accessed 4 Jan. 2013).

16. On Innovation, *Babies and Business with Dean Kamen*, http://www.oninnovation.org/videos/detail.aspx?video=1874&title=Babies%20and%20Business (accessed 4 Jan. 2013).

17. Conner Prairie Interactive History Park website, *Conner Prairie Awarded $2.3M Grant from National Science Foundation*, 10 Oct. 2012, http://www.connerprairie.org/Newsroom/News-Releases/2012/Conner-Prairie-Awarded-$2-3M-Grant-from-National-S.aspx (accessed 7 Jan. 2013).

18. Author interview with Jane Werner, Children's Museum Pittsburgh, 4 Jan. 2013.

19. Anne Bergeron, Beth Tuttle and Jennifer Wells Green, "Secrets of the Magnetic Museum: Turning Moments of Success into Momentum," American Association of Museums Annual Meeting, Los Angeles, CA, 23 May 2010.

Chapter 6 Case Study Notes

1. The information and quotations presented in this case study are taken directly from author interviews with the Natural Science Center of Greensboro staff, trustees and stakeholders, or from internal or publicly accessible organizational data.

2. Glenn Dobrogosz, "Natural Science Center's Efficiency Means Savings for Local Taxpayers," *News-Record*, 16 Apr. 2012, http://www.news-record.com/content/2012/04/16/article/natural_science_center_s_efficiency_means_savings_for_local_taxpayers (accessed 4 Oct. 2012.)

3. Amy Dominello Braun, "Two Triad Sites Rank Among Top Five N.C. Field Trips," *The Business Journal*, 2 Oct. 2012, http://www.bizjournals.com/triad/blog/morning-edition/2012/10/two-triad-sites-rank-among-top-field.html (accessed 4 Oct. 2012).

*Travelling exhibitions like "Body Worlds"
contribute to The Franklin Institute's financial
stability and fuel its mission and community-
based science education programs.*
Photo: The Franklin Institute

∩

Build Trust Through High Performance

The Franklin Institute

Instill High Performance Culture / Practice Magnetic Leadership
Build Relationships Over Time / Success Follows Success

To watch Yo-Yo Ma play his cello is to witness high performance in action. His virtuosity is matched only by the sublime joy on his face as he performs. When he was honored for a lifetime of achievement by the Kennedy Center in 2011, he was characteristically humble, and also visibly enchanted by the opportunity to hear other musicians perform tributes to fellow honorees as diverse as jazz master Sonny Rollins, pop king Neil Diamond, and Broadway soprano Barbara Cook.

Whether he is playing classical repertoire with the London Symphony Orchestra, exploring world music with the Silk Road Project, creating a bluegrass mash-up with the Goat Rodeo Sessions, or teaching Elmo to play the fiddle on Sesame Street, Ma brings the same energy and level of engagement to each of his collaborations. Despite his performance and recording commitments, Ma also makes time to work with children to connect them to the world through music.[1] He is irresistible to music lovers and completely approachable for everyone else. "I'm actually pro-people being intelligent with their imagination and with their hearts, using all of themselves," he told *The New York Times* in a 1994 interview. "That's the best part of what I do. It gives meaning to me and to my life, [and] makes it worthwhile to live."[2]

Ma embodies the most important qualities of magnetism: he is totally aligned and focused on the power of music; he engages others in his passion and creates collaborative relationships; he consistently exceeds expectations; he gives freely of his talent in service to the advancement of others; and the more he gives, the more he receives.

But Ma's magnetism did not materialize overnight. Yo-Yo Ma is an "outlier," a term

popularized by Malcolm Gladwell in the book of the same name. Gifted, yes, but also well trained, focused on his art, disciplined enough to surpass the 10,000-hour mark (the number of hours of practice required to produce mastery in any field or endeavor, according to psychologist Anders Ericsson, whom Gladwell references in his 2008 book)[3], and supported by a cast of teachers and fellow musicians, not to mention a family that valued culture, education, and hard work—just like many of the other outliers that Gladwell discusses. And that's the point. Success is a "group project," the author recounts, and rising to outlier status is not because of individual effort, but "because of the contributions of lots of different people and lots of different circumstances..."[4]

What we have learned is that Magnetic Museums are high-performance organizations that achieve extraordinary success—and they are made over time, not born. Like Gladwell's outliers, their success begins with innate talent and a kernel of vision. But what makes them different is their deep level of commitment to "practice" and how effectively they embrace the world around them, enlisting and empowering others, and leveraging their assets and those of their constituents.

While the initial aspiration or vision that is often the catalyst for change generally arises from an individual or small group of people, Magnetic Museums ultimately are the result of a coordinated effort of strategy, planning, teamwork, communication, and resource management. In other words, they are the product of the purposeful development and application of human and organizational capacity. By investing in their people, Magnetic Museums have enhanced their organizational health and effectiveness, and created high-performance cultures that consistently meet or exceed expectations. Their continuous high performance, in turn, has built valuable reserves of public trust, loyalty, and brand equity that sustain and advance their progress.

DEFINING HIGH PERFORMANCE FOR MUSEUMS

We did not initially conceive of this study as an attempt to create a definition of the "high-performance museum," yet the six case studies do offer insights that contribute to a richer understanding of what organizational characteristics and approaches have contributed to the business success that supports mission impact in these museums. Magnetic Museums have excelled by enhancing and complementing sound programmatic and educational content with a greater emphasis on developing and engaging people; enhancing relationships and experiences; gaining better market insight; and strengthening business and financial performance.

In becoming magnetic, these institutions have improved their ability to attract and retain four kinds of organizational assets that lead to sustainability: core capital, social capital, brand capital, and financial capital. *Core capital* includes the human and intellectual resources, as well as the tangible assets of collections and facilities used to imagine, manage, and deliver a high-quality museum experience. *Social capital* equates to the relationships and networks that Magnetic Museums build with and among the internal and external stakeholders and communities they serve. *Brand capital* is evident in the good will, trust, reputational equity, and sense of public value that Magnetic Museums inspire. And *financial capital*, which flows in response to the successful creation of the first three assets, sustains and enables all this activity.

When we began this project three years ago, we offered a preliminary description of the Magnetic Museum as *a high-performance institution with a superior ability to attract and retain the resources necessary to deliver sustained programmatic excellence and growth over time.* At the time, we assumed that the term "high-performance" would be as well understood in the museum field as it is in the corporate and general nonprofit sectors. To our surprise, it was not.

A search of current literature revealed that although a great deal of attention has been given to understanding various aspects of museum performance, such as educational outcomes or audience experience and impact, no broadly understood definition of "high performance" has yet been created for museums. A few initiatives over the last 25 years, primarily driven by foundations with an interest in arts management and organizational effectiveness, have looked at programmatic and business practices as a whole in order to generate a complete picture of performance in the cultural sector. Only a handful of titles exist that deal specifically with museums.

One of the earliest forays into organizational development for the cultural sector was a 1980 initiative by the National Endowment for the Arts (NEA) Advancement Program, which broke new ground by offering management assistance to arts organizations in addition to grant funds. As part of that program, the NEA brought together the insights and advice of national arts consultants to create a series of lessons learned. A toolkit of case studies, collaterals, and an organizational self-assessment (available at http://www.nea.gov/resources/lessons/index.html) emerged from that initiative.[5]

More recently, the Pew Charitable Trusts operated the Philadelphia Cultural Leadership Program (PCLP) to identify "regional cultural organizations that meet high standards of programmatic, fiscal, and management performance."[6] Using an index of national standards for well managed arts organizations, the program assisted participants

in assessing their programmatic and business practices. High-performing cultural institutions in the Philadelphia area were eligible for multi-year, unrestricted operating grants to encourage their further growth and development.

Maxwell L. Anderson, director of the Dallas Museum of Art (DMA), also addressed performance measurement in his 2004 essay, "The Metrics of Success in Art Museums,"[7] commissioned by the Getty Leadership Institute. He discusses how to define success in an environment where the emphasis has shifted from collection-building to experience-making. Anderson challenges the primacy of quantitative measures, such as attendance, box office revenues, memberships, and numbers of objects in a collection as the best indicators of success. He argues that there are many other measures providing a more robust picture of an organization, especially for qualitative things generally thought of as defying measurement—and he suggests more than 100 of them in categories ranging from quality of experience to institutional reputation to standards of governance.

Robert Stein, the DMA's deputy director, served alongside Anderson at the Indianapolis Museum of Art, where together they pioneered a web-based Dashboard to make aspects of the institution's performance transparent.[8] During a panel discussion at the 2011 Museum Computer Network conference, Stein asked, "How do we measure for epiphany?" capturing the conundrum beautifully.[9]

In designing the Magnetic Museums study (see Appendix A for a detailed description of our research methodology), we evaluated organizational performance through a combination of responses to a museum self-assessment questionnaire that was informed by the PCLP Index and adapted from the NEA toolkit, and through on-site observations and insights gleaned from dozens of conversations with numerous internal and external stakeholders and museum observers. We gathered information on nine areas of organizational performance, ranging from mission and strategic direction to management practices, finances, and community engagement.

The self-assessment questionnaire (see Appendix C) reflected our hypothesis that a critical aspect of what makes museums "magnetic" is a holistic and intentional approach that seamlessly aligns content and experience activities (collections, exhibitions, programs, interpretation, education, and engagement) with business processes (operations, management, resource development, marketing, and communications) in a manner designed to deliver high-quality, integrated, and people-centered experiences that achieve the museum's desired outcomes. That's a mouthful to say and even harder to do!

Based on our professional experiences with a range of cultural and other organizations, we expected to find that most institutions might be doing well in some areas and

needing improvement in others. We learned through our observation and via the self-assessment that Magnetic Museums are performing well in a majority of the categories *all at the same time*. While the causal links remain to be proven, we believe—and the case study museums concur—that their holistic approach to people, planning, systems, processes, products, and knowledge has been key to higher organizational performance and enhanced qualitative and quantitative results.

After spending time with the museums, we revisited the categories of performance in the pre-site visit self-assessment questionnaire in order to validate them against what we had seen and heard. We also drew on the work of André A. De Waal, of the Netherlands-based Center for Organizational Performance, who undertook a helpful synthesis of 290 extant studies of performance in for-profit and nonprofit organizations operating across a range of industries around the world. His review identified common themes and characteristics of high-performance organizations emerging from those studies.[10]

DeWaal consolidates the findings into seven categories of organizational performance, which (with the exception of those that are specific to museum programming, such as collections, exhibitions, interpretation, and the like) mirror and encompass the organizational aspects we studied in Magnetic Museums:

1. Organizational design (how the organization is structured for management and operation);

2. Strategy (the presence of vision, mission, goals, and objectives, and the level of alignment of people and programs with that strategy);

3. Process (how an organization seeks, recognizes, and rewards quality, improvement, innovation, and learning);

4. Technology (how technology enables and extends the organization's work);

5. External orientation (how an organization builds relationship with and understands its customers and enhances its value in relation to others);

6. Culture (the level of trust, empowerment, communication, transparency, and loyalty); and

7. People (leadership and employee characteristics, competency, resilience, willingness to experiment and learn.)[11]

The following table (see Figure 7.1) organizes the high-performance indicators we observed inside the Magnetic Museums within De Waal's seven-characteristic

Organizational Design	Strategy	Process	Technology	External Orientation	Culture	Leadership, Management & People
Flattened management structure	Strong, compelling mission and vision	High level of interactive internal communication	Enhances management information systems, organizational processes, training, and communications	Ensures relevance to audiences and market	Optimistic, energetic, and forward-looking	Attracts exceptional mission-motivated people with can-do attitude
Cross functional collaboration	Sets clear, ambitious, measurable goals	Commitment to ongoing planning	Supports increased engagement and empowerment of staff, board, audiences, and community	Seeks audience understanding and insight	Transparent, open, and trusting	Serves first, leads second
Facilitates widely shared knowledge and information	Creates alignment with overall direction and strategy	Continuous learning and improvement	Eliminates physical, temporal, and geographic barriers to participation	Builds and maintains positive, long-term stakeholder relationships	Mission and vision are visible and alive	Broadly distributes and shares leadership throughout
Adaptive to changing internal and external circumstances	Balances long- and short-term focus	Disciplined action guided by strategy	Invites/facilitates dialogue between organization and audience (pulls and pushes content)	Monitors external environment and responds accordingly	Empowers everyone with freedom to decide and act	Creates meaning for internal and external stakeholders
	Aligns strategy, goals and objectives with mission, market demands, and business needs	Collects and uses data to inform decisions	Increases organizational transparency	Benchmarks against the best	Establishes and lives by core values	Builds trusted relationships at all levels
	Leverages core assets (human/intellectual, collections, programs, facilities) in service to mission, audience/community engagement and impact	Shares financial and non-financial information with everyone to create pan-institutional business literacy		Seeks partnerships and value-creating networks	Committed to superior service and meeting needs of others	Engages and involves workforce
		Practices positive accountability at all levels		Aligns new initiatives with core competencies	Performance-driven	Grows leaders from within
		Continuous innovation		Conducts integrated, consistent marketing, communications, and outreach	Encourages experimentation and allows for failure as a path to learning	Stimulates change, improvement, and growth
		Continuous process improvement			Shared identity and sense of community	Coaches and facilitates
		Best practice adherence			Shares credit internally and externally	Inspires others to achieve extraordinary results
		Deploys resources effectively				Seeks diverse knowledge, skills, and experience
						Holds people accountable and is decisive about non-performance
						Committed to the long-haul
						Practices humility
						Reflects diversity of community served

Figure 7.1 Adapted from André De Waal, "The Characteristics of High Performance Organizations," January 2010.[12]

framework. This tool may be useful for museums seeking to become high-performance organizations. We hope it will prompt additional study and development by practitioners and researchers in the field.

INSTILL A HIGH-PERFORMANCE CULTURE

High performance in the 21st-century museum is about more than building, caring for, interpreting, and using collections for academic and educational purposes; it is about more than attracting audiences and contributions. High performance is both a mind-set and a set of organizational practices, benefiting from a high-touch, humanistic, and holistic approach. It emerges when an institution intentionally invests in, develops, and gives purpose and direction to a group of talented people who are reciprocally committed to an institution's success.

We identified several factors contributing to the high-performance culture of Magnetic Museums.

People First

Magnetic Museums respect, invest in, listen to, and serve people first. Whether recruiting staff members who share the institution's values and aspirations, or taking the extra step to provide superior customer service, these institutions know that people engage and contribute most when they feel welcomed, supported, heard, and included.

Holistic and Intentional[13]

Magnetic Museums have overcome outdated modes of operation and values systems that have historically created silos and operational divides within their institutions. Instead they view the cultural enterprise as a whole that encompasses multiple intelligences, capabilities, perspectives, and outcomes. They tap the wellsprings of scholarly, business, design, and operational expertise that contribute to the overall well-being of their institutions. Power struggles diminish as people find common ground in an authentically shared, high-level vision. They act with purpose, discipline, and coordinated intention towards clearly stated outcomes.[14]

Inclusive and Engaging

Magnetic Museums foster alignment by involving people from all levels of the organization and across all disciplines in developing and pursuing organizational vision, articulating goals, and contributing to the museum's overall success. They engage people by giving them meaningful work and inviting them to share in meaningful experiences.

Respectful

Respect is a signature quality inside Magnetic Museums. Team members are inspired by and respectful of their leaders, and their leaders are inspired by and respectful of their teams. Magnetic Museums also respect and empower their boards, their audiences, and their communities by inviting ongoing participation and input and then acting on what they have learned.

Relentlessly Focused

Magnetic Museums are relentlessly focused on achieving organizational vision, developing meaningful experiences and relationships, and improving organizational performance and impact. They are disciplined about what they do and sufficiently patient to stay the course and allow change to occur over time.

Failure Is an Option

Magnetic Museums appreciate the value of experimentation and failure as the path to learning and success. They encourage and empower employees to consider a variety of perspectives and be adaptive to changing circumstances. They benefit from imaginative solutions and innovation, often in spite of or arising out of significant constraints facing the museum.

Motivated by Excitement not Fear

Magnetic Museums create "no fear" work environments. They play to win, rather than to avoid a loss. They exhibit a surprising level of excitement, enthusiasm, and energy for the next endeavor, even despite the grueling economic challenges of the last decade. They trust and empower their people, and in the process, motivate and liberate them to act.

Accountable and Transparent

Magnetic Museums practice positive accountability and are committed to transparency. They set ambitious but achievable goals; clearly define milestones and frequently discuss progress towards them; inform decision-making with data; celebrate successes; and respond to shortfalls with course correction rather than blame.

Optimistic and Generous

There is little evidence of whining, complaining, or excuse-making in Magnetic Museums. People are optimistic, share knowledge and power, and assume that others are acting with good intention for the best interests of their institutions and their communities. Magnetic Museums cultivate an abundance mentality and freely share their assets and ideas with others.

Bound to Meet or Exceed

The ultimate indicator of a high-performing organization or workplace is regularly meeting or exceeding expectations and goals. Personal passion and the satisfaction of success fuels the full team—staff, board, stakeholders, volunteers—for the next challenge.

PRACTICE MAGNETIC LEADERSHIP

In the introduction to this book, we mentioned that following our 2010 presentation at the AAM annual conference introducing the Magnetic Museums concept, many in the audience expressed concern that without the presence of a visionary leader their institutions had little hope of changing. Several mentioned that their directors were not charismatic or could not command the attention of their board or staff strongly enough to effect change. Others were worried that their organizations had no ambition to improve and no one to strike that spark.

At that time, we were quick to say that leadership and ambition for change could come from anywhere within an organization. Examples came to mind from the Brooklyn Botanic Garden, where Leslie Findlen, vice president for development, had been a key stabilizing factor and a force driving the institution's transformation, especially in the difficult years during which the Garden's beloved director, Judith Zuk, battled and ultimately succumbed to cancer.[15] Ellen Rosenthal, director of Conner Prairie Interactive History Park, and Jane Werner, director of the Children's Museum Pittsburgh, both launched their organizations' transformations while serving as educators rather than as directors.

At the end of our study, we continue to believe that distributed and self-starting leadership at many levels is a defining characteristic of Magnetic Museums. However, leadership from the director's office is vital in setting the vision; in communicating, enlisting others, and inspiring in them the will to pursue that vision; and in instilling a high-performance organizational culture as a means of achieving that vision. Saleem Ghubril, president of The Pittsburgh Promise, an organization committed to enhancing urban neighborhoods and schools and providing college scholarships to underserved students, affirmed the power of leadership in setting and perpetuating organizational culture. "It takes a long time to establish the culture, but not too long for it to wash away if leadership is not in place to nurture it."[16]

While we may be culturally attuned to expect that high-performance organizations will have personally charismatic leaders, we observed a variety of personal styles among the directors we studied. They range from modest and self-effacing to gregarious and

dynamic. Personal charisma, however, which is often a plus for nonprofit leaders who must be extremely persuasive in their communications, is no substitute in Magnetic Museums for other key leadership traits that lean more strongly toward engaging and involving others.

Jay Conger, a senior research scientist at the Center for Effective Organizations of the University of Southern California, has studied leadership extensively. He identifies a set of behavioral traits, including vision, communication, empowerment, innovation, and risk-taking, which, when combined with the intense passion and focus of a leader on a highly relevant mission, vision, or set of goals, combine to create a charismatic persona.[16] Regardless of whether or not a leader is innately charismatic, Conger suggests that by cultivating these traits, a charismatic leadership style can be developed that permeates an organization.[18] These traits are often in evidence in Magnetic Museums, affording many dynamic benefits without the downsides often wrought by heroic, sometimes egocentric, charismatic leaders.[19]

We found that leaders of Magnetic Museums share remarkably similar characteristics:

- They look to the future and have an expansive vision of what is possible. They are hopeful and optimistic about making a better world through their institutions.

- They are inventive, inspired, and inspiring. They foster creative thinking and imaginative problem-solving in those around them.

- They are strategic, able to see connections and opportunities between and among people, ideas, activities, and entities. And they effectively navigate these connections and opportunities in strategic ways to realize their visions for the future.

- They are enthusiastic and passionate, devoted to their people, their museums, and their communities. They are cheerleaders for ongoing improvement and forward momentum.

- They are courageous risk-takers, willing to fail in order to achieve success in new ways and at new levels. They allow those around them to fail in pursuit of something better, more innovative, more progressive, and more creative. They abhor the status quo.

- They are effective and able communicators, adept at imparting ideas in ways that are meaningful, yet simple, memorable, and engaging to many different audiences.

- They are inclusive, collaborative, generous, and aware that strength comes from

community. They know that community-building requires many perspectives and voices, and adopt a holistic approach to valuing and involving both internal and external constituencies. They turn outward and care about those in their immediate, geographic community—board, staff, donors, volunteers, audiences, city, and region—as much as they do about the field. They also care about sharing what they've learned with others and embrace and encourage an "open source" mentality and create "cultures of collaboration."

• They embody a "servant-leader"[20] ethic, which compels them to empower others to learn and achieve, rise to the occasion, perform at their best, and push past obstacles to find solutions. And they recognize, honor, and reward the work and commitment of others. They easily share credit and, in fact, are usually humble about their own achievements.

• They are "high performers" who nurture high-performance cultures. They expect as much or more from themselves as they do from those around them. They surround themselves with smart, dedicated, hardworking, ethical people who share similar values and work ethics. They model honesty, transparency, and integrity, and in turn, engender trust, loyalty, and devotion.

More than anything else, Magnetic Museum directors use their personal passion to effectively persuade others to their cause. The literature on corporate and non-profit leadership suggests that leaders of other "magnetic" organizations embody many of these same qualities.

BUILD RELATIONSHIPS OVER TIME

Transformational change takes time and patience. We heard this again and again in our case study interviews. In Chapter 4, we shared that an emphasis on engaging, developing, and empowering people has resulted in long tenures for Magnetic Museum senior staff. These organizations benefit from the staying power of their top executives, as well. While shorter tenures may now be typical among museum directors overall, averaging five years,[21] four of the six leaders we profiled were considerably longer-tenured, serving from 13 to 22 years on the job. Randall Suffolk at the Philbrook Museum of Art (five years) and Glenn Dobrogosz at the Natural Science Center of Greensboro (eight years) are the relative newcomers in the group. Dennis Wint, director of The Franklin Institute, says it is no accident when one finds steady and consistent leadership at a successful institution. "Change is slow; it takes times to build a team and trust among them."[22]

Each of the leaders we spoke with had made an active choice to stay with his or her institution in the face of another offer from a competing museum. Although all of them had been approached about other jobs at one time or another, they did not leave because they felt there was still work to be done, more opportunity to be mined, or greater impact to be had. Almost all of the directors said that transformational change of the magnitude their organizations experienced could not happen in fewer than five to seven years and was more likely to occur over the course of a decade.

A 2011 study found that the deeper a nonprofit executive's roots, the more satisfied he or she becomes with the job.[23] As each develops and retains capable boards and staff over time, the task of leading becomes easier and more fulfilling. The implication for museums is that the longer talented directors remain in place, deftly guiding with enthusiasm and vision, the stronger their internal and external relationships and networks become. This, in turn, enhances organizational capacity to deliver results that meet or exceed expectations. Over a period of years, this can contribute to increased public trust, confidence, and support.

Further, we saw continuity of board participation as another important facet of Magnetic Museums. For example, of the 28 current members of the Chrysler board, 14 have served for five or more years; four of these members have returned to serve a second or third eight-year term; and 11 members represent significant philanthropic families or major local corporations from which members consistently have been drawn. This inter-family, inter-company and inter-generational passage of leadership attests to deep feelings of loyalty and commitment among community members. In order to make certain that its stable roster of trustees does not become a status-quo board, the Chrysler also ensures that it has a complement of members who are entirely new to the museum and serving first terms. As you will read in The Franklin Institute's story that follows, board continuity for some institutions is not just an outcome of their success, but a purposeful strategy contributing to it.

SUCCESS FOLLOWS SUCCESS

We believe high performance not only contributes to but also results from a museum's increasing magnetism. Adopting the people- and service-first philosophy of Magnetic Museums ensures that the necessary ingredient for high performance is present— namely, people who are inspired and empowered to achieve ambitious goals and deliver exceptional experiences. Magnetic Museums engage and empower people, providing

them with the tools and freedom to produce results. By consistently delivering results that meet or exceed expectations, Magnetic Museums have earned public trust and won the loyalty of their audiences and supporters. Their current successes are built on past performance, and reinforce public perceptions of organizational health, vitality, and value.

Several funders with whom we spoke indicated that they increased their level of support to the museums in this study because they had garnered trust as good public stewards. For example, Don Kimelman of the Pew Charitable Trusts in Philadelphia recounted an instance where his organization made an extraordinary contribution to The Franklin Institute's expansion campaign as a result of the science center's securing a $10 million lead gift from a new donor. "We gave them [a significant gift] for their capital campaign, which we don't normally do," Kimelman recounts. "We were struck by the growth in their base of individual support, which indicated organizational strength."[24]

Dan Harrison of the ONEOK Foundation in Tulsa shared a similar story about the Philbrook Museum of Art. When the museum approached the foundation for an event sponsorship, which was not allowed under ONEOK's grant-making guidelines, Harrison politely declined and thought that would be the end of it. Philbrook Director Rand Suffolk, however, requested a follow-up meeting to share information about the museum. When he communicated the vision for the Philbrook as a community hub, "we were energized," said Harrison. He and his board realized that "[the Philbrook is] not about the buildings and the gardens, but rather the people." ONEOK subsequently made a major commitment to fund the "Second Saturdays" program, when the museum is open free of charge and offers family-friendly activities.[25]

William Marrazzo, president of WHYY public broadcasting in Philadelphia, who joined the nonprofit sector after a successful corporate career, ruminated on the relationship between leadership, performance, and results. "Excellence breeds excellence and success follows success. Nonprofits have a responsibility to be extraordinary. The best ones have no tolerance for mediocrity in their staff, their boards, or in their products." When they are extraordinary, he concludes, "Everyone wants to be part of the game."[26]

In other words, as the story of The Franklin Institute will show, high performance is magnetic.

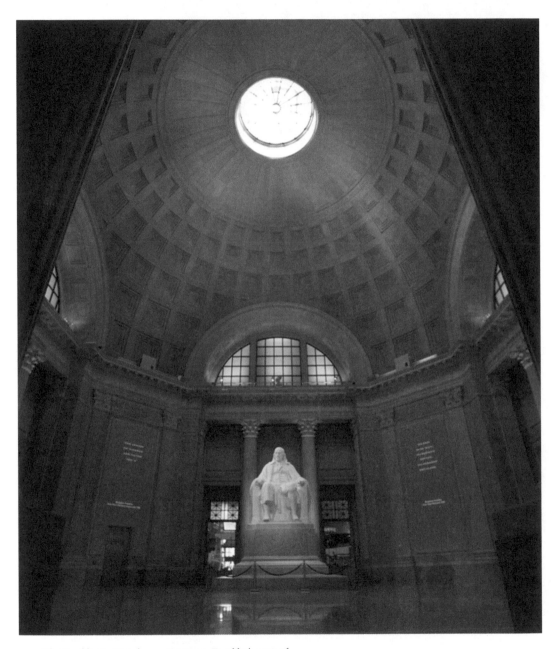

*The Franklin Institute honors Benjamin Franklin's spirit of
ingenuity and discovery and has fostered a high-performance
organizational culture throughout its ranks.*
Photo: The Franklin Institute

case study

THE FRANKLIN INSTITUTE

RIGHTING THE SHIP

If you want to build a ship, don't drum up people to collect wood and don't assign them tasks and work, but rather teach them to long for the endless immensity of the sea. —Antoine de Saint-Exupery [1]

Dennis Wint is a sailor and a scientist. He relates to the mythic power of the sea and the science of the tides, and he knows how strong the pull of both can be. Like any good captain, he also knows that safe passage often relies on the skills, instincts, and hard work of a dedicated crew that has sailed together for some time and weathered many a storm.

Over the past 18 years, Wint, president of The Franklin Institute, and his crew have charted a course to a thriving future. They have become a highly effective and entrepreneurial team linked by a deep commitment to the wonder of science and exploration.

The 189-year-old Franklin Institute is one of the oldest and most respected science centers in the United States. It originally opened in 1824 as The Franklin Institute of the State of Pennsylvania for the Promotion of the Mechanic Arts. In 1934, it moved to its current Beaux-Arts building with an enormous set of marble stairs rising up from Philadelphia's Benjamin Franklin Parkway. The Institute also houses the Benjamin Franklin National Memorial featuring a 20-foot-high statue of Franklin located in the spectacular 82-foot-high domed marble Franklin Hall, modeled after the Pantheon in Rome.

On average, more than 800,000 visitors experience the museum each year, with another 335,000 face-to-face contacts through classes and outreach programs. The Institute enjoys deep loyalty from generations of school and family visitors and an enviable level of brand awareness.[2]

History and respect alone, however, are never enough to propel an institution into the future. So in 1990, after nearly 60 years in its current location, The Franklin Institute undertook its first capital expansion. Under the leadership of

Charles Andes, a new space, called the Futures Center, was built. It included a domed IMAX theater, two major exhibition floors, a new central atrium, and an auditorium. Unfortunately, the project was undercapitalized from the start: The Institute spent $72.5 million on the expansion, but had only $50 million in hand. It also lacked sufficient annual funding streams to fully program the new space.

"It was a perfect storm," Wint explained, "where all four factors that get museums in trouble were at work. First, the facilities cost more to build than anticipated; second, the Institute raised less money than needed to adequately capitalize the expansion; third, the resulting expanded museum cost more to operate than anticipated; and fourth, the earned income and operating revenue was less than expected." He recounted that the Institute had ignored one of the most basic management philosophies: "Thou shalt not accumulate long-term debt." This was a business principal that Wint followed to great success in St. Louis where he had overseen building a new science center before joining The Franklin Institute in 1995.

Upon his arrival, Wint found a weak development operation with little culture of stewardship, and "a group of donors who were angry, mistrustful, and feeling burned." To make matters worse, shortly after his arrival, five key members of his senior staff and exhibits team were recruited away by an independent museum design firm. Wint had inherited an under-performing organization.

Heeding Ben Franklin's oft-quoted advice, "He who fails to plan, plans to fail," the Institute took the first steps toward turnaround with a major strategic planning initiative in 1996. A new forward-looking, more relevant, and audience-focused mission emerged: "In the spirit of inquiry and discovery embodied by Benjamin Franklin, the mission of the Franklin Institute is to inspire a passion for learning about science and technology." This was a radical departure from the past; since its founding, the Institute's mission had been limited to honoring Franklin and advancing the usefulness of his inventions.

The resulting plan called for a $50 million investment to make essential upgrades to the building and begin the sequential updating of the core exhibition experiences, which were aging and not as inspiring or engaging as the new mission warranted. The strategic plan to achieve this vision, which has since been updated every two to four years, has been the Institute's North Star, guid-

ing its progress towards becoming a high-performance museum. "The strategic plan," said Wint, "was the most important move that focused the staff and the board, clarified the mission, and created a clear vision and set of requirements for success that the donors could get excited about."

Executive Vice President Larry Dubinski, who has worked at the Institute in a variety of roles during his 12-year tenure, echoed Wint's comments about the importance of integrated planning. "Strategic planning has been a hallmark [of the last two decades] at the Institute and has been a large part of our success. It has kept us focused, forward-looking, and accountable."

Over the next 15 years, the Franklin Institute systematically rebuilt its board, staff, exhibitions and program offerings, its operations and business model, and its facilities. "We became a 'transition' rather than an institution," Wint recalled. "This was a dynamic, chaotic place for a while."

They focused on identifying and recruiting people with a shared passion for science and for the Institute, individuals who had the talent and energy to contribute to making the long-term vision a reality. "Without inspiring the imagination, talent, and trust of the people who enabled the plan, we would not have succeeded," said Wint.

Marsha Perelman, an accomplished CEO who had built and managed a number of energy-related and holding companies, joined the Institute's board in 1994, "ten minutes before Dennis arrived." She said that elevating, reinvigorating, and inspiring the Institute's board with the new vision and plan was critical. "When I joined the board, it was a little dry, old, and creaky, kind of like the rest of the place," Perelman recalled.

"The Institute had the usual criteria for board membership," Wint recounted, "people who represented a particular community and had credibility or cachet. And there was nothing wrong with that." Except that they were not getting the caliber of board members they needed to move to a higher level of institutional performance.

Perelman has a passion for science education that was a perfect match for the Institute. "What is the most important to me," she related, "is providing some hope to the two or three hundred thousand kids who come through [the Institute] with school groups every year…to give those kids a sense that, 'I can understand what science is and be excited about it.'"

First as a board and nominating committee member, and later as board

chair, Perelman worked to raise the profile and capacity of the board. As a result, the Institute has built what is widely recognized as one of the strongest cultural boards in Philadelphia. "What changed," Wint said, "is that we had an inspiring vision and we began holding the line, primarily not inviting anyone who was below the level of chairman or president of a company. And then we put them to work."

Gradually, the 48-member board became a committed corps with significant leadership experience who supplied the talent for a powerful executive committee. "I knew that the board had started to 'click'," said Wint, "when we began to be able to recruit a different level of trustee and see them becoming more and more engaged over time." An indication of just how far this board and the organization have come from the days when it struggled to recruit the first local CEO is the fact that there is now an informal "waiting list" of potential candidates anxious to join.

Don Morel, chairman and CEO of West Pharmaceutical Services, Inc., who became a trustee of the Institute in 2006, commented, "Philadelphia is 'board rich,' and there is a limited pool of qualified people to serve. This is one of the top boards in the city to serve on today… Although it is large, it is really a working board." Trustees participate in four board meetings and an average of six additional committee meetings annually. Committee chairs participate in four executive committee meetings, as well.

When asked how to maintain such an engaged and committed board, Perelman's advice runs counter to common wisdom: "Do away with term limits and get a great nominating process instead…I remember the look of horror on the Pew [Charitable Trusts] evaluators' faces …when we said that we had done away with term limits for trustees," she recalled. "But here's what happens with a high functioning board. Just when you've groomed someone to be ready to take on committee leadership, their term is up and they've got to step off. And because they are known as leaders in the community, other organizations that aren't stupid swoop in and grab them up while they are waiting out their time off [of the Institute's board.] And by the time they can come back to our board, there is no committee chair available for them to step into."

"Instead," Perelman continued, "we have a system in which every trustee earns the right to stay on the team by virtue of performance. We expect board performance and we measure board performance. We are not afraid to say

'thank you for your service' to anyone who is not meeting expectations or doesn't have the time or passion to work as hard as this board works. This makes room for new blood. Everyone now knows this is not a place just to hang out and build your resume."

The Franklin Institute also changed its governance structure from having a volunteer board president and a paid vice president to having a volunteer board chair and a paid president, thereby enhancing both board and staff leadership stature and presence. In 2005, Perelman became the first woman in the Institute's history to be elected chair of its board.

Matching a strong board with talented staff and empowering them to do the work was the next critical step. While losing several of his exhibition and senior management staff immediately upon his arrival was a short-term setback, Wint says it gave him the freedom to get "the right people on the bus" by recruiting new staff members who shared similar professional and personal values, and who were both excited and inspired by plans for the future. "One of my philosophies has always been to build your team and not hire the outside consultants to do your work," he explained. "Having a highly competent staff builds internal and external confidence and morale. But rebuilding the team internally took a long time."

Joy, energy, curiosity, and initiative characterize the Institute's staff today. Frederic Bertley, vice president of science and innovation, says that the board gives the staff a sense of empowerment and competency. "What I love about the [leadership] at the Institute is that they set the direction, they guide us when we ask for guidance, but then they trust the staff do the job." The staff takes pride in the imagination, creativity, and ability of the team to inspire audiences. Despite the size of the organization (around 160 full-time employees), the staff is surprisingly connected and supportive of one another at all levels of the organization.

This esprit-de-corps was evident on a hot summer day when dozens of employees gathered outside to cheer on colleagues conducting a science demonstration on the front lawn of the Institute. With more than 100 summer campers, families, and passers-by gathered, two staffers demonstrated how liquid nitrogen, when poured into a 40 gallon trash can full of hot soapy water, creates a huge, fantastic, soapy, yet safe, explosion. As the bubbles burst, coating the demonstrators and onlookers in foam, cheers and spontaneous applause

erupted from the audience. Kids mobbed the science educators with questions and soapy hands.[3]

Earlier that week, employees gathered before opening, as they do each Friday, for coffee and conversation—no agenda, just connecting. That week's staff-organized gathering featured the Franklin Olympics (in honor of the Summer Olympiad). The whimsical inter-departmental competition began with Wint being called into service to run an Olympic torch up a ramp to light the crepe-paper Franklin "flame", accompanied by a display of sparklers and smoke, rigged by a staff engineer. The games included crazy events, ranging from one that required departmental teams to snake through a hula hoop while holding hands to a ball-toss contest involving special headgear "baskets" fashioned from two gallon plastic jugs affixed to bike helmets and worn by the opponents. The staff ingenuity contributed to the fun, and the obvious pleasure the teams took in the experience was a testament to the Institute's culture.

Troy Collins, senior vice president for programs, marketing and business development, who joined the team in 2009, explained, "We hire for culture… that's number one… the people we hire have to fit the culture… and we look for people who are genuinely committed to our mission. If you don't believe in what we do here, you may not be right for this organization." As scientists who would not leave something as important as "cultural fit" to chance, the Institute has developed a carefully calibrated tool to screen potential candidates as part of its hiring process.

With the right people and culture in place and growing alignment around a central vision, the next priority was to enable the staff to put its skills to work and deliver results. At the conclusion of the first strategic plan, Wint and Perelman both recall that the board was not entirely confident that the staff could "pull it off." It took time and a series of smaller successes to build their trust.

"['Sports Challenge'] in 2000 was the first exhibition we did as a part of the new strategic plan and it was so good, so exciting, and so interesting," Wint said. "But most importantly, it was conceptualized and designed in-house by our own staff. For the first time, the board said, 'Wow! maybe these guys do know what they are talking about.'" A highly interactive 5,500-square-foot exhibit, "Sports Challenge" introduces visitors to the physics, physiology, and material science that underpin popular sports. Visitors can even compare their

own shoes to one of basketball giant Shaquille O'Neill's, or their dress size to that of tiny Tara Lipinski's Olympic ice skating costume.

Nearly every year since 2000, another new or renovated exhibition area has opened, each better received than the last. In addition to the Fels Planetarium, Franklin Theater, and Tuttleman IMAX experiences, the Institute offers 10 core exhibitions. They range from "Space Command," where a combination of artifacts and interactive experiences takes visitors into the mysteries of space exploration, to "Electricity," which dazzles with light, energy, and participatory experiences, continuing the exploration that Franklin started by flying a kite in a thunderstorm.

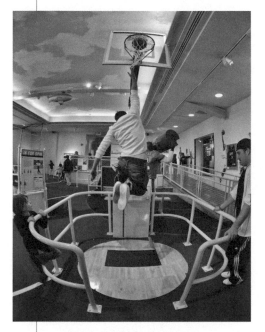

The Franklin Institute engages visitors in the physics, physiology and material science that underpin popular sports.
Photo: The Franklin Institute

Steve Snyder, vice president of exhibits and program development, pointed back to the importance of the vision and planning. "Our success… started with the fact that we had a plan, and we followed the plan. That gave [the staff] an immense amount of direction and freedom to do our jobs." Of the quest to be at the forefront of experiential and learning design, he said, "Whatever the new exhibition or experience we design is, it better make the one it is replacing look really old."

The Institute's exhibitions, museum-based experiences, and community outreach programs are linked by six core values: Curiosity, Inspiration, Engagement, Integrity, Relevance and Accessibility.[4] Its program philosophy—"Real Life, Real Time, Real Science"—emphasizes its mission to make science relevant and the Institute experience accessible, whether in person or virtually.

A walk through the hallways demonstrates the Institute's values and

commitment to audience engagement at work. Teams of facilitators—generally one senior volunteer (often a retired science, technology, engineering, or mathematics professional), joined by a teen or college student—are activating the corridors and engaging visitors by conducting real-time, hands-on science demonstrations at various stations along the way. Students, grandparents, and teachers are gathered together, learning to make paper or how to use Morse Code to send messages, and the volunteers are paired in mentor/mentee relationships, engaging with the visitors, the science content, and with each other. The audience, staff, and volunteer corps are diverse and represent a range of ages and ethnicities.

"No margin, no mission" describes the underlying business philosophy that has fueled the Institute's transformation.

In order to get the Institute back on course and enable its programmatic expansion—putting the wind in its sails, so to speak—required driving additional revenue. The Institute adopted a successful yet, to some, controversial approach to doing so. "No margin, no mission," is perhaps the central and most frequently repeated mantra at the Franklin Institute—so memorable and meaningful, in fact, that even the Institute's funders, program partners, and outside observers readily quote it (without prompting) to describe the underlying business philosophy that has fueled the Institute's transformation into a thriving 21st-century leader in STEM education. At the Institute, this rallying cry serves as a daily reminder that without the necessary resources, mission impact is impossible. The museum's commitment to financial stewardship as part of organizational performance and mission delivery has been an essential component in rebuilding its capacity, strengthening donor trust, and ensuring a solid reputation as a good investment for philanthropic dollars.

With a $25 million annual operating budget, The Franklin Institute is the largest of the institutions studied as part of this research project. Given the breadth and expansion of its programs in recent years, it is no wonder the Institute's crew pays close attention to the margins.

The Institute has successfully implemented a business model perhaps best illustrated by a characteristic Friday evening in July when every space in the Institute is activated well after closing time. Following a busy day of tourists and summer campers, staff continued to welcome visitors with timed-entry tickets for the popular "Dead Sea Scrolls" exhibition until nine p.m. With a late-night

showing of the first-run Batman film, *The Dark Knight Rises,* on the schedule, young adults queued up outside the Tuttleman IMAX Theater. Meanwhile, a bride and groom posed for pictures in Franklin Hall before enjoying their wedding reception in the Institute's event space.

This 15-hour day is business-as-usual at The Franklin Institute. Its revenue-enhancing approach to maximizing the use of its facilities is also expressed in the Institute's embrace of traveling exhibits. "Titanic: The Artifact Exhibition," the first major traveling exhibition hosted by the Institute in 2004, was anything but a disaster. Over the course of a four-month run, which was extended by popular demand, the show attracted 354,000 visitors and contributed to a 43 percent increase in admissions over the previous year. The Institute closed that year with a budget surplus.

In 2005, the Institute presented "Body Worlds: The Anatomical Exhibition of Real Human Bodies" and, in 2007, "Tutankhamun and the Golden Age of the Pharaohs," both of which also drew record audiences. These exhibitions were followed by a series of popular major traveling exhibitions ranging from "Star Wars: Where Science Meets Imagination" to "Chronicles of Narnia" to "The Dead Sea Scrolls" in 2012.

To understand the financial implications of the Institute's decision to become a preeminent East Coast venue for traveling exhibitions, one need look no further than the American Alliance of Museum's *2009 Museum Financial Information* report. Data for 2008, drawn from museums of all types and sizes, showed that earned income overall accounted for less than a third of total museum income. For children's museums and science centers, which typically report higher levels of earned income, the percentage in 2008 was 48 percent.[5] In comparison, The Franklin Institute derived closer to 80 percent from earned sources.

While it is hard to argue with success, this special exhibition strategy and reliance on earned income is not the best model for every organization. It has raised concerns for some in the museum field. Art historian Albert Elsen, in a 1984 address to the Art Museums Association of Australia, humorously defined a blockbuster as a "large-scale loan exhibition, which people who normally don't go to museums will stand in line for hours to see."[6] Some members of the museum community question this programming approach as potentially a slippery slope that can undermine an institution's mission and integrity. Others

see it as a valid means to a variety of ends, including increased revenue, broader audience appeal, greater relevance, enhanced economic impact, and funding programs for the economic disadvantaged.

Gail Harrity, president and chief operating officer of the nearby Philadelphia Museum of Art, also a venue for marquee shows, articulated the concern. "First and foremost, [we] want to be relevant to [our] community and these shows may do that…but the concern increases when the choices appear less mission-driven and more like those of a presenting venue."

Meryl Levitz, president and CEO of the Greater Philadelphia Tourism and Marketing Corporation, who has seen the positive impact these exhibitions have on tourism, nonetheless regards the blockbusters as "a double-edged sword." She related, "On the one hand, these exhibitions are a tremendous boost to our tourism marketing efforts, but on the other, they can make it harder to promote the evergreen value of the institutions. The difference here seems to be that if the exhibits are seen to be congruent with the mission, then it is less likely for the institution to fall into the trap and become dependent on the draw of the show, no matter what."

Wint readily admits that some of the Institute's choices in the early years may have been too far afield from the core content and science mission of the Institute. "While it is pretty hard to say that "Galileo," "Cleopatra," "Leonardo," or the "Dead Sea Scrolls" are not a part of our mission..."Narnia," "Pirates," and some other things…were not as on-target."

Dale McCreedy, Franklin Institute director of gender and family learning programs, has been with the organization for 30 years. "I remember there was a moment in time when we had Subaru cars in our lobby and it was a real point of tension. I wondered, 'What are we doing to ourselves?'"

"I [thought] the same thing about these big blockbusters. 'Where's the science? Where's the education?' . . . But I now have a whole different perspective. [These shows] have brought people in that had never come here before and actually exposed them to science and to the Institute. And when those people came, it gave the staff and the educators access and insight into how to work better with adults, which we are doing today."

Derrick Pitts, the Institute's chief astronomer, encapsulated how the "No Margin, No Mission" mantra works as a unifying filter for the staff decision-making. "We look at everything through the lens of mission, market, and

margin. We try to address what the audience is looking for while at the same time not throwing mission out the door for the sake of the market. And even if the market and mission support an idea, it's also got to have some margin in terms of impact, finance, or visibility." McCreedy added, "We've become an organization and a culture that thinks about those pieces altogether."

The organization, to its credit, is honing its selection process in order to avoid future missteps. In 2011, the Institute undertook a major study of the impact these exhibitions have had on audience attitudes, awareness, and participation behaviors. When asked for their impressions about whether the Institute was "getting better at what they do," "staying the same," or "getting worse," 60 percent of members and 68 percent of multiple-visit non-members perceived the Institute as gaining momentum.[7] When asked, "What first comes to mind when you think about [The Franklin Institute]?" more respondents mentioned "permanent exhibitions," "it's a science-oriented attraction," or "provides an overall positive experience (education/fun)," than mentioned the special traveling exhibits.[8]

Trustee Don Morel noted, "The business model and the mission model have to be linked. We question ourselves constantly about the touring exhibitions and their link to science. However, they have allowed us to fund tremendous mission-driven programs on the ground."

Wint explained the realities of the "No Margin, No Mission" philosophy at the Institute. "There are things that we do that sometimes are more focused on margin and others that are focused on mission… It is like making a quilt where you have different pieces that you sew together to make something whole at the end… The traveling exhibitions are just the visible tip of the iceberg. Under that is this enormous array of programs like a science high school, programs funded by National Science Foundation grants—all of which is mission-related and made possible by the revenue we generate."

The new community-responsive, mission-related outreach programs Wint references include the Science Leadership Academy (SLA), an acclaimed science magnet high school founded by the Institute in 2006. The Institute contributes to curriculum development and provides educational resources and experiences for SLA students and teachers. In 2012, SLA received more than 2,000 applications for 125 spaces in the 2013 freshman class.

Another, the competitive STEM Scholars program, provides intensive

programs to support students on STEM college and career paths. The Partnerships for Achieving Careers in Technology and Science (PACTS) program offers year-round science enrichment and education, paid internships, and mentoring to underserved students in Philadelphia's public middle and high schools. More than 3,000 students have enrolled in the PACTS program since its founding.

Thanks to the Franklin Institute's willingness and ability to convene others, Philadelphia is now home to a fast-growing science festival. In 2011, the Institute brought together more than 100 partnering institutions to launch the citywide event, which reached more than 100,000 participants in its first year. Despite playing a lead role in creating the festival, the Institute was careful to share the stage with others and take equal billing with its partners. Steve Snyder said, "The biggest payoff for all our efforts is that there has been a shift between us chasing the opportunities to the opportunities chasing us."

Civic, corporate, and philanthropic leaders focus on the results and do not seem to harbor any concerns about the Institute's approach. In fact, their attitude is quite the opposite. Stephen Mullin, a civic leader and donor to the Institute, is vice president and principal with EConsult, a Philadelphia-based economic consulting firm. From his perspective as an expert in municipal economic development, "the Institute is an important cultural amenity that contributes enormously to the quality of life for the residents of Philadelphia. [Its exhibition strategy] is not only working for the museum … but also for the city by bringing in wealth and resources. [The Institute] is attracting visitors, businesses, and attention to the city, growing [Philadelphia's] national stature, and building its intellectual reputation."

William Marrazzo, president and CEO of WHYY public broadcasting in Philadelphia, says that while the Institute was historically strong in its programs and exhibitions, now it is equally distinguished by its business performance. When asked what he views as factors in the Institute's success, he responded, "Their focus and the priority they place on mission and business strategy. I've watched them remain disciplined about living within their plan and not wasting time on the margins. That is [Wint's] footprint—he established a tone at the top and created a culture that helps people perform." Board chair Perelman added, "Everything in this place is measured on a minute-by-minute basis and

that discipline is just enormously... important in terms of what we've done. Good management is good management."

The Institute has delivered an operating surplus for all but three of the last 18 years (2008 and 2009 were two of those "off" years, as they were for nearly every cultural organization). Its business success has enabled the institution to create and grow signature educational and community-based programs. This, in turn, has resulted in the Institute becoming a more essential, trusted, and connected player in the life of the city.

PNC Bank is one supporter for which the Institute's solid financial reputation, combined with its emphasis on building relationships, has led to deeper engagement and increasing investment during the last 30 years. Beginning with a modest $1,000 gift, PNC has contributed more than $1.3 million in annual, programmatic, and capital support to date. Bill Mills, the straight-talking president of the bank, began a conversation about the Institute by saying, "PNC has a corporate foundation that does charitable things. However, we are not a charitable foundation. And that's an important thing to understand in terms of how we work with nonprofit partners. The Institute has been a good partner to PNC, and that's not semantics, it's a fact."

"The Franklin Institute is is an important cultural amenity that contributes enormously to the quality of life for the residents of Philadelphia."

A "good partner," according to Mills and Regina Canfield, senior vice president and director of corporate communications at PNC, is one that helps the Bank meet its business, marketing, and communications goals, and thus delivers a good return on investment. Most importantly, a good partner is one that listens carefully to PNC's needs and objectives and doesn't waste staff time trying to convince them to fund something that is not aligned with the Bank's programmatic emphasis.

The relationship took a significant step forward with a $200,000 gift in 2009 to launch a "Grow Up Great With Science" partnership with the Institute. It was part of a $100 million national commitment PNC made over 10 years to ensure high quality, pre-school education for underserved children. Canfield related that PNC's first "Grow Up Great" partnership investment with the Institute was a direct result of their long-term engagement with the Bank and the levels of familiarity and trust that had grown over time. "We had

a long-standing relationship with the folks here [at the Institute], so as 'Grow Up Great'... was being introduced [by PNC], the Franklin Institute understood where we were coming from in terms of what our goals and objectives were ... for [developing] science and math skills for Pre-K kids."

PNC's increasing participation is indicative of the growing financial support and success the Institute's performance has engendered. In 2006, the Institute launched its "Inspire Science" campaign with an initial goal of $60 million to complete a new 53,000-square-foot addition adjacent to Franklin Hall, along with other maintenance and life-safety projects. The addition will include the Institute's newest core exhibit on the brain, expanded climate-controlled space for traveling exhibitions, and educational program areas. By the fall of 2012, the campaign had raised over $65 million, surpassing its goal despite the deep and lingering effects of the 2008 recession.

Annual corporate giving for unrestricted operating expenses has risen 53 percent in the last decade. Other sources of funding also have been on the rise. Individual unrestricted giving has more than doubled and board giving has increased by nearly 80 percent from the same number of trustees over the same period. The Institute also has been successful in institutional fundraising. From 2000 to 2005, it received eight federal grants totaling $6.4 million, and by 2012, the Institute was a lead or partner in 20 federal grants totaling $20.6 million.

Marsha Perelman credits the Institute's fundraising growth to its investment in building new relationships and its reputation for success. "As...we have accomplished more and more, doing what we said we were going to do, people have increasingly wanted to buy into that. The simplest proof... is when we announced the [lead gift to the capital campaign] in October (a $10 million donation from a new donor couple), which got us from $47 [million] to $57 [million], it was only a blink [of an eye] to get from $57 to $65 million," where the Institute finished the campaign.

Since 1998, the Institute has been part of the Pew Charitable Trusts' Philadelphia Cultural Leadership Program, in which regional cultural organizations were evaluated against national standards for well-managed arts institutions.[9] In 2010, The Franklin Institute was the highest-scoring organization evaluated. Don Kimelman, managing director of the Pew Charitable Trusts' Information Initiatives and its Philadelphia Program, explained, "Leadership and management are the key here and leadership comes in two forms: the board chair and

the museum director. The partnership between Marsha [Perelman] and Dennis [Wint] is very strong. The quality of the staff management team is also very strong… [Together,] they have created a highly effective cultural organization."

Perelman drew a parallel between high-performance corporations and nonprofits. "It's the same thing as being on a for-profit board of a public company. The stocks trade on whether your earnings met target, whether your quarterly announcements are in line with the guidance you gave at the beginning of the year. It all boils down to whether you are going to trust a company if senior management does not deliver on what it says it is going to do… And it's the same for nonprofits… If an organization gets in trouble, people will only rally around it if there is enormous love and appreciation of the institution."

The Franklin Institute has proven its ability to attract and retain human, social, brand, and financial capital through its consistent delivery of high quality programs, its disciplined approach to management, and its investment in people. Wint credits the Institute's strengthened performance as a catalyst for increased stakeholder enthusiasm "Earlier on, the Institute was well positioned in the community and had a fine reputation as a place to be involved with. But the passion wasn't there until we communicated a vision and built the strength of the organization to support it. The level of commitment we see today came about because of our increased performance."

PNC's Bill Mills agrees. "Museums, like banks, are in the relationship business. They have to win trust and perform at the highest level every day. There is no substitute for good leadership, management, and people at the helm."

As Wint eyes retirement from the Institute "to go sailing as often as I can," his staff and trustees prepare for the transition. Succession planning and the impact a change in leadership may have on the Institute's culture are of concern, according to Trustee Don Morel. "This is our number one issue right now. We need to look for someone with new skills and [his/her] sights set on the new horizon to take us forward, while preserving the cultural integrity of the workplace that has gotten us [to] where we are today." Wint, however is confident in his crew's ability to carry on. He knows that they have been charting the course to the future and trimming the sails all along.

SIX MAGNETIC TIPS
FOR CREATING HIGH PERFORMANCE TEAMS

1. Create a team that shares common values and work ethics, has the requisite skills and knowledge, and visibly communicates enthusiasm for the museum vision.

2. Establish an optimistic, energetic, and forward-looking culture that motivates staff to meet or exceed expectations. Ensure a "no-fear" workplace that encourages candid feedback, experimentation, learning, and positive accountability.

3. Push financial literacy down and build budgets from the bottom up. Establish widespread understanding of the mission/margin balance. Live within your means and deliver on what you promise.

4. Recruit the best possible trustees and never settle for less. Enhance board performance by investing significant time to regularly inform, involve, and consult with members about the museum's work. Evaluate board performance on an annual basis.

5. As a leader, be self-reflective and engage in continuous adaptive planning to ensure that efforts are on track, goals and approaches are responsive to changing environments, and the board/staff team is fully engaged in the process.

6. Gauge how much change your organization can handle and how fast. Arm yourself with patience; stay the course and don't quit too soon. Remember that change takes time.

Chapter 7 Notes

1. Yo-Yo Ma.com, http://www.yo-yoma.com/yo-yo-ma-biography (accessed 20 Dec. 2012).

2. James R. Oestreich, "At Lunch With: Yo-Yo Ma: 1 Part Earnestness, 1 Blast of Laughter," *The New York Times*, 21 Sept. 1994, http://www.nytimes.com/1994/09/21/garden/at-lunch-with-yo-yo-ma-1-part-earnestness-1-blast-of-laughter.html?pagewanted=all&src=pm (accessed 20 Dec. 2012).

3. Malcolm Gladwell, *Outliers: The Story of Success* (New York: Little, Brown and Company, 2008), 35-69.

4. Gladwell.com, http://www.gladwell.com/outliers/index.html (accessed 22 Dec. 2012).

5. Morrie Warshawski, ed., "Organizational Self-Assessment Checklist," *Lessons Learned*, National Endowment for the Arts, http://www.nea.gov/resources/Lessons/warshawski.html (accessed 22 Dec. 2012).

6. The Pew Charitable Trusts, Philadelphia Cultural Leadership Project, http://www.pewtrusts.org/uploadedFiles/wwwpewtrustsorg/TaxonomyCopy/Arts_and_Culture/Philadelphia_Cultural_Leadership_Program/PCLP-Program-Description-2013.pdf (accessed 12 Dec. 2012).

7. Maxwell L. Anderson, "The Metrics of Success in Art Museums", (Los Angeles: The Getty Leadership Institute, J. Paul Getty Trust, 2004).

8. Indianapolis Museum of Art, http://dashboard.imamuseum.org (accessed 20 Dec. 2012).

9. Museumgeek.wordpress.com, "How is the World Different Because Your Museum is Online?" 24 Aug. 2012, http://museumgeek.wordpress.com/2012/08/24/how-is-the-world-different-because-your-museum-is-online/ (accessed 3 Jan. 2012).

10. André A. De Waal, "The Characteristics of a High Performance Organisation," January 2010, www.hpocenter.nl (accessed 23 Dec. 2012).

11. *Ibid.*

12. *Ibid.*

13. Museum evaluator Randi Korn of Randi Korn & Associates proposed the concept of "holistic intentionality" in an article published in *Curator*, April 2007. She writes, "Museums that strive for intentionality operate from a set of carefully crafted intentions that…define and describe what the museum wants to achieve. They reflect and describe the essence of the museum and its unique value and potential impact on the community. Most importantly, they represent the deepest passions of the museum leadership and staff…" (257). "Intentionality requires that a museum operates holistically and seeks active participation from all museum staff and board" (260). While we use the terms in a different way, the concepts are closely related.

14. Randi Korn, "The Case for Holistic Intentionality." *Curator*, Vol. 50, Issue 2, April 2007. http://www.randikorn.com/docs/the_case%20for_holistic_intentionality_042007.pdf (accessed 12 Nov. 2012).

15. Anne Bergeron, Beth Tuttle, Leslie Findlen, and Ellen Rosenthal, "Inside the Magnetic Museum: Leadership Perspectives on Building Core, Brand and Social Magnetism," American Association of Museums Annual Meeting, Houston, TX, 23 May 2011.

16. Author's interview with Saleem Ghubril, The Pittsburgh Promise, 24 Jul. 2012.

17. Conger emphasizes that in order for a leader to be perceived as charismatic, his/her vision must be vision perceived by constituents as relevant or important to their needs.

18. Jay A. Conger, *The Charismatic Leader: Beyond the Mystique of Exceptional Leadership*. (San Francisco: Jossey Bass Inc., 1989) 25-34.

19. *Ibid.* 20.

20. The Greenleaf Center for Servant Leadership, http://www.greenleaf.org/whatissl/ (accessed 26 Dec. 2012).

21. American Association of Museums, "2012 National Comparative Museum Salary Study," (Washington, DC: American Alliance of Museums in collaboration with Association of Midwest Museums, Mountain Plains Museum Association, New England Museum Association, Southeastern Museums Conference, 2012) 19.

22. Author interview with Dennis Wint, The Franklin Institute, 2 Aug. 2012.

23. Maria Cornelius, Rick Moyers and Jeanne Bell, "Daring to Lead 2011: A National Study of Nonprofit Executive Leadership," (Washington: CompassPoint Nonprofit Services and the Meyer Foundation, 2011) 5. http://daringtolead.org/reports-briefs/full-report/ (accessed 10 Nov. 2012).

24. Author Interview with Don Kimelman, The Pew Charitable Trusts, 3 Aug. 2012.

25. Author interview with Don Harrison, ONEOK Foundation, 17 Aug. 2012.

26. Author interview with William Marrazzo, WHYY, 3 Aug. 2012.

Chapter 7 Case Study Notes

1. Antoine de Saint-Exupery, *The Wisdom of the Sands*, (New York: Harcourt Brace, 1950).

2. The information and quotations presented in this case study are taken directly from author interviews with The Franklin Institute staff, trustees and stakeholders, or from internal or publicly accessible organizational data.

3. YouTube, "Double Bubble Soap Monster," http://www.youtube.com/watch?v=sVWeUdpfdL4 (accessed 8 Jan. 2013).

4. The Franklin Institute, Strategic Plan, 30 Sep. 1996.

5. Elizabeth E. Merritt, and Philip M. Katz, eds., *Museum Financial Information 2009*, (Washington. DC: American Association of Museums, 2009), 56–58.

6. *Australian Science and Technology Exhibitors Network*, http://www.astenetwork.net/issues/blockbuster_phenomenon.html (accessed 5 Jan. 2013).

7. Rabin Research Company, "The Franklin Institute Community Study Report," 16 Nov. 2011, 59.

8. *Ibid.*

9. The Pew Charitable Trusts, Philadelphia Cultural Leadership Project, http://www.pewtrusts.org/uploadedFiles/wwwpewtrustsorg/TaxonomyCopy/Arts_and_Culture/Philadelphia_Cultural_Leadership_Program/PCLP-Program-Description-2013.pdf (accessed 12 Dec. 2012).

chapter 8

On Becoming Magnetic

When we began this research project in 2009, it was a challenging time for museums, nonprofits, and other businesses. The economic downturn had constrained resources for numerous organizations, and the bright passion and enthusiasm that so many of our colleagues brought to work every day were dampened by a sense of concern for the future. But through this study, we found a group of museums that were thriving, growing, and having fun despite the challenges. Their stories offer guidance that we hope will be helpful to others.

Becoming a magnetic organization, as the case studies show, is about making intentional choices. The museums we profiled have clarified, for themselves and their communities, what their museums aspire to be, whom they serve, and why they matter. They have purposely chosen to invest time and resources to engage and empower their employees, trustees, donors, and audiences. They have purposely chosen to look outward to their communities and to generously share their assets. They also have proactively invited their communities to participate in the lives of their museums. Moreover, by sustaining a superior level of organizational performance and being responsible and responsive cultural stewards, they have garnered both trust and respect from their communities and their peers. They have taken a holistic approach and embraced the six practices of magnetism so that each reinforces the other. And while the leaders of Magnetic Museums would not say the task was easy, they do agree it was worth the effort.

Today, your organization may be facing any number of challenges. Perhaps the economic downturn still has you looking for new ideas to increase earned and unearned revenue streams to eliminate a troublesome deficit. Or your facility is suffering from deferred maintenance or inadequate storage for collections. Perhaps there are critical vacancies on your board or senior staff, and limited succession planning for both. The museums whose stories are shared in this book experienced all of these things and much more.

Yet, even so, they all started their journeys to magnetism in the same manner. They stepped back and got to the heart of what they believed was their true value and purpose—the "why"—at the center of their museums. You can start there, too. For the institutions in this book, the answer to that "why" question always led back to a fundamental and abiding belief in the power of museums to change lives and communities in myriad ways.

National Public Radio's "This I Believe" program, produced from 2005 through 2009, featured personal essays by people from all walks of life sharing stories about their values, philosophies, and experiences. The five-minute pieces were always thought-provoking, but occasionally one of the essays would reach out, grab the listener by the ear, and not let go. Seven-year-old Tarak McLain of Austin, Tex., submitted one such memorable story, called "30 Things I Believe." As a kindergartener, McLain was asked to bring to class 100 items in celebration of the 100th day of school. He chose to bring in a somewhat unusual collection: a list of 100 things he believed in.

McLain's list included such statements as:

"I believe life is good."
"I believe everyone is weird in their own way."
"I believe hate is a cause for love."
"I believe in magic."
"I believe we live best in a community."

McLain's upbringing instilled in him a strong sense of community, even at a very young age. He recounted that he tries to put his beliefs into action, raising $350 for a school in Thailand and organizing friends and neighbors to hold a yard sale to benefit another school in Honduras. Listening to the authenticity in McLain's young voice as he reads 30 of his 100 beliefs out loud, one cannot help but be drawn to him. [1]

We rarely hear people speak of their core beliefs and values so explicitly, which may explain what makes the NPR program, and Magnetic Museums, so engaging, so compelling, and so successful.

If you are a museum professional reading this book, you will likely say that a message conveying an aspirational belief like "art transforms lives" simply doesn't work to create the kind of public support and engagement that the museums in our study are engendering. (See Cincinnati's *ArtsWave* report cited in Chapter 6.) We would suggest that the reason lies in the difference between "saying" and "doing."

Ultimately, perceptions (like brands) are built not on what organizations say about themselves, but on the ways in which others come to know and experience them.

Magnetic organizations not only express their beliefs, they take them one step further. They bring their beliefs to life by enacting them in ways that make their visions and aspirations tangible and visible. They direct their beliefs and actions to specific audiences or communities, to specific needs to be addressed, or to specific outcomes to be achieved. They are mission-driven, audience-focused, and purpose-linked around a compelling vision. Above all, they deliver the experiences they promise.

GETTING STARTED

Following the lead of the museums in this study, the first step in making your organization magnetic is identifying and reigniting your passion. You must do this for yourself and with others who are essential to your enterprise so that together you can begin the process of putting the six practices in motion. A good way to start is by inviting your staff and trustees to tell their stories. Think about a time when your organization was operating at peak performance, having exactly the kind of desired impact on audiences. Who was there? What was different? How did people respond? Reflect on what your staff was hearing, seeing, and saying in that moment. Stand in the shoes of a visitor and imagine what s/he might have been thinking and feeling. Remember a time when an experience or encounter genuinely moved you, and dig deeper to find the true meaning behind the moment. The time that you spend collectively finding the motivation behind your institution's mission will be worth the effort. By telling stories, you will begin to shift from your head to your heart. And the heart is where the spark of every individual's passion lies.

We found that the strength of a museum's magnetism relies, more than anything else, on the level of passion, energy, and commitment of the people who dedicate themselves to the museum. Their authentic voices raised in support of the institution's values lend credibility and power to the organization's message. Once you have engaged your "peeps" in the process of collective visioning, ensure that key individuals on the staff and board share the values and vision that will guide your organization's future. If they do not, take decisive action. If your museum is experiencing issues related to morale, initiative, or attention to quality, we urge you to remember the internal and external benefits that accrue from adopting a customer-service orientation.

Embrace the principal themes of this book: alignment, engagement, empowerment, inclusion, relevance, and performance. The genesis of magnetism is core alignment—and internal engagement and empowerment lead to alignment. External engagement and inclusion broaden the reach of the magnetic field and its ability to attract others. Increased relevance and sustained performance strengthen an organization's magnetic "pull." All of

these combine to attract and retain the critical resources of core, social, brand, and financial capital. The reinvestment of that capital over time will begin a positive cycle of results.

The museums we profiled did not achieve results by focusing solely on their own agendas. Each of these institutions turned outward, connected with its community, listened deeply to its stakeholders' needs and aspirations, and worked diligently to serve those needs. In every case, the resources that returned to these museums were driven by and proportional to the amount of investment they made in others.

As you envision your museum's future, remember to invite donors, partners, and members of the community to tell their stories—why they visit or support your institution, or why they stay away; what issues and needs concern them; what role your museum can play in their lives. The experience of sharing stories begins the process of creating relationships and building trust.

PUTTING IT ALL TOGETHER

Throughout this book we have written about the alignment that must occur at the center of an organization in order for it to become magnetic. We've also written about a holistic, 360-degree, continuous approach to engagement, empowerment, and community building, which we and the museums profiled here believe results in increased relevance, loyalty, motivation, and satisfaction, as well as stronger overall organizational performance.

We have traced the two strands of "meaning" and "means" that are purposefully woven together inside Magnetic Museums. "Meaning" is created in museums in a variety of ways. Visitors experience "meaning" when they encounter and respond to objects, information, people, and ideas. Employees, trustees, and volunteers derive "meaning" from doing work that aligns with their personal values, interests, and passions. Civic leaders and community members ascribe "meaning" to the museum based on its relevance, value, and role in the public arena.

"Means," on the other hand, are the organizational cultures, structures, processes, programs, and initiatives that fuel the museum enterprise. They include the human, intellectual, and financial resources needed to conduct business.

Magnetic Museums successfully integrate "meaning" and "means." They make the connection between people and performance. They develop relationships and deliver return on investment. Moreover, they link and enhance intrinsic cultural value with extrinsic civic value, which allows them to thrive and grow in the midst of ever more appreciative and supportive employees, stakeholders, audiences, and communities.

The identifying characteristics of an individual, especially those that are innate,

immutable, and unchanging, are often described as being part of that person's DNA. And although our study makes clear that organizational magnetism is largely made, not born, the familiar three-dimensional double helix model of the gene, which carries the essential code of life, is a useful metaphor for visualizing what's happening inside these museums. (Figure 8.1)

Figure 8.1 Deoxyribonucleic acid (DNA). Photo: Shutterstock

The two strands of mission orientation (meaning) and business orientation (means) spiral in opposite directions. Powerful bonds created by a museum's efforts to align, engage, empower, and intersect with the people it serves connect and strengthen the strands. When all the bonds are in place and interconnected, the institution becomes its best, whole, true self. A museum experiences genuine "well being," manifest not only in the absence of "illness or pathology," [2] but more positively by realizing its unique potential through physical, emotional, spiritual, and social health, especially in relation to its stakeholders and its community.

The case stories have shown how these Magnetic Museums built strength by sharing their strengths. The more they supported their people, the more their employees and trustees became personally responsible and accountable for the organization's work. The better they managed their resources, the more willing people were to invest in them. The more they cultivated and nurtured relationships, the stronger the bonds of community loyalty and support grew. And the more consistently they delivered positive results, the more people trusted that they would continue to deliver positive results in the future.

Although some of the museums began their journeys to magnetism focused on one or two of the practices, by applying and integrating all six practices over time, their efforts gained traction and momentum. As they practiced continuous 360 engagement, their magnetic fields grew stronger and reached farther. Talented staff joined their organizations and stayed. Strong board members became easier to recruit and funding became easier to attain.

Putting it all together means nurturing high-performance people to create high-performance organizations. Putting it all together means attracting and retaining the resources to fuel a museum's mission and vision, making them tangible and visible in ways that draw more talented people to the cause. Putting it all together means connecting the pathways of meaning and means, reinforcing what has gone before and contributing to what lies ahead.

THE MEANING OF MAGNETIC MUSEUMS

We were drawn to the field of museum work by the promise it offered—to us as individuals, to our communities, and to society as a whole. The time we have spent with the many museums that helped us to tell this story of magnetism has only reinforced our own passion for the valuable role of museums in today's world. We hope that reading this book will have the same impact on its readers.

Becoming magnetic is a journey and remaining magnetic is a lifetime pursuit. Each museum was quick to reassure us, however, that the path to magnetism and the cycle of engagement get easier over time. Not a group to rest on its laurels, once the museums in the case studies neared or reached their initial goals, they immediately began to formulate a vision for the next horizon—enlisting, aligning, and empowering the right "peeps;" continually widening the circle of engagement; and taking the pulse of their communities to stay essential and relevant, even amidst changing circumstances. Continuous visioning, experimentation, listening, and improvement are essential parts of maintaining high performance.

We hope that the experiences of these six Magnetic Museums inspire you and your organization—large or small, nonprofit or corporate—to embrace the art and science of engagement in order to build trust and loyalty, create meaningful experiences, and nurture relationships with and among people. Here's to becoming magnetic.

Chapter 8 Notes

1. Tarak McLain, "Thirty Things I Believe," 18 Jan. 2009, prod. Jay Allison and Dan Gediman with John Gregory and Vicki Merrick, *All Things Considered,* (National Public Radio).

2. Fiona McAllister, "Wellbeing Concepts and Challenges," Dec. 2005, 6, http://www.sd-research.org.uk/wp-content/uploads/sdrnwellbeingpaper-final_000.pdf (accessed 14 Jan. 2013).

appendix a
Methodology

PROJECT BEGINNINGS

At the 2010 AAM annual conference, we made a presentation called "Secrets of the Magnetic Museum: Leveraging Brand and Social Capital." Our talk was designed to share the success stories of nine museums that had undergone significant transformations as a result of adopting a principal strategy of community engagement—building relationships with and more deeply engaging internal and external stakeholders. The topic was eminently interesting to us, but we weren't quite sure anyone else at the conference shared our passion.

The huge empty conference room that AAM had assigned to us for the late Sunday afternoon presentation did little to alleviate our initial worries. We thought that AAM had overestimated interest in our topic and we'd be facing 25 people lost in a sea of unoccupied seats. Much to our surprise, that didn't happen. Over 200 people eventually filled the room and we had a lively and engaging discussion. At the end, someone asked, "When's the book coming out?" So, to speak directly to this individual and those at the presentation who may have wondered the same thing, we'd like to say, "It's here."

Magnetic is a direct result of the thinking that led up to that presentation and the culmination of a two-year research project. We share this anecdote, not simply to make this otherwise dry methodology section more inviting to read, but because our insights and our methods were substantially informed by the many people who helped us along the way, including the unidentified person who suggested that we write a book. In fact, the more we acted like Magnetic Museums—turning outward and inviting the outside in—the more our thinking expanded and the more this project benefited from numerous voices, perspectives, and expertise.

We are grateful for all of the insights, questions, and comments that we received along this journey, in particular, from our friends at AAM and at Georgetown University's Center for Public and Nonprofit Leadership, where we served as visiting practitioners in 2010–12, and from the 11-person Advisory Committee we organized, all of whom are recognized in the Acknowledgements.

OUR APPROACH

The goal in our research and writing of *Magnetic* was to examine how and why some organizations had outperformed their peers over the last decade and to identify the common practices and traits contributing to their success. We had a hypothesis in mind, based on anecdotal conversations and our own experience with dozens of museums, that one factor of success might be the level of investment the museums had made in nurturing and leveraging internal and external relationships. We were interested in exploring the organizational and business impact of adopting a people-oriented and externally focused strategy and management philosophy.

This book seeks to weave together a number of the current threads of conversation that have been developing in the field for some time, among them, "being for someone as well as about something," "moving from nice to necessary," "becoming more than a museum," and "building community." The qualitative case-study approach has enabled us to document what these museums have been doing and the business results they have experienced, as well as to explore the "why" that has motivated their transformations. We hope this book will make a substantial contribution towards a definition of high performance in the museum sector. Further, we hope that it will inspire and be a useful guide for institutions seeking similar transformations.

We are practitioners, and one of the most valuable things we do is to bring a range of perspectives and a depth of multi-institutional experience and insight to the challenges that organizations face. We sought, therefore, to draw on the breadth of current research and thinking about leadership, organizational culture, customer service, civic engagement, innovation, and talent management from both the corporate and nonprofit sectors. While many of the insights that emerged validated our experience, others challenged us to think anew about many of the accepted norms of museum management.

We are not social scientists, nor did we have access to funding to support our work (although we did try—even Kickstarter rejected our application!). Both of these issues posed limitations to the study. We were well advised, however, in crafting a systematic approach to identifying the universe of high-performing museums and conducting the case studies.

The insights and conclusions we offer are based on a combination of 1. quantitative analysis of the performance of museums using self-reported data from the triennial AAM Museum Financial Information survey and the National Center for Charitable Statistics; 2. what we saw and heard during our case study visits; 3. qualitative insights drawn from numerous additional conversations and interviews; 4. a wide-ranging review of the literature, including academic studies, popular business books, and just about everything in between; and 5. our own practitioners' perspective and experience. Causal links can only be hypothesized and any correlations we draw reflect the perceptions and experiences shared by the study participants.

METHODOLOGY: LEARNING TO (SORTA) BE SOCIAL SCIENTISTS

Phase 1: Defining "High Performance"
and Setting Parameters

Definitions

The first step in our process was to develop a working definition of the hypothetical "Magnetic Museum." Based on preliminary insights gleaned from a series of conversations with colleagues and experts in the field and in-depth interviews conducted with nine museums in preparation for our 2010 AAM presentation, we developed a set of descriptive statements that encapsulated our hypothesis:

> *Magnetic Museums are high-performing organizations that take very intentional approaches to developing and articulating inspiring visions or future goals. They invite participation and shared ownership by prioritizing visitor engagement, building relationships, and strengthening brand identity as the means to achieve their visions. We hypothesize that, through this approach, they attract and retain increased human, programmatic, and financial resources.*[1]

At the conclusion of the study, we developed a new definition:

> *Magnetic Museums are high-performance organizations that deliver tangible cultural and civic value, and achieve superior business results, through a commitment to service, engagement, and empowerment of others. They are distinguished by powerful alignment around a compelling vision and the lasting bonds they create through meaningful experiences that enrich and strengthen their internal and external communities.*

The most significant challenge we faced, as anyone who studies museums knows, is the lack of commonly accepted definitions in the field and a comprehensive go-to source for data. As Elizabeth Merritt writes in the introduction to the AAM *2009 Museum Financial Information* (MFI) report, "You can't really define museums…you can't count museums…you can't categorize them as museums, at least not neatly, [and] museums do not speak a common statistical language."[2] Unlike the for-profit sector where financial performance is the universal standard for measuring success, this is inadequate for the cultural sector (and the nonprofit sector in general). In terms of museum performance, intangibles and qualitative differences do matter.

Despite protestations that the triennial MFI report is "an act of faith…entail[ing] fuzzy boundaries and an optimistic belief that we are indeed measuring what we hope to measure,"[3] it remains the best available and deepest source of consistently collected and analyzed longitudinal data. We are grateful to AAM for making this resource available to us.

As noted in the Introduction, we asked ourselves whether "bigger is better" in terms of defining high performance for museums. Following the recession, for example, many organizations have made "right sizing" their priority, rather than growth. So while growth is not a sufficient or the only measure of a healthy and effective institution, it is an indicator of positive momentum. Because our original inquiries had focused on the relationship between audience and stakeholder engagement and generating the resources required to fuel the programmatic efforts that facilitate

mission impact, we determined that growth was an appropriate indicator for helping to identify Magnetic Museums.

As there is no standard definition of high performance for museums and no commonly accepted set of metrics, we had to develop these tools. In June 2011, we convened our 11-member Advisory Committee on a hot summer afternoon in Georgetown to seek counsel on how and what to measure in relation to organizational performance. They also guided us in developing the case study methodology that we utilized in this project.

We created a Magnetic Museums Performance Metrics chart adapted from an index created by the Pew Charitable Trusts for its Philadelphia Cultural Leadership Program, which defined areas for programmatic, fiscal and management performance.[4] We also consulted AAM's *National Standards and Best Practices for U.S. Museums*[5] to ensure that we incorporated the accepted benchmarks for museum performance in our Magnetic Museums assessment. The chart, which served as our internal research guide, summarized key indicators and metrics in the following categories: Identity and Purpose; Leadership and Management; Programs and Collections; Facilities and Physical Space; Finance; Strategic and Business Planning; Resource Development; Internal and External Stakeholder Engagement; Audience Development, Insight and Engagement; Brand, Marketing and Communications; and Social Capital Building.

We excluded from this study any independent examination or assessment of education, interpretation, or other content and collection-based practices to determine "quality" or "impact," because that was beyond the scope of our expertise and our available resources. Instead, we chose to highlight relevant approaches taken by the study museums to leverage or otherwise use their collection assets and functions in support of engaging audiences and stakeholders.

Parameters

We also needed to set parameters for the study that would make it meaningful and useful to readers. We used the following criteria to screen and select organizations for the study:

Size/Scale of Operations. Museums range in size from very small, with budgets in the tens of thousands of dollars and run by volunteer staff, to very large, with hundreds of thousands of square feet of facilities and a myriad of objects in their collections. Because we were interested in how museums relate to their external publics, and this generally requires a minimum number of staff and financial resources, we decided to exclude museums with annual operating budgets of less than $1 million. We did not set a parameter on the high end of operations.

Governance. Museums in this study are independently governed, meaning that at least 50 percent of their boards of trustees are not appointed by or subject to the approval of a parent entity. Their governing board is the body with legal and fiduciary responsibility for the museum and for approving its policies.

Sources of Revenue. We were interested in museums that pay their own way each year. Museums that receive more than 50 percent of their annual operating funds from a government, university, endowment, or other single source were excluded.

Geography. Museums in all 50 United States, U.S. territories, and the District of Columbia were eligible for the study. In selecting the case study institutions, we sought geographic distribution to the extent possible as represented in the eligible sample.

Museum Type. We used AAM's six classifications of museum type: Art Museum, Children's/ Youth Museum, General Museum, Historic House/Site, History Museum/Historical Society, Living Collections (Aquaria, Aboreta/Botanical Gardens, Nature Centers and Zoos), Natural History/Anthropology Museum, Science/Technology Center/Museum, and Specialized Museum. For illustrative purposes, we selected a range of types of institutions for the case studies.

Time Frame. Three factors influenced our selection of the decade from 2000 to 2010 as the focus of this study. We were interested in studying organizational transformations that had been underway long enough to see resulting performance and business trends. We wanted to ensure that sufficient numbers of people who had been personally involved with or aware of the organization during the study period were still in place and available for interviews. We also thought it was important to correspond the study's time frame with AAM's data collection cycle, which spanned from 2000 to 2002 (reported in 2003), 2003 to 2005 (reported in 2006), and 2006 to 2008 (reported in 2009). All study museums were asked to complete a supplemental survey providing comparable data in order to bring the data set up to 2010.

Conflict of Interest. We excluded from this study any institutions for which either Anne Bergeron or Beth Tuttle had been employed or hired on a consulting basis during the time frame of this research project.

Literature Review

We did a significant amount of reading and created an annotated bibliography of current and recent past literature on both for-profit and nonprofit leadership and management; museums and arts organization management; social capital and community engagement; audience development and visitor engagement; and branding, corporate marketing, and storytelling. This helped to ground our research and bring an outside perspective to the study.

Phase 2: Identifying High-Performing Museums

AAM Data Set

We began our research with an existing set of self-reported, unattributed museum financial data collected by the American Association of Museums between 2000 and 2008 through its Museum Financial Information (MFI) survey. (Per the time frame notation above, this data set was compiled from AAM's 2003 MFI and 2009 MFI.) AAM's MFI survey instrument remained largely the same for both collection cycles, which made data comparison possible. One hundred ninety-seven museums had completed the survey in both of these years.

In order to prevent skewing, we determined that institutions must have provided, at minimum, information on operating income and operating expenses to be included in the study. We excluded museums that derived 50 percent or more of their operating income from a single source,

like an endowment or a parent organization (i.e., university), as well as those that had been in capital campaign mode during the time period, which skewed their unearned revenue. After removing those with incomplete surveys, as well as those with single source or campaign funding, our data set comprised 142 museums.

From the original AAM survey instrument, we selected 18 key indicators for analysis—number of full-time paid staff positions; attendance; total operating income; total operating expenses; breakout of operating income (government, private, earned, and investment); breakout of operating expenses (museum-related activities, management and general expenses, and fundraising); membership income; endowment (operating income, value of endowment, principal net change, market value net change); operating income from other investment sources; and marketing budget.

Comparing 2000 to 2008, we calculated a ratio of change for each indicator—(2008–2000)/2000—and eliminated all zero values to avoid the presence of any irrational numbers. Then we undertook a standard deviation process, deriving standard scores by converting percent of change for each indicator to a normalized z-score.

In statistics, a standard score indicates how many standard deviations an observation or data value falls above or below the mean. So in this case, it indicated how well a museum performed above or below the average. If a raw score is above the mean, the z-score will be positive; if a raw score is below the mean, the z-score will be negative. Approximately 95 percent of the data values will have z-scores between -2 and +2, and only 2.5 percent will have z-scores above +2.

Using a fair and even application of weighting for each indicator, we calculated descriptive statistics (summarizing the sample) using Microsoft Excel and IBM Statistical Package for the Social Scientist software. To compile overall z-scores, we averaged the z-scores for each individual museum, and from this produced a final ranking. We also segmented the museums into three clusters according to operating budget size—small, medium and large—and re-ranked them within each cluster. We wanted to see if there was any difference when comparing similarly sized peers. It turned out there was not.

The quantitative analysis of the AAM sample identified 51 of the 142 museums as above average (with a positive z-score of 0+) in rates of growth and operating performance.

What was interesting to note is that 35 percent of the high-ranking museums (18 of the 51) were self-classified as art museums. We did not have the ability to tell if art museums were doing something differently from the rest of the field to score higher on quantitative metrics or if simply more art museums had completed the AAM financial surveys during the time period we studied. However, of the six case study museums, we did choose to highlight two art museums.

Another point that caught our attention is that four of the museums we profiled have children, youth, and families as their principal audiences, and two of these are science-based (Children's Museum Pittsburgh, Conner Prairie Interactive History Park, The Franklin Institute, and Natural Science Center Greensboro). Although the case study makes clear that Conner Prairie was not always so interactive, we wondered if there might be a lesson to be learned from family-oriented institutions. Those that have families and children as their focus often incorporate participatory

audience engagement into their practices. Science organizations are grounded in the scientific method and may be more naturally inclined to embrace experimentation, data-driven decision-making, and organizational learning. Further research is required to better understand this issue.

NCCS Data Set

For validation and comparison purposes, we then analyzed a corresponding set of available financial data for museums, historical societies, and other similar organizations, as compiled by the National Center for Charitable Statistics (NCCS) of the Urban Institute. NCCS aggregates information from the completed 990 forms filed by nonprofit organizations with the Internal Revenue Service.

The data set included organizations that self-identified as one or more of the following National Taxonomy of Exempt Entities (NTEE) codes: museums (A50), children's museum (A52), folk art museums (A53), history museums (A54), natural history museums (A56), science and technology museums (A57), historical societies and historic preservation (A82), botanical gardens and arboreta (C41), and zoos and aquariums (D50).

The selected organizations were evaluated over a seven-year period, from 1998 to 2005 (the data made available to us). The data set comprised 3,239 organizations that filed 990s in both years.

The NCCS sample contained scant indicators of performance and only two that overlapped with the AAM indicators—total operating income and total operating expenses. Using the same analysis methods as the AAM sample, we calculated a ratio of change for each indicator and computed an average z-score for each organization.

The quantitative analysis of the NCCS sample identified 149 organizations as above average in rates of growth and operating performance as indicated by the selected metrics. Recognizing that this ranking was based on very limited information, we then wrote to each of these organizations and asked them to complete a Magnetic Museums financial survey that included the subset of questions used in the AAM instrument, from which we had drawn the 18 target metrics to gauge organizational performance. Thirteen organizations responded with completed surveys, providing information about their operational performance in 2000 and 2008. We analyzed the data using the same standard deviation process outlined above.

We made note of the fact that the AAM sample is biased high relative to the NCCS model. The average total revenue for the AAM data sample is $5,821,048, with a 95 percent confidence interval of $3,854,711 to $7,787,385. (A confidence interval indicates the reliability of an estimate; in this case, we chose to use 95 percent as our standard of confidence for the data.) The average total revenue for the NCCS data sample is $1,169,111, which falls well below the 95 percent confidence interval.

Obstacles to Comparable Data Set Analysis

Phillip M. Katz, assistant director for research at AAM, and Carlos Manjarrez, director of the office of planning, research, and evaluation for the Institute for Museum and Library Services (IMLS), advised us through the quantitative analysis of museum data. They encouraged us to study a set of museums that performed below the norm in order to compare their experiences with those of our

high performing group. This type of matched-pair study is used to identify significant differences between the results of two similarly situated organizations.

There were several barriers to our ability to conduct a review of comparable organizations. First, finding truly comparable museums was nearly impossible. To constitute a match, we needed to find museums of similar size and focus in similarly situated markets that had been doing essentially the same things over the same period of time, yet achieving different results. Although we could use the AAM data to identify low performers, in order to truly understand the differences, we would have to rely on the cooperation of those low-performing organizations to complete the study. We concluded that being identified as low-performing institutions would be a significant disincentive to their participation.

The Results

Aggregating the z-scores from the 142 AAM museums with those from the 13 NCCS museums, we re-ran the ranking. Of the 155 museums in the combined sample, 26 organizations ranked one standard deviation or above in measures of financial growth and audience participation (their z-scores ranged between +0.16 and +4.51).

Phase 2: Selecting the Study Museums

Because the AAM museum information was anonymized, distinguished only by a unique numeric identifier, we turned to AAM for assistance in "outing" the museums. AAM President Ford Bell wrote to each of the 26 museums ranked as high-performing, requesting permission to reveal their names to us; 23 museums agreed to participate in the study.

We wrote and then telephoned the leadership of the 23 high-performing museums to conduct preliminary screening conversations; 20 of the 23 museums responded to our request for interviews. In the screening conversations, we inquired about what had transpired at the museum over the prior decade. We also asked what, if anything, had the museum done differently in that time to produce their above-average performance. After capturing these preliminary stories in narrative form, we reviewed and made note of some of the emerging commonalities. We then narrowed the group to a "short list" of six to study in depth, selecting for size, geographic location, and institutional focus (i.e., art museum, history museum, science museum, zoo, etc.) to ensure appropriate diversity.

Phase 3: Case Study Methodology

This book is based principally on qualitative descriptive research or case-study methodology. Due to time and funding constraints, no quantitative studies were conducted to verify causal links between institutional initiatives and organizational, audience, or community outcomes. We relied on case study museum evaluation data, and referenced relevant research and writings from outside the field to provide context and inform our observations and conclusions, and to point towards additional museum-specific research needed in the future.

Document Review

We requested and carefully reviewed hard-copy information documenting mission, values and vision; exhibition and education program guidelines and history; audience development initiatives; brand development, marketing campaigns, communication vehicles and press coverage; audience or constituent surveys and program evaluations; annual reports and sample fundraising collaterals; long-range planning materials; plus organizational charts, board lists, and committee structures. We also consulted other sources of publicly available information, such as websites, GuideStar, and media coverage, and compiled all of the materials into hard-copy binders and electronic folders.

Organizational Self-Assessment

Using the categories of performance metrics identified in Phase 1 as part of defining high performance, we created a Magnetic Museums Organizational Self-Assessment (see Appendix C) and asked three representatives from each museum to complete it independently—the museum director, a current trustee (most often, the chair), and another senior staff member. We later used the self-evaluations as a reference against our own appraisal of each organization.

Case-Study Visit Protocols

With the advice and counsel of our Advisory Committee, as well as other social scientists in the field, we developed and consistently employed a case-study protocol. Anne Bergeron conducted two independent site visits to the Natural Science Center of Greensboro and the Philbrook Museum of Art. Beth Tuttle conducted three independent site visits to the Children's Museum Pittsburgh, Chrysler Museum of Art, and The Franklin Institute. Both authors conducted the site visit to Connor Prairie Interactive History Park, and Bergeron analyzed the findings and prepared the case study.

Each site visit consisted of a tour of the community given by the director or a senior staff member; a tour of the facilities led by the director or a staff member; individual interviews with the director; and group or individual interviews with senior staff, mid-management staff, select trustees, and representatives from the community—directors of peer institutions, funders, civic leaders, media representatives, and others—with direct knowledge and experience of the organization.

Interviews

We prepared three standardized guides for use in interviewing approximately 15 to 30 museum and community representatives during a two-day site visit to each organization: one for conversations with staff, one for trustees, and one for external observers. Using our criteria for selection, the museums identified the interview subjects and scheduled the meetings. Most of the interviews were one hour in duration and conducted face-to-face during our site visits; on occasion, a few were conducted by telephone when individuals were unavailable at the time of our visit.

Following each site visit, we typed up or transcribed our field notes. Each author then shared her notes and reports with the other to ensure clarity of meaning, and to identify and resolve inconsistencies in interpretation.

Case Summaries

We drafted detailed case narratives for each museum, drawing on the background materials provided by the museums and outside research, as necessary. The written cases were shared with each respective museum for fact-checking to ensure accuracy in our storytelling.

Phase 4: Synthesis of Findings

We deliberated long, hard, and often, looking for patterns, shared traits, and commonalities of practice among the six museums we studied in depth. We even holed up in a lovely hotel in Philadelphia for three days to unpack our findings and map the trajectory of the book. As we narrowed our sights on the six practices identified in these pages, we sought the advice of our advisors, who often referred us to another expert to contact or another reference source to review for guidance. We informally tested our ideas with trusted colleagues before settling on the final model encapsulated in this book. We have included a lot of information from outside sources and have noted where our findings correlate or conflict with existing research or accepted wisdom. Through an iterative and dialogic process, we found that something more than a set of findings emerged. This book proposes a philosophy for museums that we hope you find engaging, thought provoking, and inspiring.

A FINAL NOTE TO RESEARCHERS AND FUNDERS

We believe that the field is hungry to develop and embrace high-performance culture, leadership, and management practices. We have observed that, increasingly, museums are turning their attention outward, focusing on creating meaningful audience experiences and relevant community impact. We know that the demands to produce enhanced business results will only grow.

We believe that more research is needed to support and guide these ambitions and validate the efficacy and impact of the types of initiatives this book proposes. A different approach to funding—one that recognizes the value of investing in the people and processes that deliver cultural programming and impact—is also needed to build the high-performance capacity of the sector.

Appendix A Notes

1. Anne Bergeron, Beth Tuttle and Jennifer Wells Green, "Secrets of the Magnetic Museum: Turning Moments of Success into Momentum," American Association of Museums Annual Meeting, Los Angeles, CA, 23 May 2010.

2. Elizabeth E. Merritt and Philip M. Katz, eds., *Museum Financial Information 2009*, (Washington, DC: American Association of Museums, 2009), 1-2.

3. Elizabeth E. Merritt, ed., *Museum Financial Information 2006* (Washington, DC: American Association of Museums, 2006), 1.

4. Pew Charitable Trusts. "PCLP Program Description." *Philadelphia Cultural Leadership Program*. http://www.pewtrusts.org/uploadedFiles/wwwpewtrustsorg/TaxonomyCopy/Arts_and_Culture/Philadelphia_Cultural_Leadership_Program/PCLP-Program-Description-2013.pdf (accessed 4 Jan. 2013).

5. American Alliance of Museums. *Standards and Best Practices*, http://www.aam-us.org/resources/ethics-standards-and-best-practices/standards (accessed 4 Jan. 2013).

Stakeholder Interview List

Children's Museum Pittsburgh

Staff

Yvonne Atkinson, Child Development Specialist, 7-24-12

Kimberly Bracken, Community and Youth Programs Coordinator, 7-24-12, 1-09-13

Lisa Brahms, Research Fellow, 7-24-12

George Brezinski, Director of Visitor Services, 7-24-12

Lisa Carvajal, Exhibits Design Manager, 7-24-12

Amy DiPlacido, MakeShop Coordinator, 7-24-12

Gina Focareta-Evans, Director of Development, 7-24-12

Angelo Galioto, Café Chef, 7-24-12

April Klonicke, Accounting Clerk, Finance, 7-24-12

Penny Lodge, Director of Museum Experiences, 7-24-12

Suzanne McCaffrey, Director of New Media, 7-24-12

Rebecca McNeil, Director of Finance, 7-24-12

Kana Otaki, New Media Coordinator, 7-24-12

Andy Rinefierd, Development Assistant, 7-24-12

Jennifer Roach, Admissions and Membership Manager, 7-24-12

Bill Schlageter, Director of Marketing, 7-24-12

Angela Seals, Education Program Manager, 7-24-12

Chris Seifert, Deputy Director, 7-24-12

JuWanda Thurmond, Youth Programs Manager, 7-24-12

Christian Tsu-Raun, MakeShop Teaching Artist, 7-24-12

Jane Werner, Executive Director, 4-18-11, 7-23-12, 1-4-13

Lois Winslow, Director of Education, 7-24-12

Trustees

Jennifer F. Broadhurst, *Vice President*; Philanthropist and Community Volunteer, 7-23-12

Evan Rosenberg, *President*; LSM/Director of Sports Marketing, KDKA-TV / WPWC, 7-23-12

Funders/Peers/Observers

Gregg Behr, Executive Director, The Grable Foundation, 7-24-12

Larry Berger, Founder and Executive Director, Saturday Light Brigade Radio, 7-23-12

Rich Fitzgerald, County Executive, Allegheny County, 7-23-12

Saleem Ghubril, Executive Director, The Pittsburgh Promise, 7-24-12

Darlene Harris, City Council President, City of Pittsburgh, 7-23-12

Janet Sarbaugh, Senior Program Director, The Heinz Endowments, 7-24-12

Thomas Sokolowski, Former Executive Director, Andy Warhol Museum, 8-15-12

Fred Thieman, President, The Buhl Foundation, 7-24-12

Chrysler Museum of Art

Staff

Terry Benson, Maintenance Supervisor, 6-21-12

Amy Brandt, McKinnon Curator of Modern and Contemporary Art, 6-21-12

Edwina Bell, Director of Development and Communications, 6-21-12

Anne Corso, Director of Education and Public Programs, 6-21-12

Dana Fuqua, Chief Financial Officer, 6-21-12

Jefferson Harrison, Chief Curator, 6-21-12

William Hennessy, Director, 4-25-11 and 6-21-12

Colleen Higginbotham, Director of Visitor Services, 6-21-12

Robert Holtzscheiter, Gallery Host, 6-12-12

Christine Gamache, Visitor Services Supervisor, 6-21-12

Susan Leidy, Deputy Director, 6-21-12

Molly Marder, Registrar, 6-21-12

Gary Marshall, Website Manager, 6-21-12

Dawn Penny, Assistant, Director's Office, 6-21-12

Charlotte Potter, Manager, Glass Studio, 6-21-12, 10-11-12

Brian Wells, Membership Manager, 6-21-12

Trustees

Macon F. Brock, Retired Chairman and CEO, Dollar Tree, Inc., 6-22-12

Henry D. Light, Esq., Of Counsel, Crenshaw, Ware and Martin, PLC; Retired Senior Vice President, Law, Norfolk Southern Corporation, 6-22-12

Peter Meredith, *Chair*; Chairman and CEO, Meredith Construction Co., Inc., 6-22-12

Funders/Peers/Observers

Richard Barry, Retired Vice Chairman, Landmark Corporation. 6-22-12

Rob Cross, Executive and Artistic Director, Virginia Arts Festival, 6-22-12

Maurice Jones, Deputy Secretary for U.S. Housing and Urban Development, former President, Pilot Media, 7-20-12

Angelica Light, Retired CEO, Hampton Roads Community Foundation, 6-22-12

Conner Prairie Interactive History Park

Staff

Amy Ahlersmeyer, Director of Marketing and Communications, 9-26-12

Rosie Arnold, Education Program Manager, 9-27-12

Carol Bennett, Guest Services Director, 9-27-12

Vinona Christensen, Guest Services Manager, 9-27-12

Michelle Evans, Operations Manager, 9-27-12

Cathy Ferree, Vice President of Exhibits, Programs and Facilities, 9-26-12

Dan Folta, Vice President of Advancement, 9-27-12

Susan Johnson, Vice President of Human Resources, 9-27-12

Brian Mancuso, Director of Exhibits, 9-27-12

Elaine Molin, Store Manager, 9-27-12

Susan Morin, Youth Experience Manager and Kid Wrangler, 9-27-12

Chris Petrelli, Director of Programs, Education and Evaluation, 9-27-12

Ellen Rosenthal, President & CEO, 3-15-10 and 9-27-12

John Spicklemire, Director of Facilities, 9-27-12

Nancy Stark, Director of School and Youth Programs, 9-27-12

Yvonne Todd, Catering and Banquet Sales Manager, 9-27-12

Jody Walker, Director of Annual Fund and Membership, 9-27-12

Kyle Wenger, Chief Financial Officer, 9-27-12

Trustees

Terry Anker, Chairman, Anker Consulting Group, Inc., 9-28-12

Christopher Clapp, *Vice Chair*; Chief Executive Officer, Bluelock, LLC, 9-24-12

William Corley, Retired President and CEO, Community Health Network, 9-28-12

Tim Hassinger, *Chair*; Global Leader, Agricultural Chemicals, Dow AgroSciences, 9-24-12

Marjorie Meyer, Civic Leader and Philanthropist, 9-28-12

Jay Ricker, *Chair, Development Committee*; President, Ricker Oil Company, 9-28-12

Julie Viellieu Thompson, Community Advocate, 9-28-12

William Weldon, PhD., Vice President, Global Research and Development, Elanco Animal Health, 9-28-12

Megan Wiles; *President,* Conner Prairie Alliance, 9-28-12

Funders/Peers/Observers

Scott Faultless, President, Fishers Town Council, 9-27-12

Brenda Myers, Executive Director, Hamilton County Visitors Bureau, 9-28-12

Gene Tempel, President Emeritus, Indiana University Foundation and Founding Dean, School of Philanthropy, Indiana University, 9-28-12

Michael Twyman, Grants Program Director, Nina Mason Pulliam Trust, 9-28-12

John Vanausdall, President and CEO, Eiteljorg Museum of American Indians and Western Art, 9-27-12

The Franklin Institute

Staff

Frederic Bertley, PhD., Vice President of Science and Innovation, 8-2-12

Jamie Collier, Director of Volunteers, 8-2-12

Troy Collins, Senior Vice President of Programs, Marketing and Business Development, 8-2-12

Larry Dubinski, Esq., Executive Vice President, 8-2-12

Bruce Fishberg, Senior Vice President of Finance and Administration, 8-2-12

Kristi Fogarino, Assistant Director of Sales, 8-2-12

Noel Fronezyk, Operations Manager, 8-2-12

Marci Generose, Director of Development Events and Operations, 8-2-12

Felicia Jones, Admissions Director, 8-2-12

Dale McCreedy, Director of Gender and Family Learning Programs, 8-2-12

Derrick Pitts, PhD., Planetarium Programs Director and Chief Astronomer, 8-2-12

Richard D. Rabena, Vice President of Operations and Capital Projects, 8-2-12

Steven L. Snyder, PhD., Vice President of Exhibits and Program Development, 8-2-12

Reid Styles, Vice President of Human Resources, 8-2-12

Paul Taylor, Traveling Science Show and Communications Outreach Manager, 8-2-12

Marisa Wigglesworth, Vice President of Development, 8-2-12

Dennis Wint, PhD., President and CEO, 4-21-11, 8-2-12 and 8-3-12, 11-29-12

Trustees

Marsha Perelman, *Chair*; Retired Energy Industry Executive and Community Leader, 8-2-12

Dr. Donald Morel, Jr., Chairman and CEO, West Pharmaceutical Services, Inc., 8-3-12

Funders/Peers/Observers

Regina E. Canfield, Senior Vice President, Director of Corporate Communications, The PNC Foundation, 8-2-12

Barbara Del Duke, Senior Manager, Public Affairs and Community Relations, FMC Corporation, 8-3-12

Gail Harrity, President and COO, Philadelphia Museum of Art, 8-3-12

Donald Kimelman, Managing Director, Information Initiatives and the Philadelphia Program, The Pew Charitable Trusts, 8-3-12

Meryl Levitz, President and CEO, Greater Philadelphia Tourism Marketing Corporation, 8-3-12

William Marazzo, President and CEO, WHYY, Inc., 8-3-12

J. William Mills, President, The PNC Foundation, 8-2-12

Stephen P. Mullin, Senior Vice President and Principal, Econsult Corporation, 8-3-12

Natural Science Center of Greensboro

Staff

Rick Betton, Director of Exhibitions and Programs, 8-28-12

Rick Boling, Zoo Curator of Reptiles and Invertebrates, 8-29-12

Glenn Dobrogosz, Executive Director, 4-27-11 and 8-28-12

Marcia Farrow, Visitor Services Manager, 8-29-12

Beth Hemphill, Director of Finance and Human Resources, 8-28-12, 8-30-12

Jessica Hoffman, Animal Discovery Curator, 8-29-12

Roger Joyner, OmniSphere Curator, 8-29-12

Keli Landing, Resource Manager, Volunteers/ Collections, 8-29-12

Dennis Law, SciQuarium Curator, 8-29-12

Steffany Reeve, Director of Marketing, 8-29-12

Martha Regester, Curator of Community Programs, 8-29-12

Ron Settle, Curator of Public Programs, 8-29-12

Jill Vincent, Retail Services Supervisor, 8-29-12

Michael Wood, Maintenance Supervisor, 8-29-12

Lindsey Zarecky, Director of Business Operations, 8-28-12, 8-30-12

Trustees

Kevin Baker, *Vice Chair*; Executive Director, Piedmont Triad International Airport, 8-29-12

Betty Barry, Volunteer and Retired Medical Practice Executive, 8-29-12

Robert (Bob) Braswell, *Campaign Chair*; President and CEO, Carolina Bank/Carolina Bank, 8-29-12

Gary Brown, *Chair*; Retired computer and software engineer, 8-29-12

Eric Calhoun, *Vice Chair*; President, Richardson Corporation, 8-29-12

Ron Miller, *Vice Chair*; Principal of Ron Miller & Associates, 8-29-12

Robert Scheppegrell, *Treasurer*; Senior Vice President, New Business Development, Lincoln Financial Group, 8-29-12

Funders/Peers/Observers

April Harris, Executive Director, Action Greensboro, 8-29-12

Robert (Bob) Klepfer, Executive Director, Tannenbaum-Sternberger Foundation, 8-29-12

James Melvin, President/CEO, Joseph M. Bryan Foundation; Retired Banker, Former Greensboro Mayor, 8-30-12

Richard (Skip) Moore, President, Weaver Foundation, 8-29-12

Sandy Neerman, Assistant City Manager, City of Greensboro, 8-29-12

The Honorable Robbie Perkins, Mayor, City of Greensboro, 8-29-12

Steve Saucier, Executive Director, North Carolina Science Museums Grassroots Collaborative, 8-30-12

Philbrook Museum of Art

Staff

Christina Burke, Curator of Native American and Non-Western Art, 7-30-12

Charisse Cooper, Facility Manager, 7-30-12

Donna Durrin, Director of Finance, 7-30-12

Karen Fraser, Fundraising Events Manager, 7-30-12

Susan Green, Museum Educator, 7-30-12

Amanda Hodges, Graphic Designer, 7-30-12

Chris Kallenberger, Director of Collections and Exhibitions, 7-30-12

Melinda McMillan, Manager of the Gardens, 7-30-12

Tricia Milford-Hoyt, Director of Communications, 7-30-12

Jeff Martin, Online Communications Manager, 7-30-12

Tanya Paul, Ruth G. Hardman, Curator of European Art, 7-30-12

Lauren Ross, Nancy E. Meinig, Curator of Modern and Contemporary Art, 7-30-12

Diane Shen, Event Coordinator, 7-30-12

David Singleton, Chief Operating Officer, 7-30-12

Randall Suffolk, Director, 5-9-11 and 7-30-12

Roselle Tyner, Education Coordinator, 7-30-12

Catherine Whitney, Chief Curator, 7-30-12

Trustees

Casey Cooper, *Chairman*; Attorney and Shareholder, Hall Estill, 7-31-12

Larry Lee, *Vice President*; Retired, former CEO of RAM Energy, 7-31-12

William Thomas, Co-Owner, Senior Star Living, 7-31-12

FundersPeers/Observers

William Major, Executive Director, Zarrow Foundation, 7-31-12

Gary Shaffer, CEO, Tulsa City County Library, 7-31-12

Suzanne Tate, Former Director, Oklahoma Arts Council, 7-31-12

Sharon Terry, Retired; Trustee, Tulsa Historical Society, 7-31-12

Dan Harrison, Senior Vice President, Administrative Services and Corporate Relations, ONEOK, 8-17-12

appendix c
Magnetic Museum Self-Assessment Tool

Museum Name: _____
Your Position: ___ Board member ___ Director
___ Sr. Staff: _____

Organizational Self-Assessment

Please indicate with an "X" your valuation on a scale of 1 to 5 – with 1 equating to Weak and 5 equating to Strong – of each of the performance categories below, choosing only one value per category. If the category is non-applicable to your museum or if you don't know, choose N/A. Please complete and return this form to Anne Bergeron at anne@magneticmuseum.com or via fax at 401.437.8271.

Area of Performance	Weak 1	2	3	4	Strong 5	N/A
I. Identity and Purpose						
1. Clear and compelling articulated mission, core values and vision						
2. Mission/vision/values used by board in decision-making						
3. Mission/vision/values used by staff in decision-making						
4. Articulated and institution-wide understanding of annual and long-term goals and objectives						
II. Leadership and Management						
A. Governance						
1. Governance exemplifies AAM standards and best practices^						
2. Qualified board leadership						
3. Board is well-respected in its community						
4. Shared leadership and empowerment among board, informed by executive staff						
5. Board is purpose-built and represents communities served						
6. Board members are active and effective museum ambassadors						
7. Board members are active donors						
8. Board members are effective fundraisers						
9. Succession plan is in place						
B. Management						
1. Operational systems exemplify AAM standards and best practices^						
2. Qualified executive leadership						
3. Executive leadership is well respected internally and externally						
4. Executive leadership is empowered by the board						
5. Executive staff encourage and enable shared leadership throughout the organization						
6. Staff at all levels exhibit leadership, take initiative and foster mutual empowerment						
7. Effective personnel management, performance evaluation and professional development programs are in place						
8. Cross disciplinary and inter-departmental planning approaches are in use throughout the museum						
9. Succession plan is in place						
III. Collections, Exhibitions, Programs and Interpretation						
1. Collections care and stewardship exemplify AAM standards and best practices^						
2. Collections are used effectively to engage audiences						
3. Exhibitions and programs exhibit scholarship						
4. Education and interpretive programs exhibit scholarship and exemplify AAM standards and best practices^						

Area of Performance	1	2	3	4	5	N/A
5. Regular use of cross-disciplinary staff teams for program development, budgeting and planning						
6. Audiences and desired impacts are articulated for programs						
7. Programs are aligned with institutional strategic direction and contribute to brand identity						
8. Exhibitions and programs are regularly evaluated and assessed						
9. Programs actively engage audiences in informal learning (on-site and virtual)						
10. Programs support formal learning activities in the community (i.e., school based programs for students and teachers)						
11. Programs are responsive and relevant to communities served						
12. Content-related activities contribute to reputation building and leadership within the field						
IV. Facilities and Physical Space						
1. Welcoming, well maintained, safe environment for visitors and staff						
2. Architecture, environmental design and facilities reflect brand and support organizational mission, program and administrative functions						
3. Way finding supports positive visitor experience						
4. Space is made available for community gatherings and events						
V. Finances						
1. Dedicated, experienced staff and financial management systems exemplify AAM standards and best practices^						
2. Adequate revenues are generated to support current and future operations						
3. Rational mix of income sources (i.e., earned, contributed, investment)						
4. Adequate capitalization and cash reserves are in place						
5. Budget aligns with and supports organizational and programmatic priorities						
6. Habits and practices of business literacy are evident throughout the organization						
7. Financial data is regularly collected and analyzed						
8. Budget assumptions are transparent and contribute to shared responsibility for organizational success						
VI. Strategic and Business Planning						
1. Regular, integrated and inclusive strategic, programmatic and business planning processes are in place						
2. Strategic planning is a collaborative effort by staff and board						
3. External viewpoints and expertise are sought to inform planning process						
4. Articulated measurable goals, objectives and action steps aligned with financial projections						
5. Quantitative and qualitative metrics of success are defined and performance-to-plan review process is in place						
VII. Resource Development						
1. Fundraising management systems adhere to industry standards and best practices						
2. Dedicated and experienced fundraising staff are in place						

Area of Performance	1	2	3	4	5	N/A
3. Adequate fundraising budget, proportional to organizational scale						
4. Fundraising informs and is aligned with strategic direction and priority programs						
5. Active program of donor identification, cultivation, solicitation and stewardship						
6. Level of giving by patrons and funders meets or exceeds expectations						
7. Evidence of strong relationship and community-building between the museum and its constituents						
8. Rational mix of contributed funds from the four donor groups (individuals, foundations, corporations, government)						
9. Fundraising "storytelling" is aligned with brand messaging and communications						
10. Current technologies are used to engage supporters						
VIII. Brand, Marketing and Communications						
1. Communication approaches adhere to industry standards and best practices						
2. Dedicated and experienced marketing and communications staff are in place						
3. Adequate marketing and communications budget, proportional to organizational scale						
4. Brand architecture guides institutional image, personality and communications						
5. Graphic identity and brand marketing efforts are aligned with strategic direction and support programmatic objectives						
6. Effective program of outreach and visibility building						
7. Key messages are consistently communicated and well understood internally						
8. Key messages are consistently communicated to external audiences						
9. Current technologies are used to communicate with and engage audiences						
10. Relationships with key media are in place and activated						
IX. Stakeholder, Audience and Community Engagement						
1. Commitment to engagement and building relationships with audiences, stakeholders and community are core operating principles						
2. Dedicated staff and/or volunteers for visitor services, interpretation and education, outreach and program delivery						
3. Responsibility for audience/stakeholder engagement (on-site and virtual) is broadly shared across departments						
4. Advisory committees or other structures/practices are in place to encourage stakeholder and community involvement						
5. Proactive audience development and diversification efforts						
6. Regular collection and assessment of market research (membership, audiences, program participants)						
7. Regular dialogue with, engagement and stewardship of key stakeholder groups (staff, board, patrons/funders, advisors, volunteers)						
8. Strategic partnerships, collaborations and alliance-building with other cultural, educational and social benefit organizations						

Magnetic Museums[SM]: A project by Anne Bergeron and Beth Tuttle Page 3

^ For further information on the standards and best practices for museum management as codified by the American Association of Museums, please see http://www.aam-us.org/aboutmuseums/standards/stbp.cfm. This resource is provided with permission by AAM.

N.B. This chart was adapted with permission from the National Endowment for the Arts *Lessons Learned* website, which was compiled, written and edited by our good friend, Morrie Warshawski, http://www.warshawski.com/. For more information, please see: http://www.nea.gov/resources/Lessons/warshawski.html

V.4-17-12

Acknowledgements

This book is the result of the contributions of many individuals whose hands, hearts, intellects, and voices contributed to our understanding of what it takes to be magnetic … and what it takes to do a research project of this breadth. We are deeply grateful for all the assistance that we received, and we have endeavored below to recognize everyone who played a role in bringing this book to fruition. Please forgive us if we inadvertently neglected to mention a name or an institution.

First and foremost, we are grateful to the American Alliance of Museums for the assistance and encouragement that its staff provided to us throughout this three-year project, especially Ford Bell, Philip Katz, and John Strand. Were it not for AAM's collaborative support and capable expertise, this book would just have been an interesting one-off idea presented at a professional conference.

And then, of course, we are deeply indebted to the staff, board, and stakeholders of the six museums featured in the book, for the considerable commitment that was required to participate in every phase of this project, and for doing so with the same level of passion, service, and dedication that they bring to their work every day. We are impressed by their creativity and resourcefulness, and humbled by their deep devotion to their institutions and communities. We are proud to highlight their accomplishments here. Our warmest, most heartfelt thanks to Children's Museum Pittsburgh, Chrysler Museum of Art, Conner Prairie Interactive History Park, The Franklin Institute, Natural Science Center of Greensboro, and Philbrook Museum of Art.

To our Magnetic Museums Advisory Committee members, whose guidance, thoughtful questioning, gentle probing, and ongoing encouragement helped us to navigate some thorny issues and tricky questions of process. We are deeply appreciative for the insights offered by Rich Cherry, Marian Godfrey, Philip Katz, Randi Korn, Kathy Kretman, Carlos Manjerrez, Micki McGee, Maureen Robinson, Nina Simon, Dan Solomon, and Tom Stoner.

To our colleagues in The Museum Group, we thank them for their informed advice, welcome counsel, and enthusiastic cheerleading, especially whenever we got stuck or needed a neutral perspective to test our thinking. In particular, we are grateful to Leslie Bedford, Diane Frankel, Ellen Hirzy, Mary Ellen Munley, and Laura Roberts.

The original nine museums that we featured in our presentation at the 2010 AAM conference were an inspiration to us, and their stories of transformation helped to shape our early thoughts about magnetism. In addition to Ellen Rosenthal at Conner Prairie Interactive History Park (one of the original nine museums), we owe our thanks to Diana Duncan, Dorothy Kozinski, and Bonnie Pittman at Dallas Museum of Art; Annie Philbin and Jennifer Wells Green at Hammer Museum; Paul Bessire at Institute of Contemporary Art Boston; Daniel P. Jordan at Thomas Jefferson's Monticello; Holly Hotchner at Museum of Arts & Design; Shannon Alexander and David Mosena at Museum of Science and Industry Chicago; Uri Herscher and Jocelyn Tetel at Skirball Cultural Center; and Lynn Williams at United States Holocaust Memorial Museum.

We are deeply appreciative of the other museums we spoke with during the course of our research. Each of these museums is magnetic in its own way, and had we more time and resources, we would have liked to learn more of their stories. Our sincere thanks to Peter Sutton at Bruce Museum of Art; Judy Wellington at The Clay Center; Lial Jones and Randy Roberts at Crocker Art Museum; Robert Goldsmith at The Frick Collection; Wyona Lynch-McWhite at Fuller Craft Museum; Stephen Fleishman at Madison Museum of Contemporary Art; Colleen Schafroth at Maryhill Museum of Art; Greg Koos at McLean County Museum of History; Sally Dietsch, Terrell Falk, and Nicole Small at Museum of Nature and Science, Dallas (now Perot Museum); Jonathan Burke and Paul Fontaine at Museum of Science, Boston; Douglas Hyland at New Britain Museum of American Art; Emily Jones at San Antonio Museum of Art; and Arthur Feldman at Sherwin Miller Museum of Jewish Art.

To the organizations culled from the National Center for Charitable Statistics data who responded to our request to complete the Magnetic Museum survey instrument, we are grateful for the time spent to share your organization's quantitative information with us. Our thanks to Atlanta Botanical Garden, Baltimore Museum of Art, Buffalo Botanical Gardens, Iowa Children's Museum, Lied Discovery Children's Museum, Milwaukee Public Museum, Museum of Performance & Design, The Rock and Roll Hall of Fame and Museum, Speed Art Museum, The Henry Ford, The Toledo Museum of Art, and Virginia Aquarium & Marine Science Center.

We also want to acknowledge the support of the Georgetown University Center for Public and Nonprofit Leadership, where we served as Visiting Practitioners from 2010 to 2012, and in particular, Kathy Kretman and Luisa Boyarski for being our institutional partners in this effort. In addition, we want to thank Leslie Findlen at Brooklyn Botanic Gardens for exemplifying with grace the concept of distributed leadership; Kara Sincich Hershorin for her incredible statistical analysis skills; Megan Lavelle for her talented graphic design; Peter Linett at Slover Linett Strategies for helping us to frame our inquiry; Mark Morrow for his words, guidance, and skillful electronic red pencil; Kelley Shangle for aiding us in compiling such a useful annotated bibliography; Janine Underhill at idea-360 for her magical graphic recording; and Ruth Wieder for being our first reader.

Anne Bergeron wishes to personally thank the following individuals for their assistance in both getting to and moving beyond the finish line. To Alexandra Duran and Rosie Reardon for their help in illuminating the many pathways forward; Steve Robinson for his wise and attentive

counsel; Eric Fischl for so humorously introducing me to the concept of "peeps;" Nancy Klaus for her friendship, support, and wonderful parties that always put guests at the center; Max Anderson and Rob Stein for the opportunity to return to in-house practice at a great museum, which fundamentally believes in engagement; Katherine Bergeron and Butch Rovan for their steadfast support and loving encouragement; my parents, Kathryn and Edward Bergeron, for setting examples of personalized internal and external engagement; and Steve Wellmeier for being my ballast in all ways, big and small.

Beth Tuttle extends her appreciation to the following people who provided assistance and support along this journey. To Karen Coda and Mary Jo Smet for encouraging me to get away from the keyboard; Terese, Jim, Nick, and Abby Wilson for 20-plus years as our co-family; David Cofrin for always keeping "yes" in mind; Glenn Howard and the Cultural Data Project for the opportunity to continue the important work of building high-performance cultural organizations; Olga Viso for her friendship and encouragement; my parents, Elbert and Virginia Tuttle, and grandparents, Elbert and Sara Tuttle, high-performance servant-leaders of the first order; my children, Jimmy and Maggie Carragher, who inspire me daily with their optimism and spirit; and Bob Carragher for being the most aligned, engaging, empowering, and ultimately, magnetic person in my life.

About the Authors

Anne Bergeron is Associate Director of External Affairs at the Dallas Museum of Art, responsible for engaging its internal and external communities. Prior to her appointment in Texas, she founded Anne Bergeron & Co. Consulting LLC to provide resource and organizational development counsel to cultural and social enterprise nonprofits.

Before starting her own company, Anne held senior management posts at diverse organizations, such as the National Writers Voice Project, where she managed the national expansion of a Manhattan-based literary arts program; the Missouri Arts Council, where she oversaw the programmatic development of a $200 million statewide cultural trust fund; and the Solomon R. Guggenheim Museum, where she planned a $100 million capital campaign, secured landmark status for its historic building and multi-million dollar funding towards its restoration. She regularly presents at conferences and has led fundraising and philanthropy workshops for her clients and the Bank Street museum education graduate program, among others. She served as a 2010–12 Visiting Practitioner at the Center for Public and Nonprofit Management at Georgetown University, collaborating with Beth Tuttle to further their research on Magnetic Museums.

A native of Connecticut, Anne has a B.A. in English from Trinity College and an executive certificate in nonprofit management from Georgetown University. A past trustee of ArtTable, she is a member of the American Alliance of Museums, the Association of Fundraising Professionals, and The Museum Group. She and her husband were recognized by the State of Missouri for restoring an architecturally significant mid-century home designed by Harris Armstrong in St. Louis. She resides in Dallas, Tex., and Providence, R.I., with her husband.

Beth Tuttle is President and Chief Executive Officer of the Cultural Data Project (CDP). Beth's work at the CDP, which strengthens the national arts and cultural sector through the collection and reporting of reliable, standardized organizational and financial data, builds on her commitment to creating high-performance organizations that deliver significant public benefit.

Previous to her appointment at CDP, Beth founded and served as managing director of METStrategies, LLC, a strategic communications and management consulting firm where she was a leadership advisor, organizational, and brand strategist for the cultural, philanthropic, advocacy, and corporate sectors. Beth served as Deputy Director and Chief of External Relations and Planning for the Smithsonian's Hirshhorn Museum and Sculpture Garden, and as Senior Vice President for Communications for The Freedom Forum and Newseum. She combines expertise in organizational planning and communications with experience in fundraising and philanthropy, having also held key advancement positions in nonprofit advocacy and the foundation sector for more than a decade.

In the private sector, Beth honed her skills in advertising, brand marketing, and consumer research with leading New York and Washington, DC, consumer advertising agencies. She also has advised corporate leaders in strategic and crisis communications.

A graduate of Brown University, Beth is a frequent guest lecturer, speaker, and presenter. She was a 2010–12 Visiting Practitioner at the Center for Public and Nonprofit Management at Georgetown University, where she and Anne Bergeron developed their Magnetic Museums research. She is member of the American Alliance of Museums, Americans for the Arts, and The Museum Group. Beth resides in Philadelphia and Alexandria, Va.

Index